# Christopher Ameruoso

# Pets and Their Stars

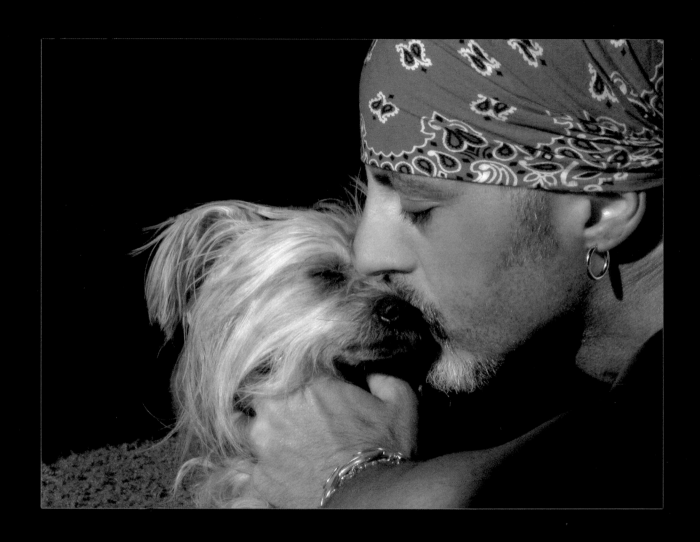

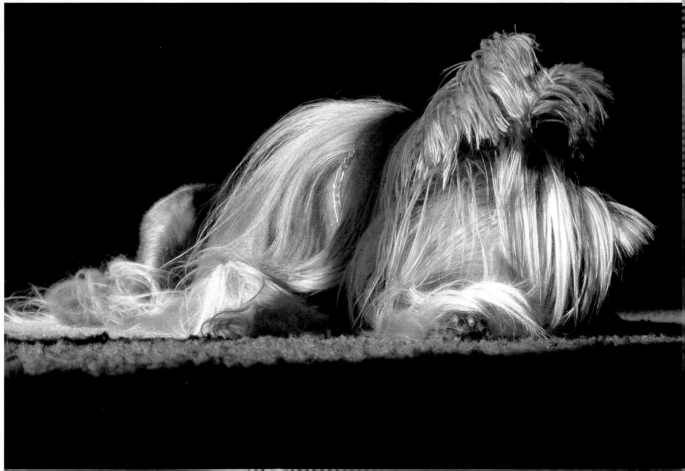

# DEDICATION

I would like to begin by thanking the two most influential people in my life: my mother and my father, Mary Jean and Vito Ameruoso. Without my parents who brought life to me, I would not be the person I am now. From my first breath, they taught me to honor life and to treat others with respect. My good upbringing has kept me out of trouble and kept me focused on being creative. Most of all, my mother and father have taught me life's most precious lesson: to respect myself. I love you both.

My first book was dedicated to an amazing person who I have had the honor of knowing: Chris De Rose, founder of Last Chance for Animals (www.lcanimal.org). Chris has made many sacrifices in his profession and is witness, on a daily basis, to the despair that abused animals endure. Through LCA, he has been instrumental in rescuing countless animals in need and ending their despair - promoting a message of hope, love, and the right to live a safe and happy life. Therefore, it is my wish to start this dedication by acknowledging Chris. Three years ago, while at an animal adoption, he introduced me to someone who changed my life and to whom I dedicate this, my second book: Linda Blair.

Linda Blair has devoted her life to what she believes in: animal rights and rescue. The words invincible, driven, and tenacious come to mind when I think about this woman. I am completely blown away by her commitment. She has the strength of four men and wouldn't hesitate to stand up to four men if they were harming an animal.

For those who view Linda Blair as the character that Hollywood created, it is time to look further and see one of the biggest hearts for animals on this planet. Just imagine receiving an e-mail stating that two mother dogs and fourteen puppies were going to be put down due of lack of space in a local shelter. Many of us would simply press delete and go on with our lives without a second thought. Not this 5 foot 5 inch, petite woman who jumped into her car and headed to one of the worst areas in South Central Los Angeles to rescue the innocent creatures and give them the chance at life they most deserve. Thus, Linda, with a split second gut decision, created a new life for herself with sixteen newfound dogs.

Everyday, this woman does something that amazes me - whether she is running to the veterinarian, picking up food, dropping off dogs, or finding them homes (all the while, keeping up her acting career). I have seen her take on challenges and watched how even the let-downs drive her more each day - well beyond the point where most people would have given up.

Her undying love and commitment to animals is reflected in her own non-profit foundation, where she dedicates all that she has into saving the lives of those who can't help themselves. It is with great pleasure that I dedicate my time, work, and this book to the truly wonderful Linda Blair.

I know Linda was right on track when she named her foundation Linda Blair's World Heart Foundation; her heart is as big as this world. I love you Linda. This book is for you.

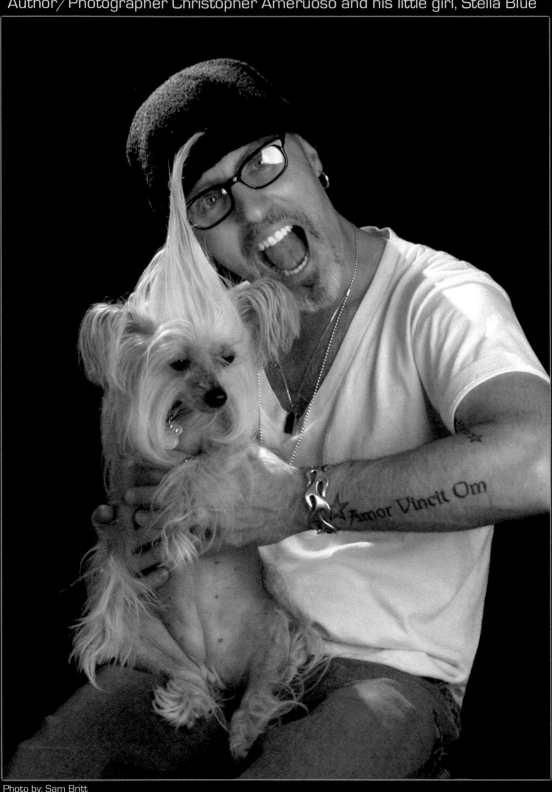

With the success of my first book, I thought it only appropriate to follow up with a second version.

Throughout my career, I have had the opportunity to come across many people working in the animal world who have made me step back and think about issues we don't often see or realize – the many animals that have been abused and need homes and also the people that dedicate their lives to rescuing and caring for traumatized animals. Working in the animal world as photographer and with animal charities has been, and continues to be, a life-long journey of learning and inspiration for me.

I'm continually shocked by people who abuse and profit from these helpless, defenseless creatures. Shelters are filled with dogs that are trained to fight and then abandoned when they become unprofitable or uncontrollable. And there are certain groups that accept large charitable donations from corporations, but never use them to benefit the animals. I know that one day these people will be called to face their ugliness and to pay for their despicable acts.

As for those who dedicate their lives to the cause of aiding and protecting animals – in shelters, rescue organizations, and reputable charities - I respect and honor you for your courage and strength. I want to acknowledge the hard work, sweat, and tears that go into rescuing animals and living this type of life style. Please accept my praise and sincere Thank You.

A few years ago, my life came to a crossroads when I made a decision to move on from a career in music. I began to notice celebrities walking their dogs and became fascinated with their relationship – how open and candid they were around their pets. My father, Vito, is an artist who dabbled in photography, and both of my parents always encouraged me to think creatively. I took a risk and made a career change to photography, where I find myself now. Thus, I began on a journey of working with celebrities who could help make a difference.

Celebrities have a way of getting people to look and listen. We don't always see them in their true light, but often stereotype them from what we see on television and the silver screen. At times, the public has portrayed them as villains. But I want to show the real side of these talented and decent individuals. Armed with my camera, I set out to photograph some of Hollywood's finest along with their pets, who truly bring out the best of these stars.

My initial goal was to raise awareness on the issues of the animal world. If I could get people to view animals' livelihood differently through my photographs, then I could help make a difference. Today, the same desire and goal - to raise animal awareness - is what drives me as I continue to work with celebrities and animal charities. People listen to celebrities, and, because of my work, I've had the opportunity to invite them to animal events and fund raisers for homeless animals. This has made an impact and resulted in positive changes in our society as people are becoming more educated about the overpopulation and mistreatment of animals.

The majority of my time and profits have been donated to the cause of animals and their needs. Thus, it is my continuing wish and goal to give more. By purchasing this book, you will have donated to Linda Blair's World Heart Foundation (www.lindablairworldheart.com) and are helping to make a difference for animals in need. It takes an incredible amount of manpower and funding to run a rescue organization. This is the least I can do to help.

I thank you for your interest in my work. Please help me in educating others about the mistreatment of animals.
Adopt, Spay, and Neuter.

Best,
Christopher Ameruoso

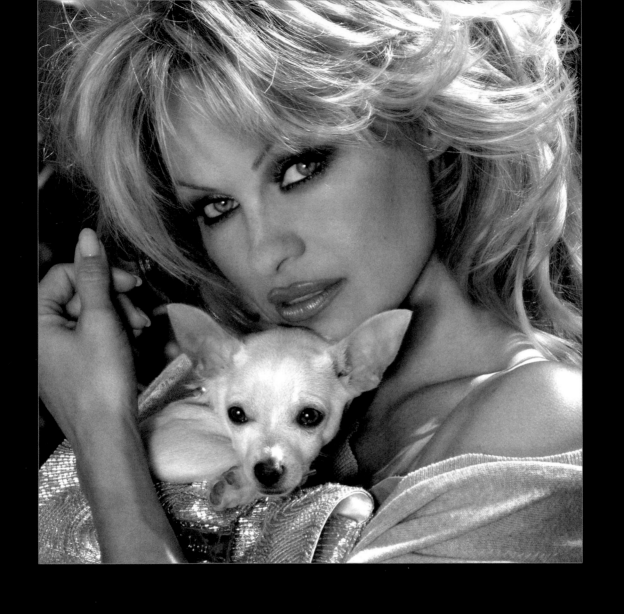

Pamela Anderson & Luca Pizzaroni Pasquin

# Foreword

My passion for animals first surfaced when I was a little girl on Vancouver Island in Canada. I happened to enter into the shed behind our house soon after my father returned from a hunting trip. The scene plays in my mind like a horror movie. I opened the shed door, and there was a beautiful deer, her fur splattered with blood, hanging upside down, her wide eyes now cold black marbles. I shrieked. My father tried to calm me down, saying, "It's just an animal." Realizing that he had killed her on purpose made me cry harder. He never went hunting again, and I promised myself from that moment on that I'd always protect animals.

When I began acting on Baywatch, one of my first promo gigs was an appearance at an auto show in Dallas to sign autographs. On the opening day of the show, there was a ruckus over at one of the displays. It was a protest of the company's secret car crash tests, which involved bludgeoning pigs, dogs, and rabbits. I was shocked. I couldn't imagine anyone treating my dog that way! For the rest of the show, I signed autographs with a message to boycott that company, which has since stopped using animals.

Eventually, I got the casting call I'd always hoped for: would I please appear in an anti-fur billboard in Times Square? The slogan was "Give Fur the Cold Shoulder." I took a red-eye flight when I was seven months pregnant to launch that campaign in Manhattan, where it amazes me that some designers still turn animals into fashion victims. It's my firm belief that, if you wouldn't wear your dog or cat, you don't have any business wearing any other animal's fur either.

One of my role models growing up was the late Linda McCartney, who not only used her public platform to defend animals, but raised her kids to respect them. I'm honored to be able to do the same thing now. As you look at these photos and read these quotes about people and their animal companions, please remember that animals everywhere need our love and help. There are a million easy things you can do for the animals you love, starting right at your own home, like letting them off chains and out of cages. If you're considering welcoming an animal into your life, rescue one (or two!) from your local animal shelter, where there are always plenty of sweet, loving friends in need of a good home. Finally, be sure to help prevent further shelter crowding by always spaying and neutering your pet.

Animals have played a huge role in my life, and I am forever indebted to the four-legged friends who have been by my side through good times and bad. I hope you enjoy this book and what Christopher Ameruoso has put together. Christopher Ameruoso's enthusiasm is inspiring! He's a great animal activist, a great photographer, and every time I see him it's an encouraging experience. I learn something – and we get great pictures.

Pamela Anderson

"Dixie is a woman of mystery."

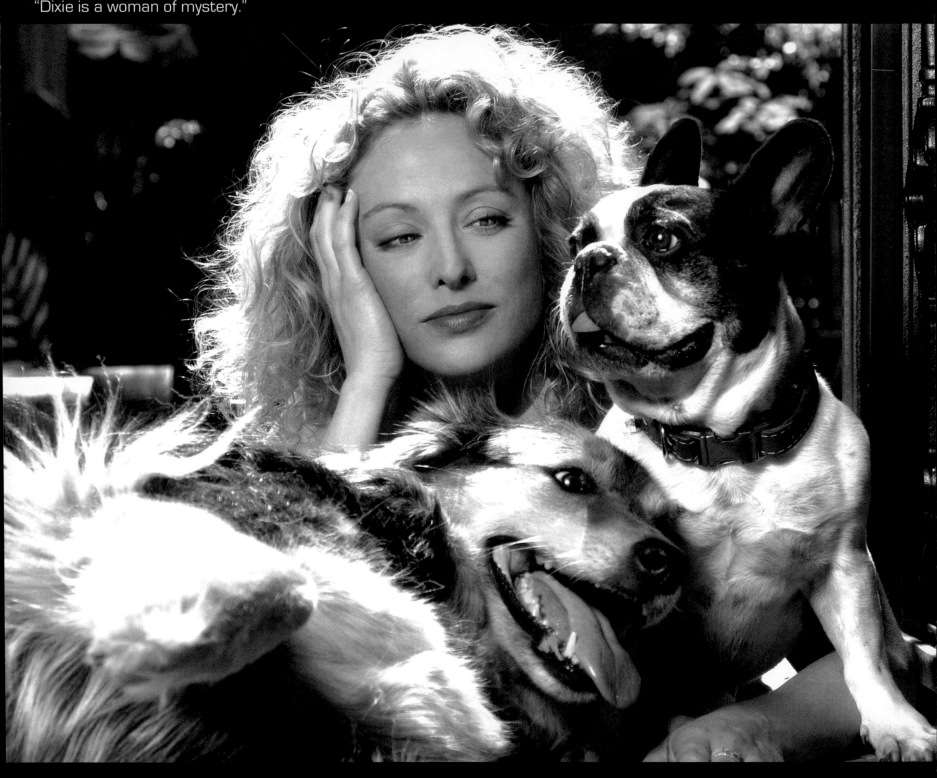

"Dixie was named after a character I played and Spike, well, he decided on that name because he believes he is big."

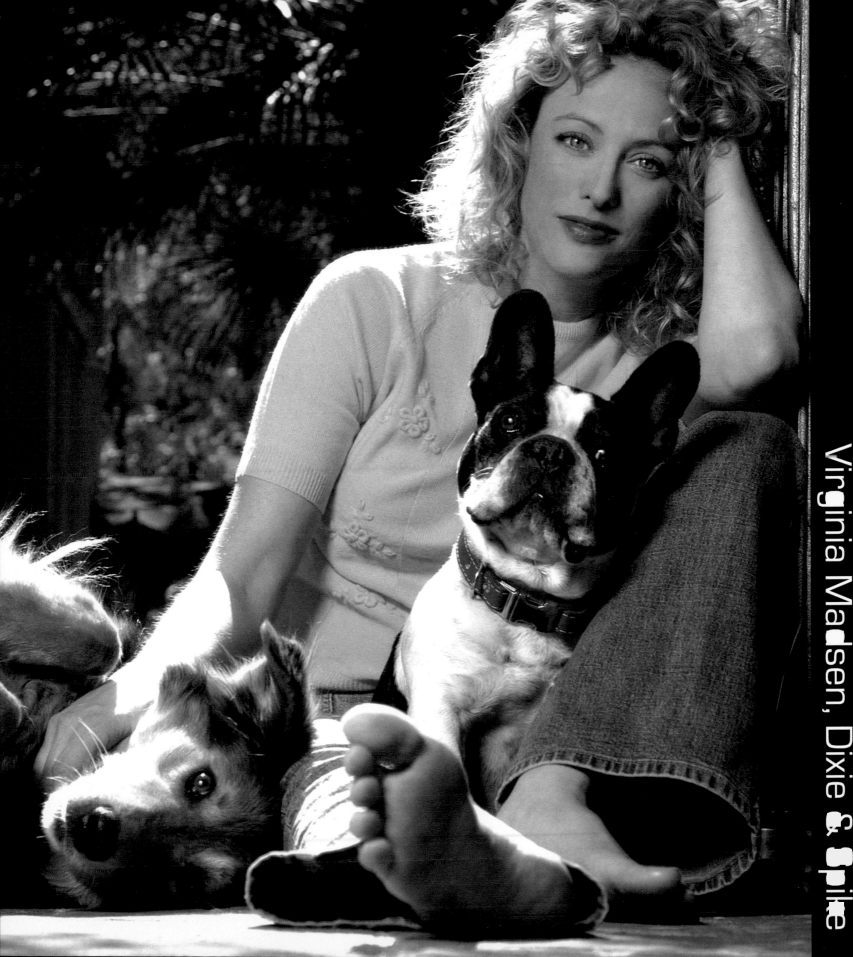

Virginia Madsen, Dixie & Spike

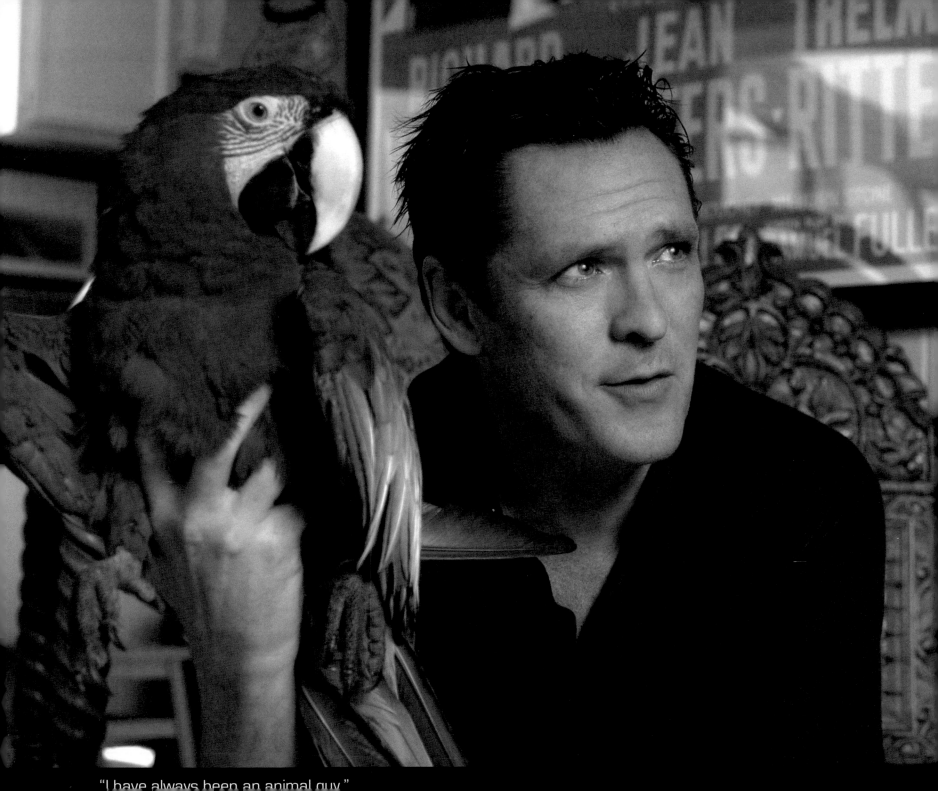

"I have always been an animal guy."

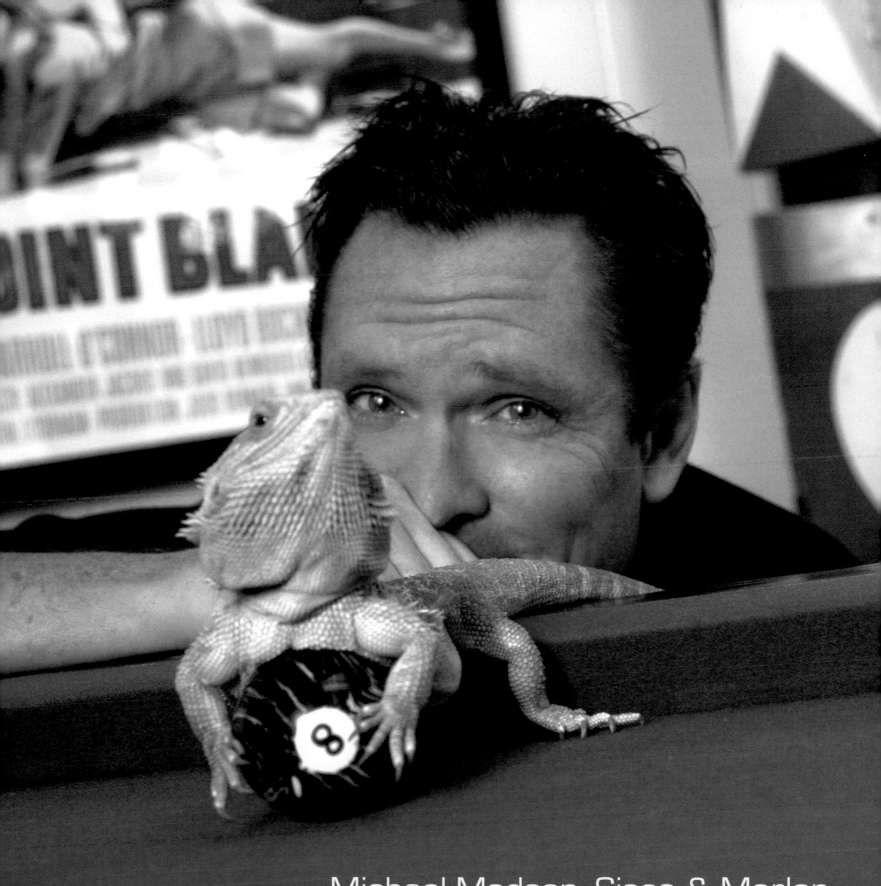

Michael Madsen, Sisco & Marlon

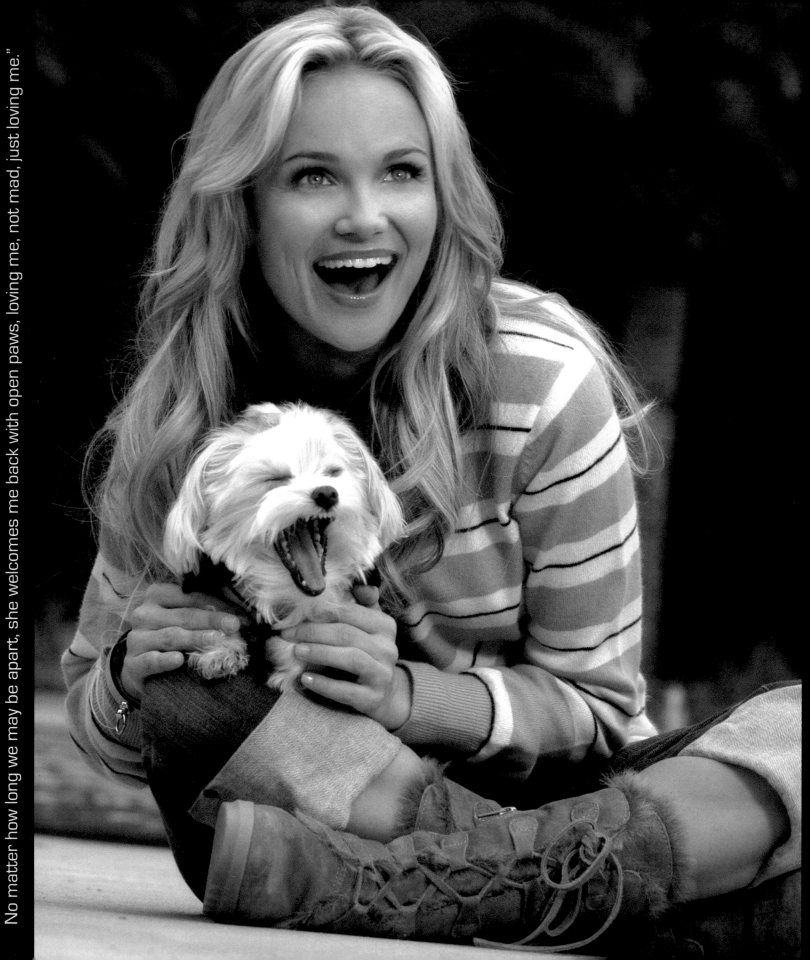

"She's a constant reminder of how to keep things in perspective. No matter how long we may be apart, she welcomes me back with open paws, loving me, not mad, just loving me."

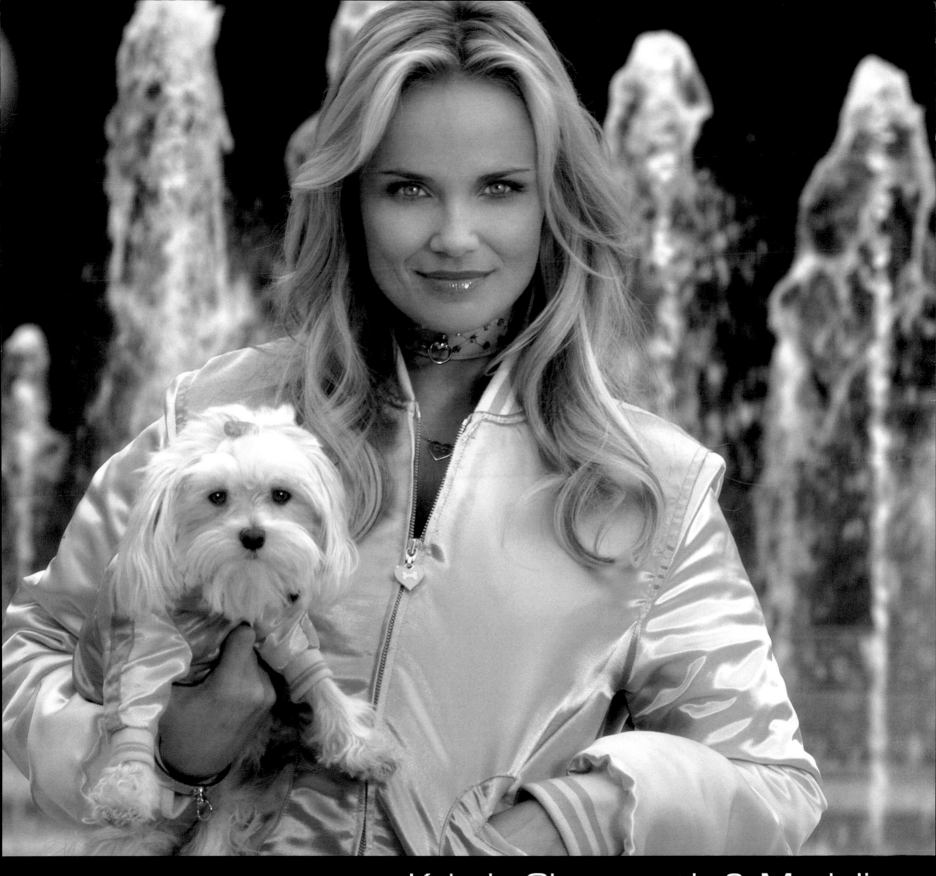

Kristin Chenoweth & Madeline

"Cats are very healing, very mystical animals."

"Sidney is such a critic when I'm acting."

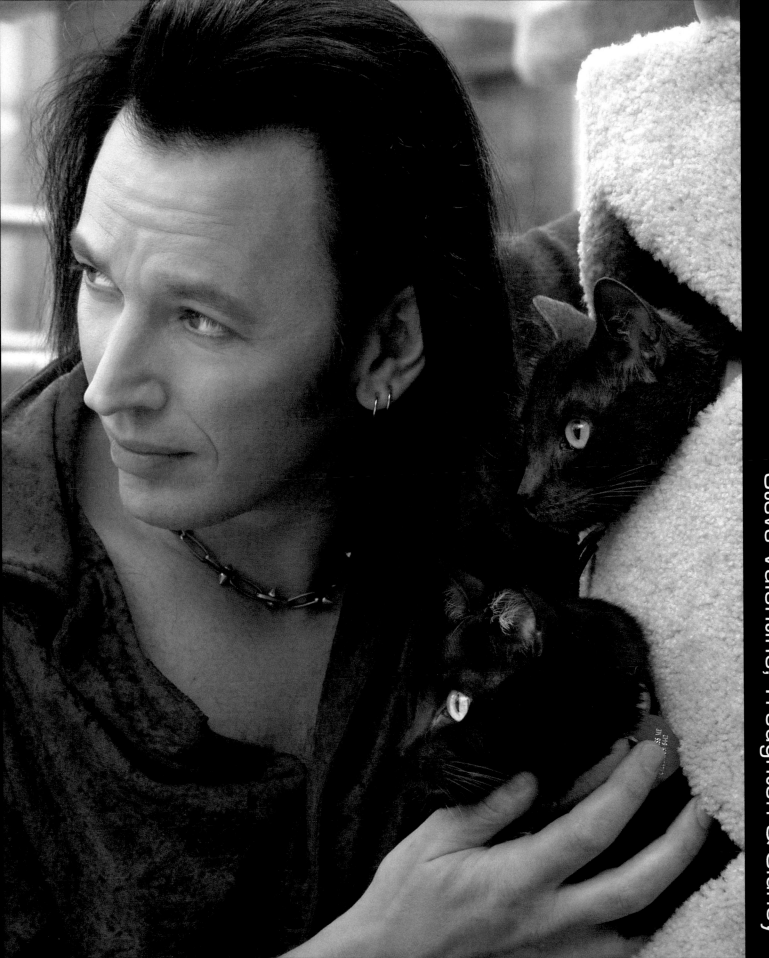

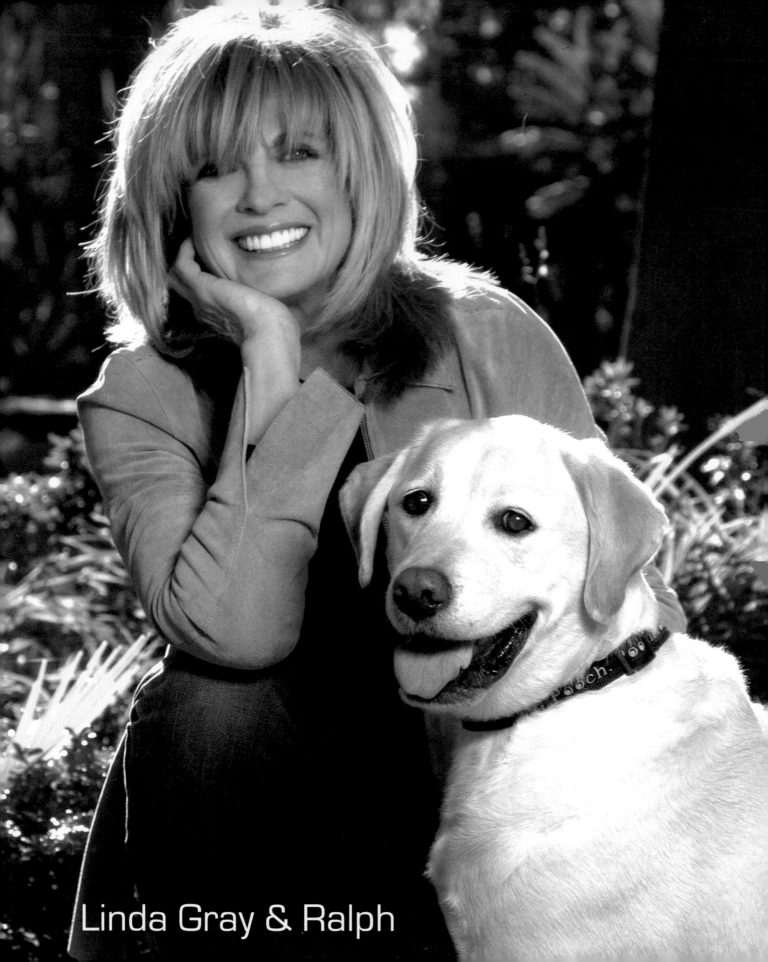

Linda Gray & Ralph

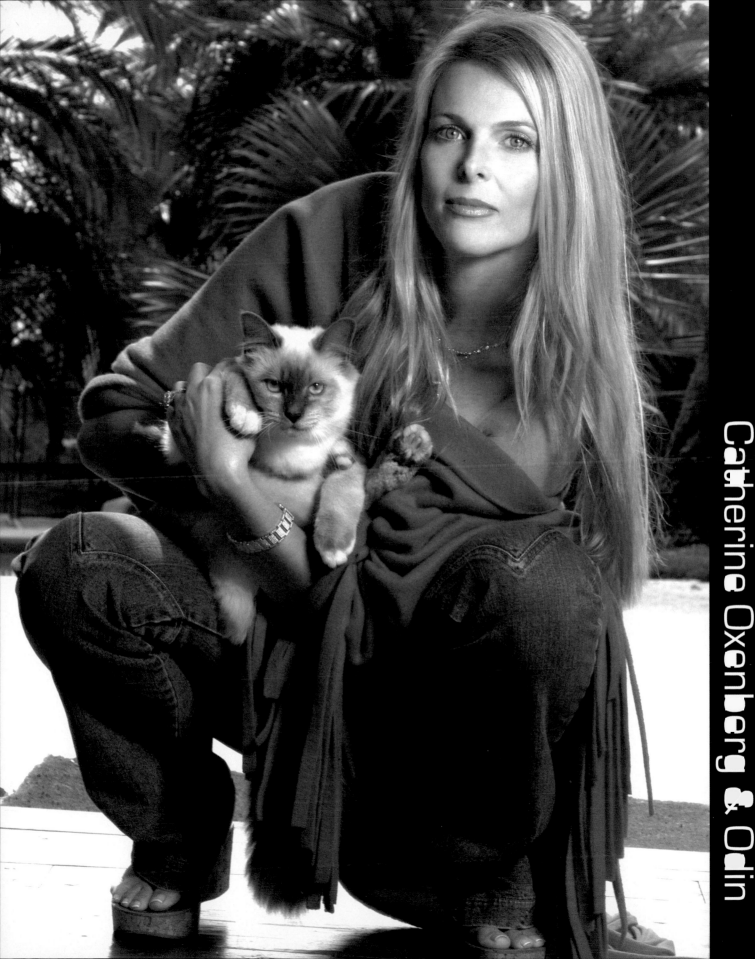

Catherine Oxenberg & Odin

"Chooch is that missing member of the family that finally showed up."

"I can tell that he's got the personality of an Italian boy. He yaps just like us."

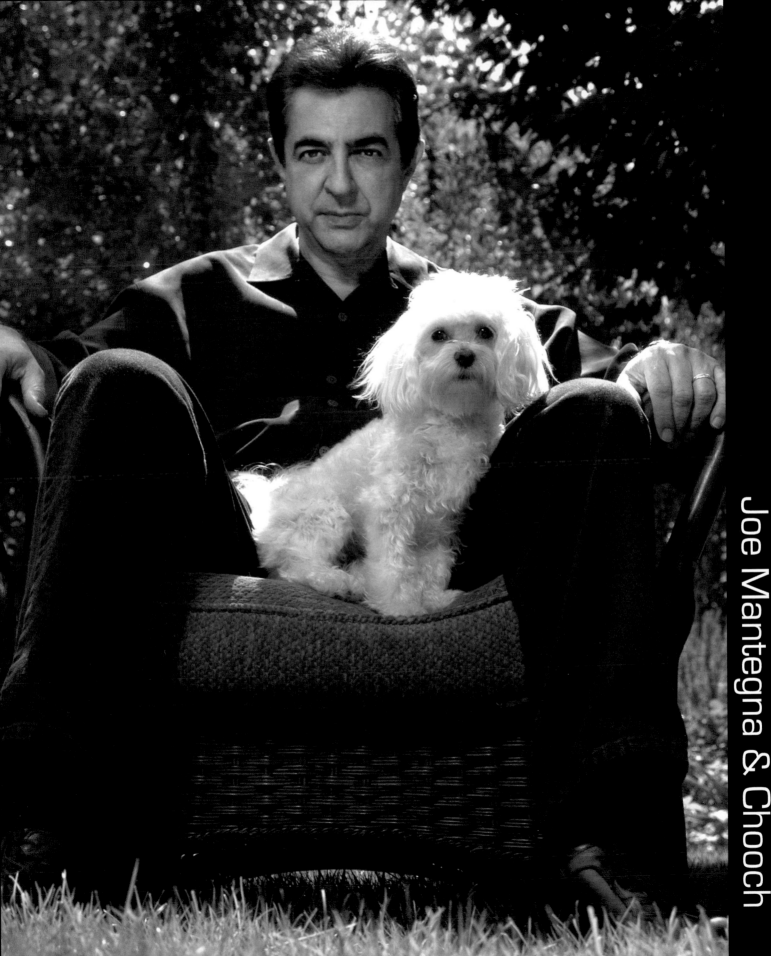

Joe Mantegna & Chooch

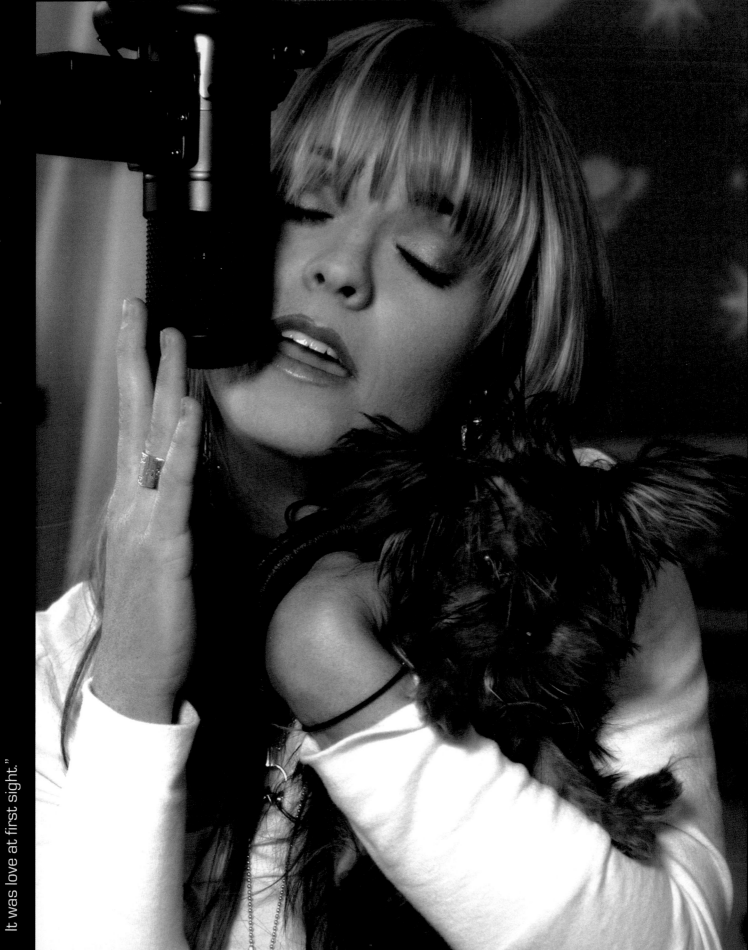

"You know how in a relationship it takes forever to say, 'I love you, I love you'? I looked at him and said, 'I love you. Come on, let's go.' It was love at first sight."

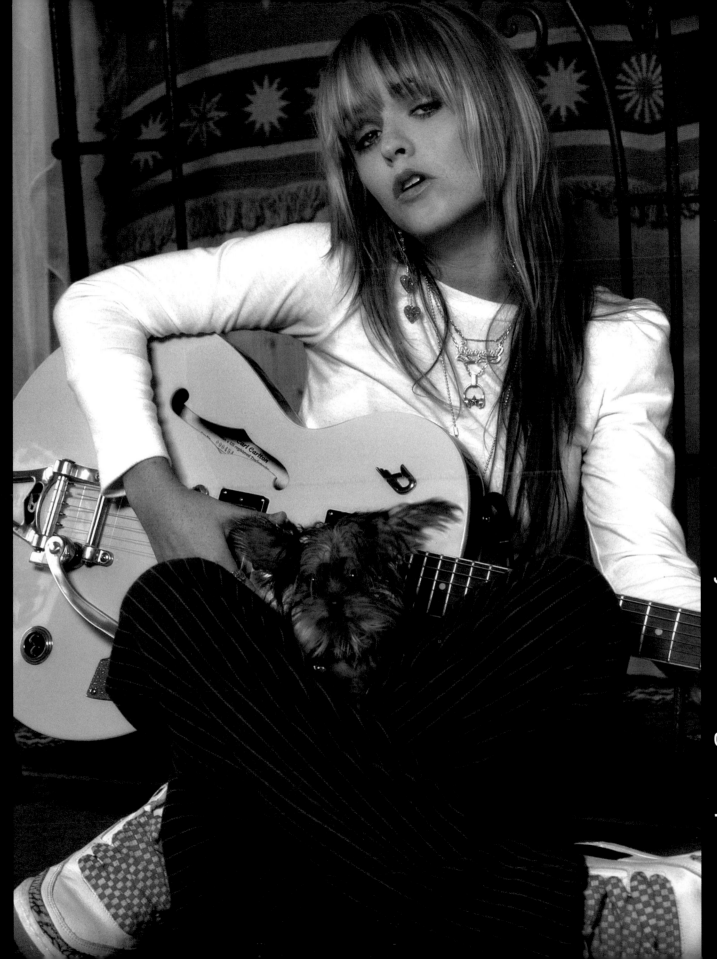

Taryn Manning & Speakers

"It's so funny how we have co-dependant relationships with our animals.
It's hysterical, and a little frightening."

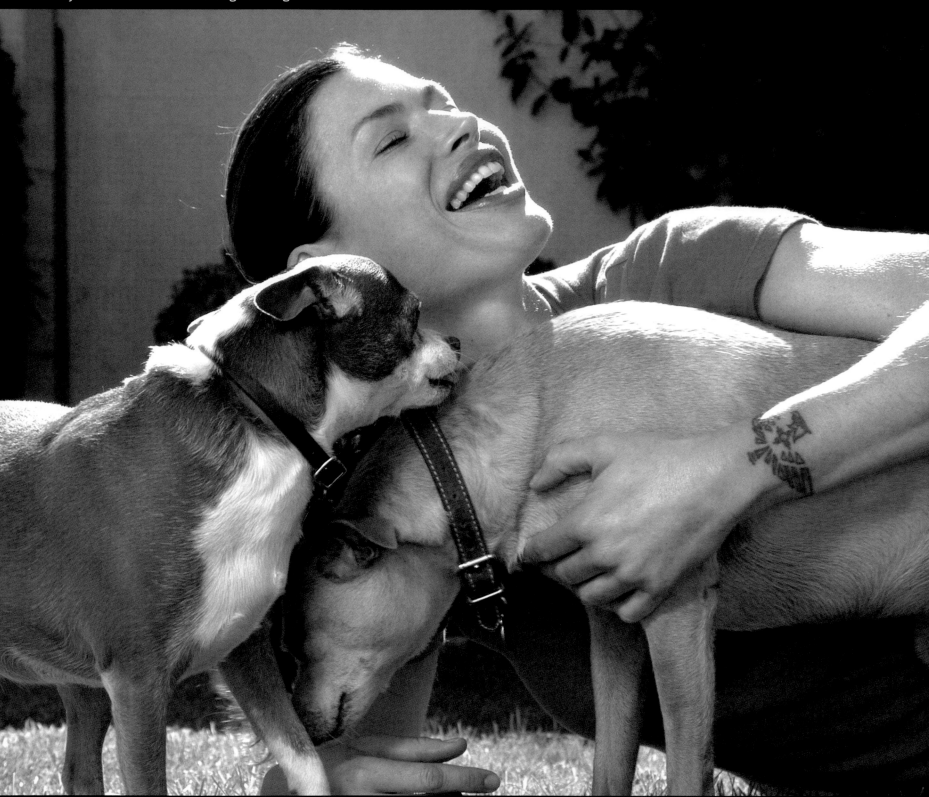

"They're my family. They have seen me through everything."

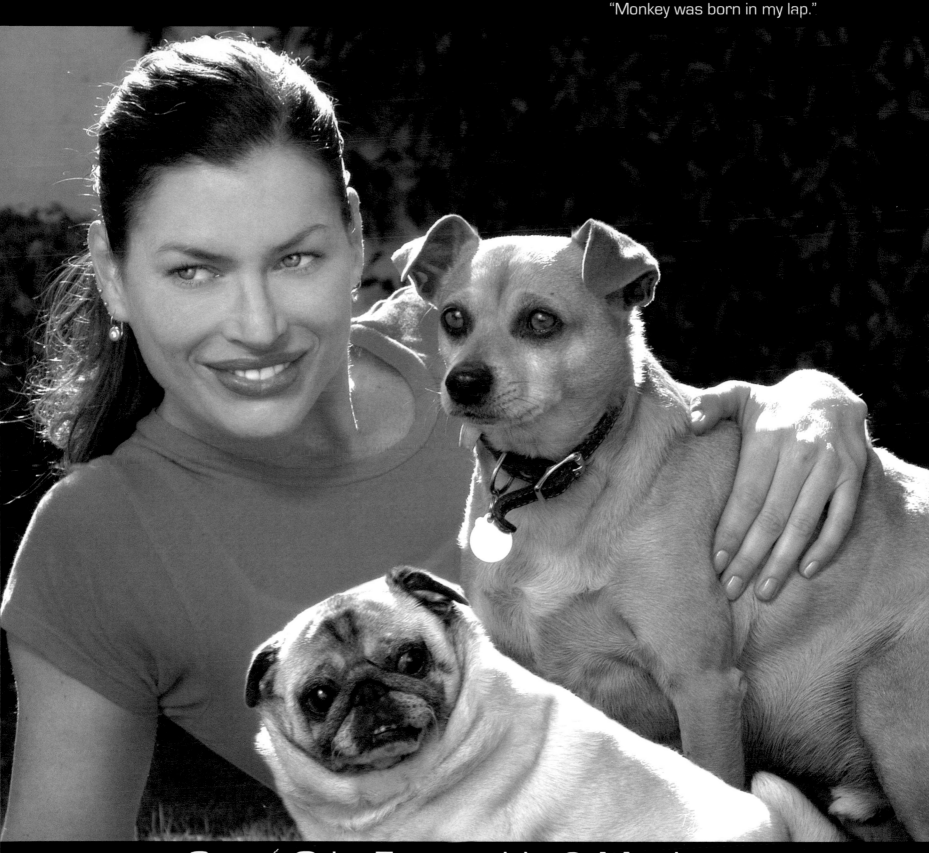

"Monkey was born in my lap."

Carré Otis, Esmerelda & Monkey

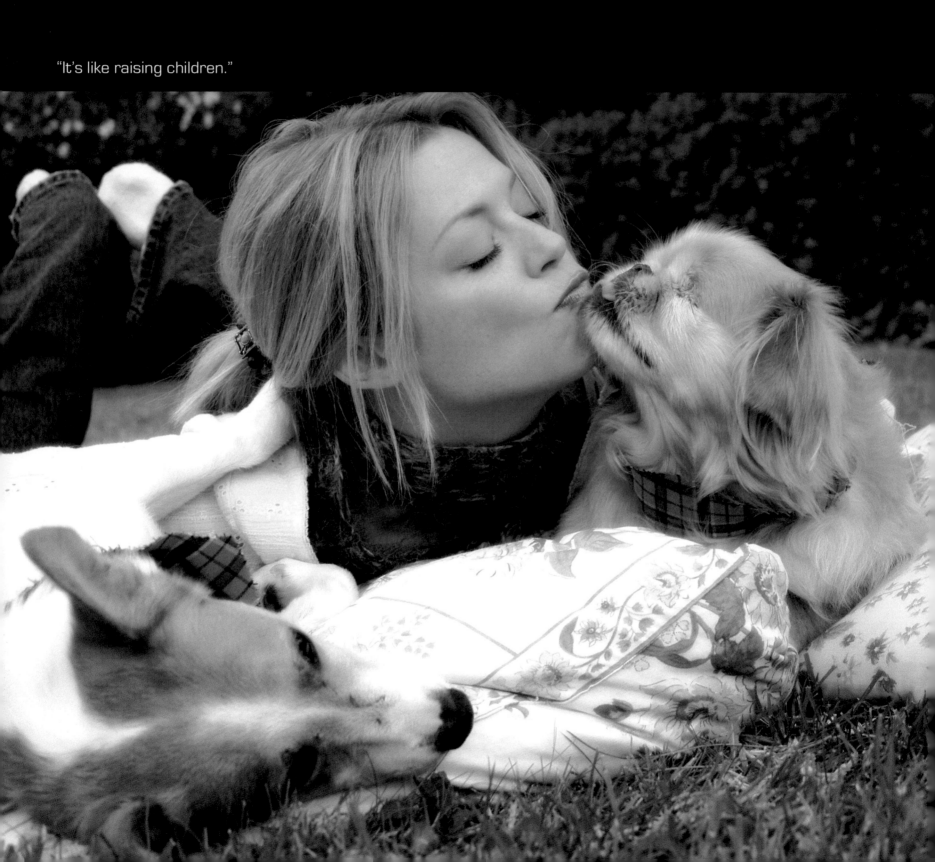

"It's like raising children."

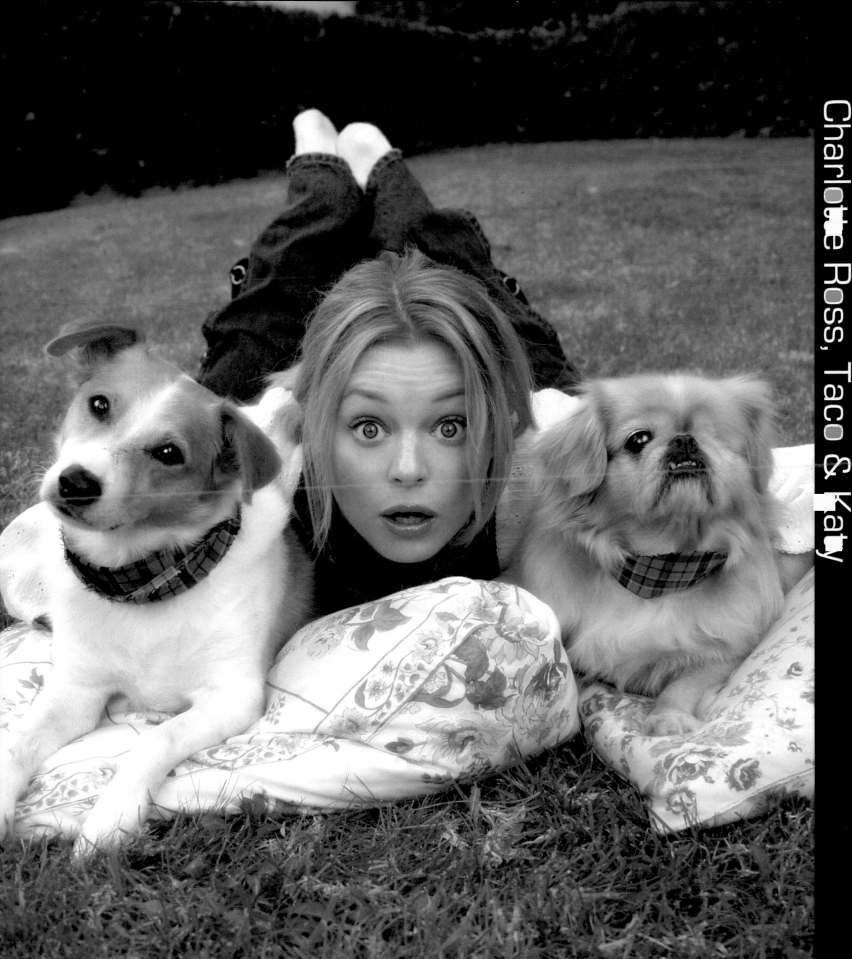

Charlotte Ross, Taco & Katy

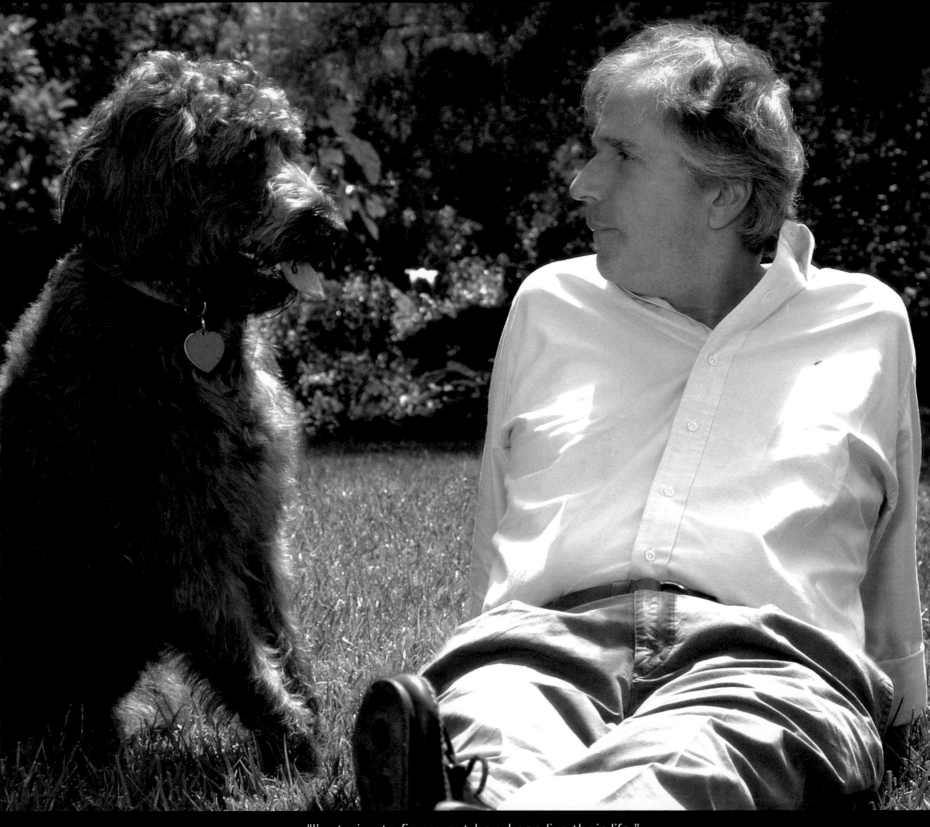

"I'm trying to figure out how I can live their life."

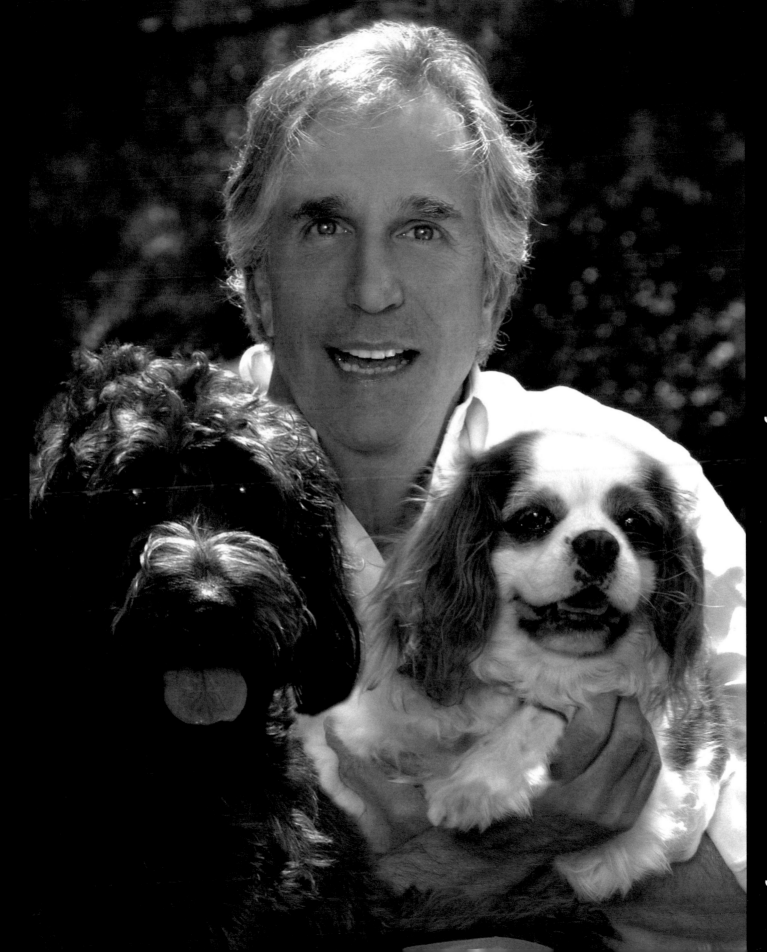

Henry Winkler, Charlotte & Monty

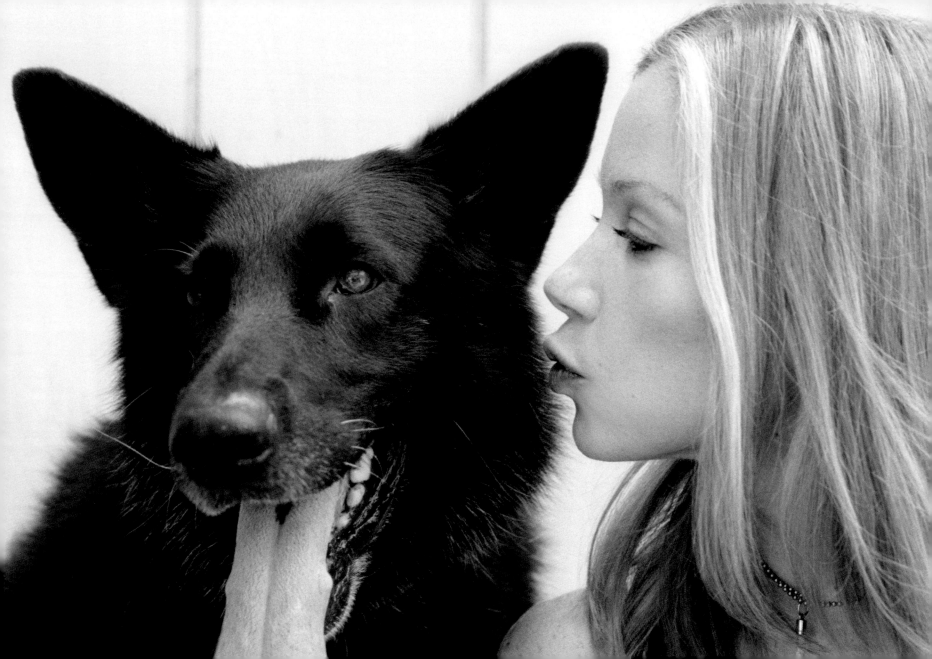

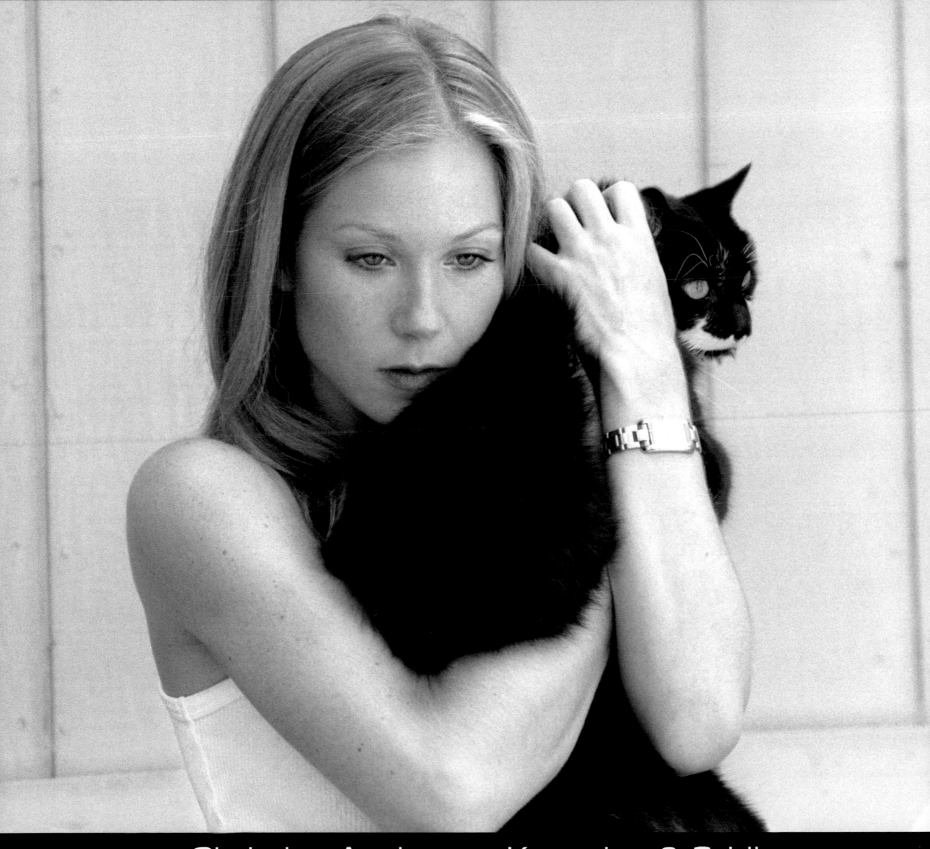

Christina Applegate, Kaanaloa & Sybil

"I think Tito is so handsome it's not even funny!"

"Not only do I cuddle with Tito, but I sometimes use him as a pillow."

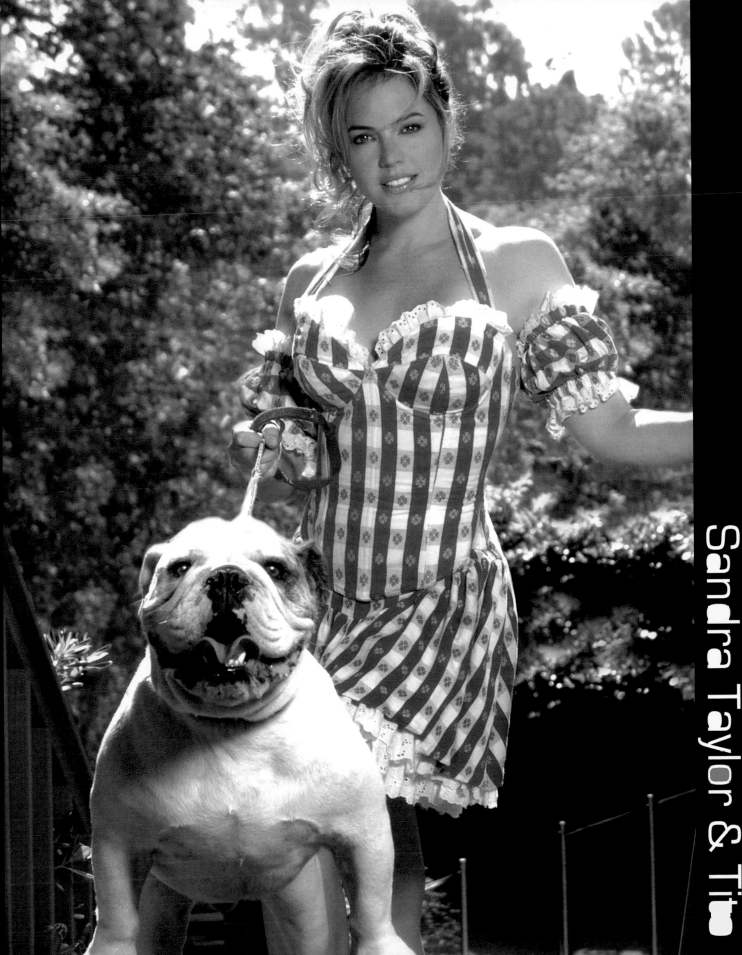

Sandra Taylor & Tito

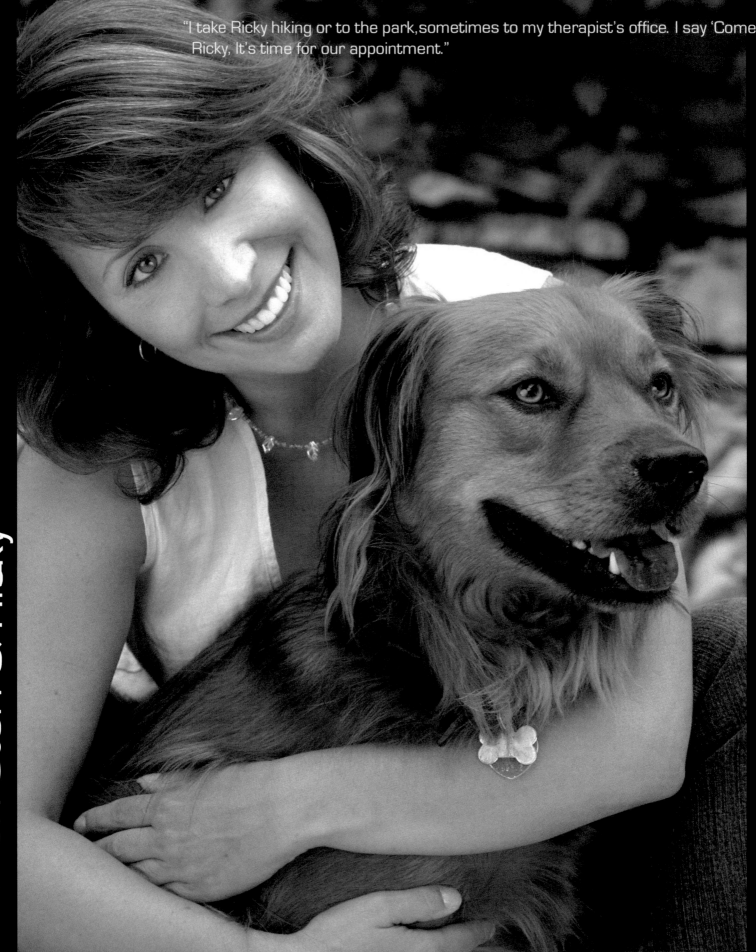

"I take Ricky hiking or to the park, sometimes to my therapist's office. I say 'Come Ricky, It's time for our appointment."

Cheri Oteri & Ricky

People think I'm a bad ass, but I'm not. I play with my puppies, and I'm a huge animal lover, just a big sap.

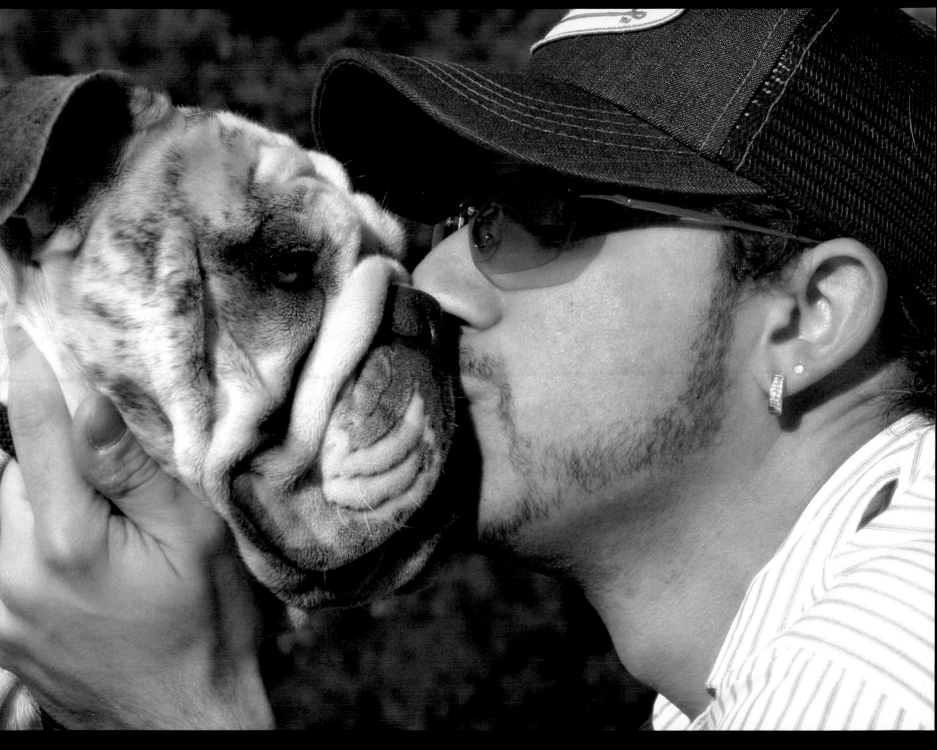

AJ McLean & Tank

When I take Mia to work with me she likes to sit in the make-up chair and they put blush her and she feels very special.

"If I'm ever feeling sad or sick she will not leave my side. Mia will sit on me until she know's I'm feeling better."

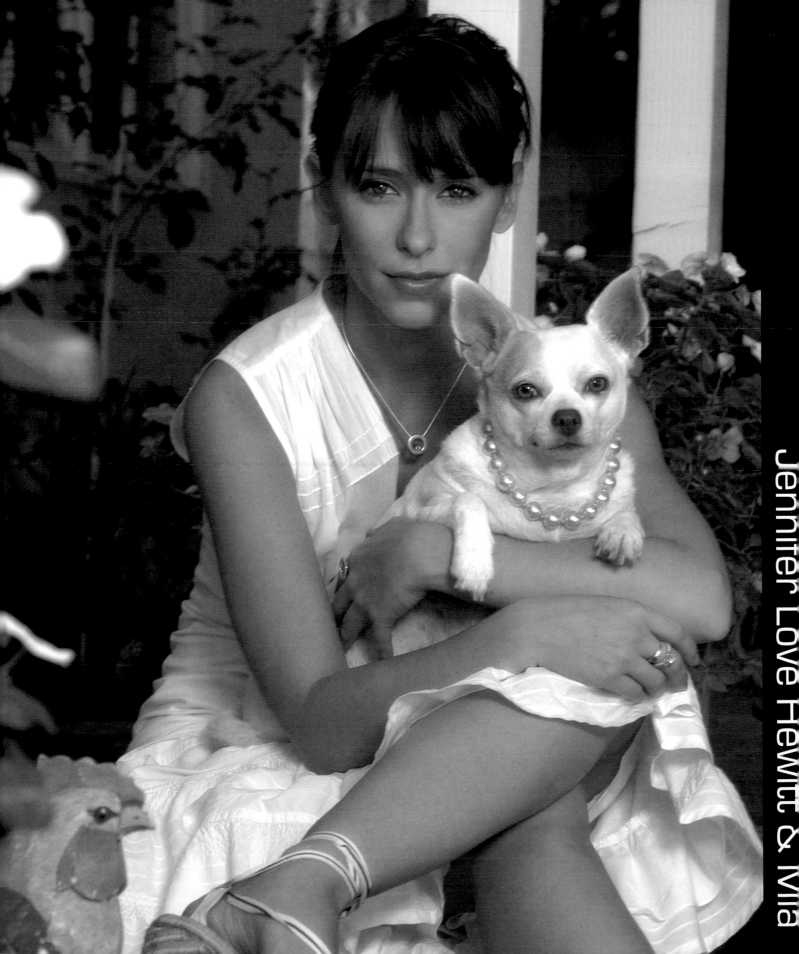

Jennifer Love Hewitt & Mia

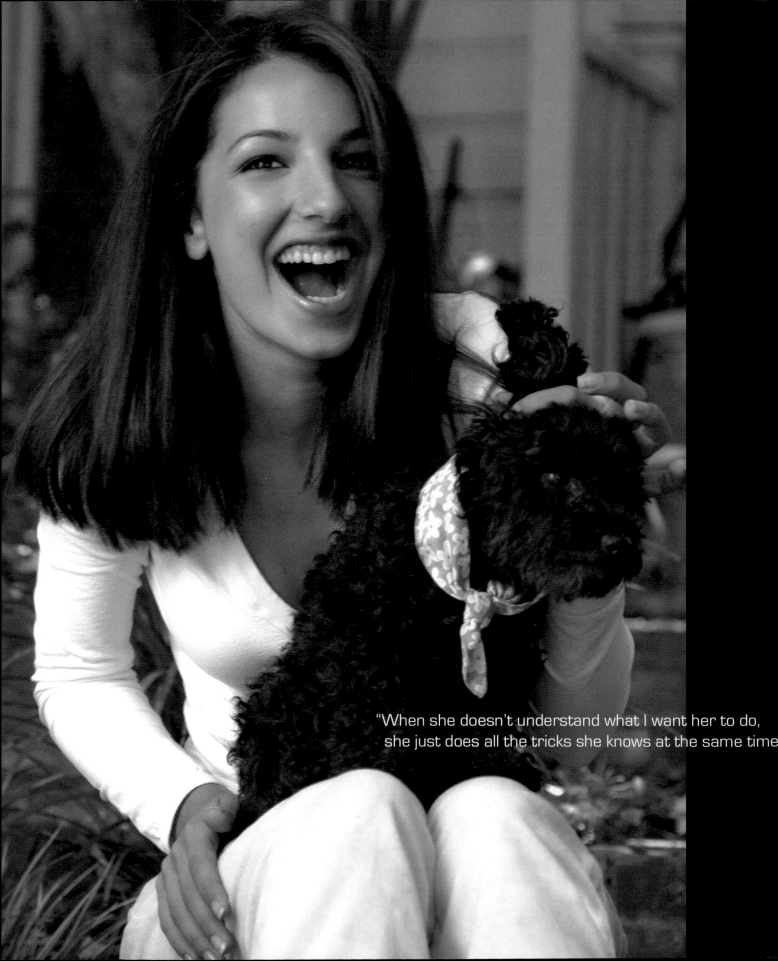

"When she doesn't understand what I want her to do, she just does all the tricks she knows at the same time."

Anyone who loves my dog is all right with me."

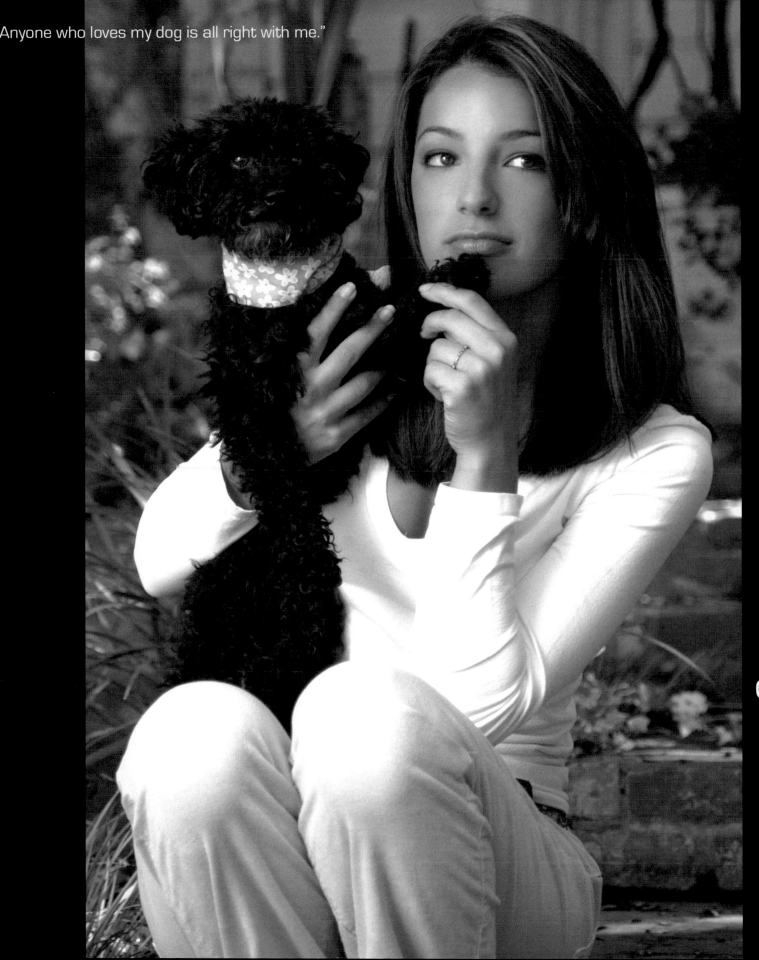

Vanesa Lengies & Marci

My dogs are my best fur buddies! I would do anything for them and I love them both so much! The best feeling is being able to see that they love me as much as I love them!"

"Bentley has taught me to just chill out, and that getting loved on will make the worst day better. He also taught me how to curl up in bed and sleep in."

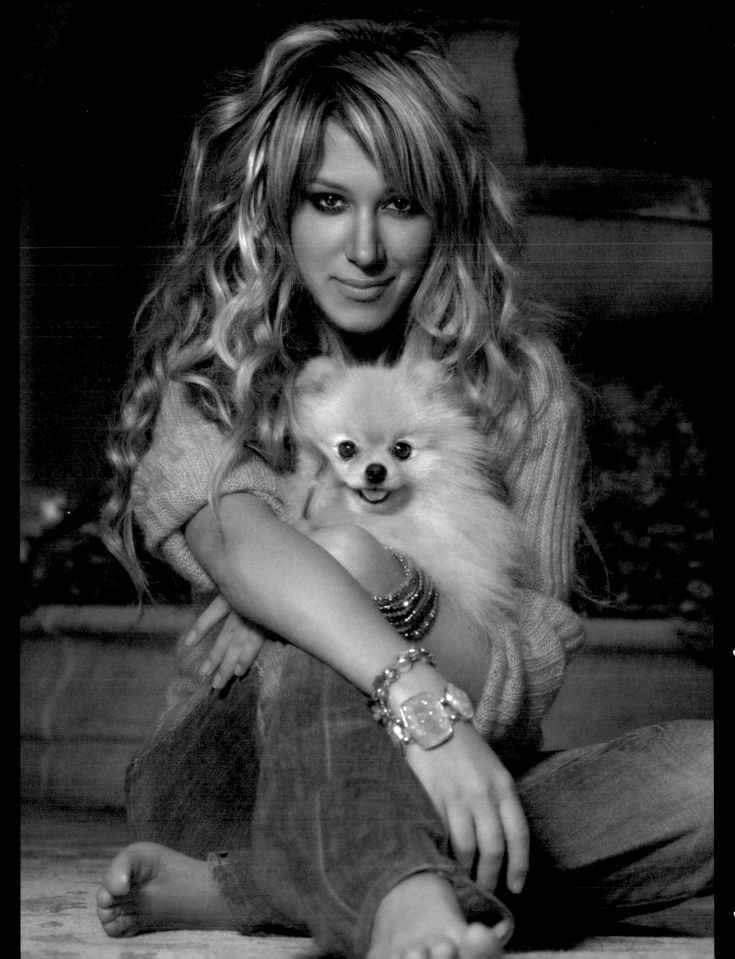

Haylie Duff & Bentley

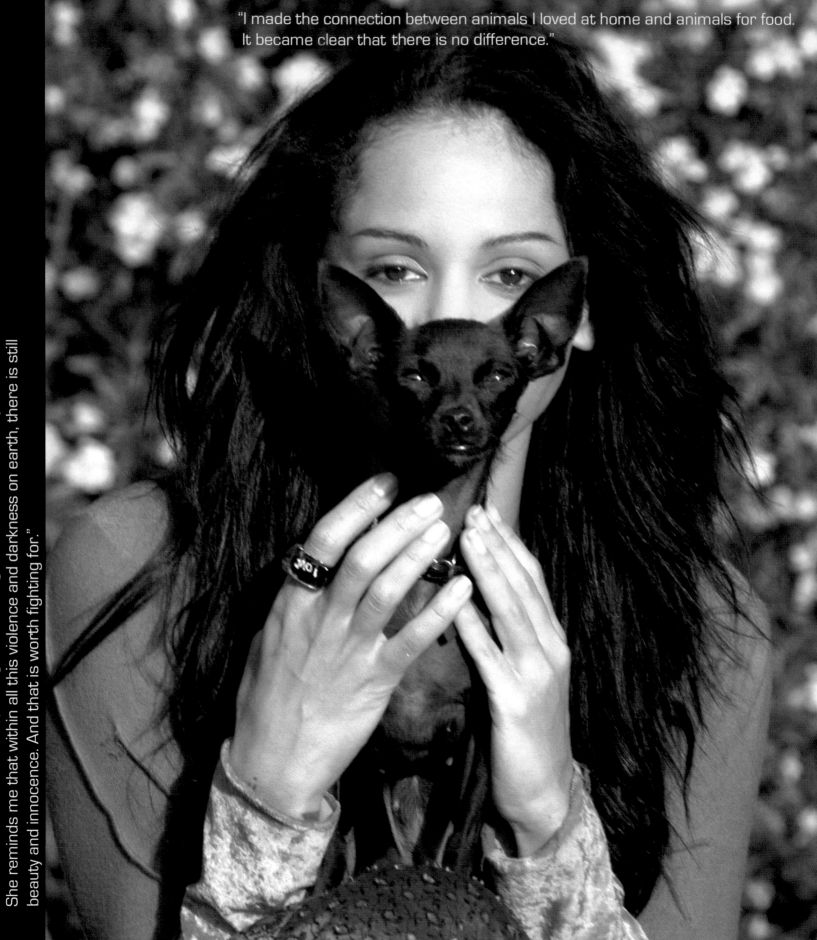

"I made the connection between animals I loved at home and animals for food. It became clear that there is no difference."

I can't believe that a small package could bring this much love into my world. She reminds me that within all this violence and darkness on earth, there is still beauty and innocence. And that is worth fighting for."

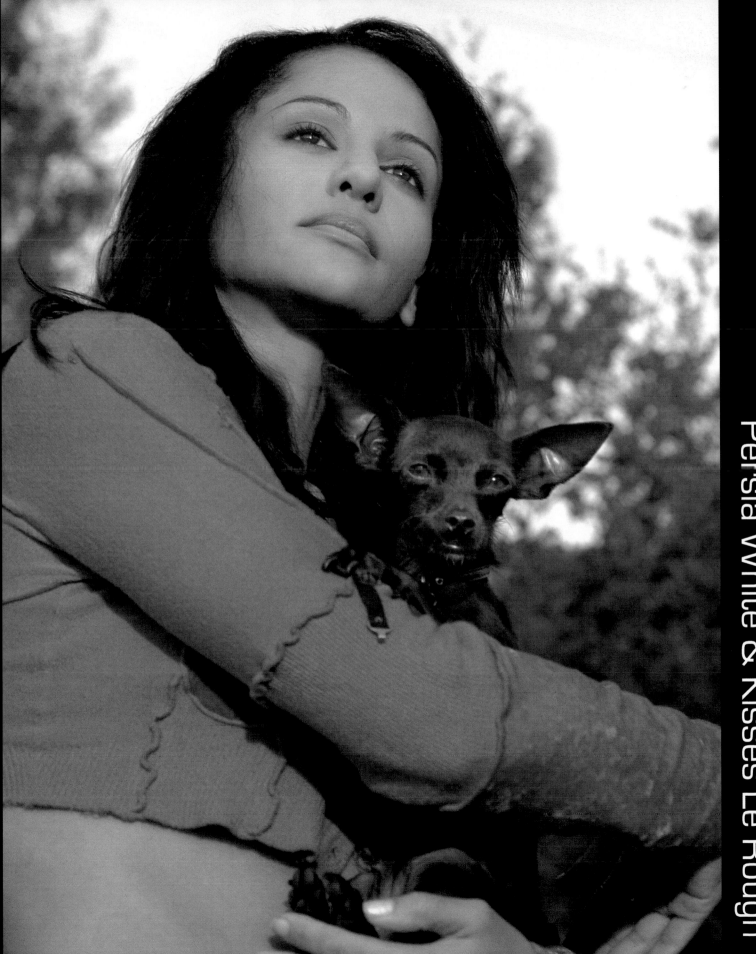

Persia White & Kisses Le Rough

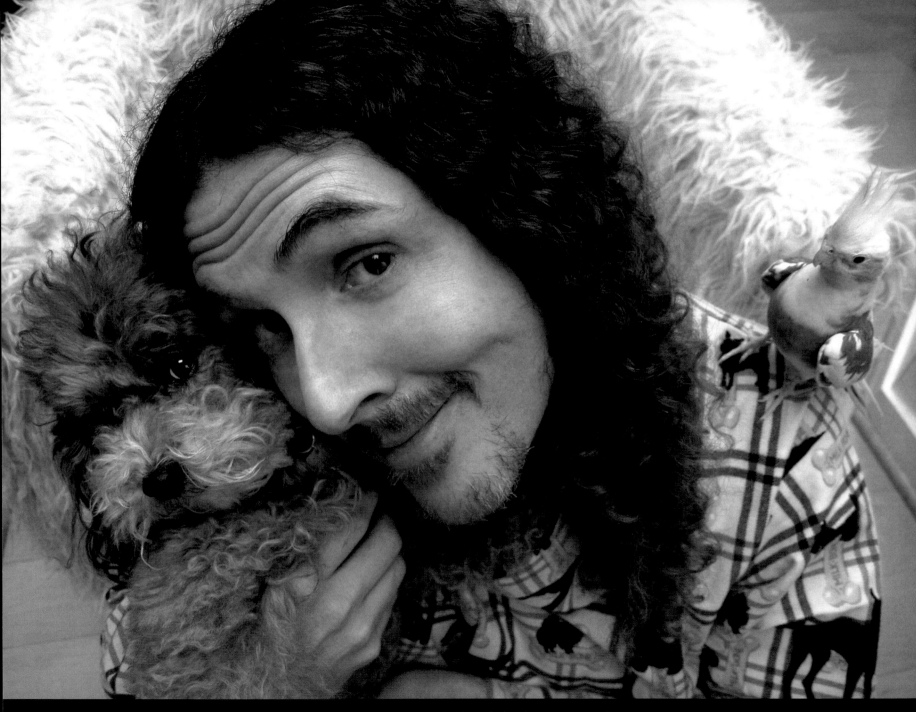

"I Love animals so much that I don't eat them."

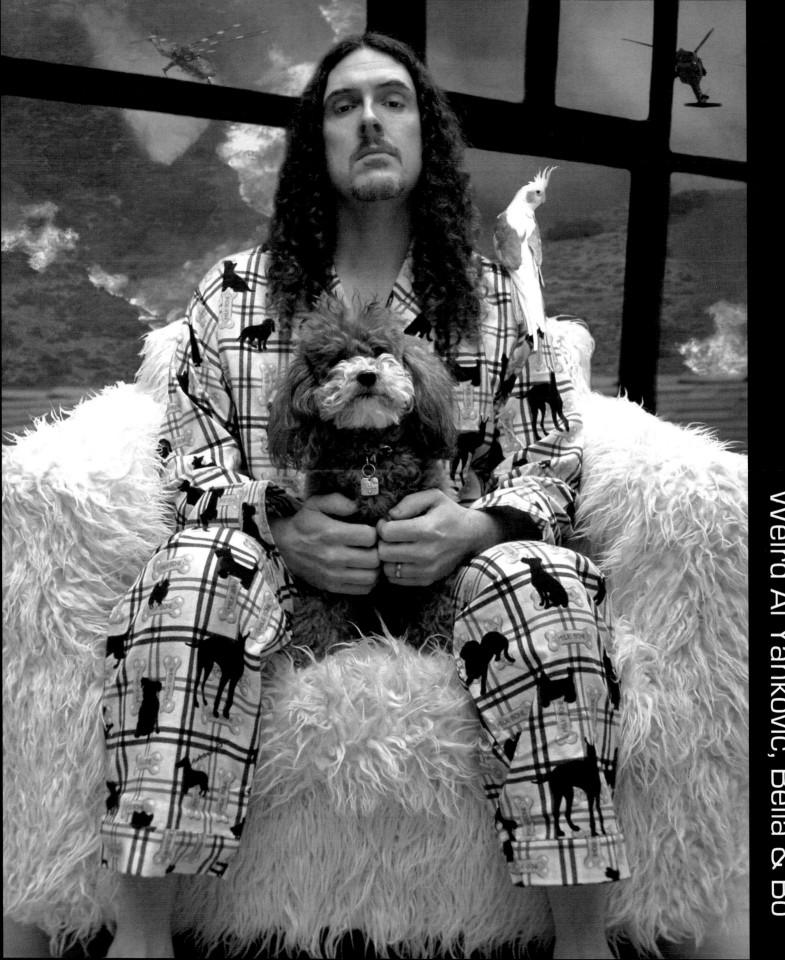

"Almost all the characters I've played would have owned a dog like Jackie."

William Lee Scott & Jackie

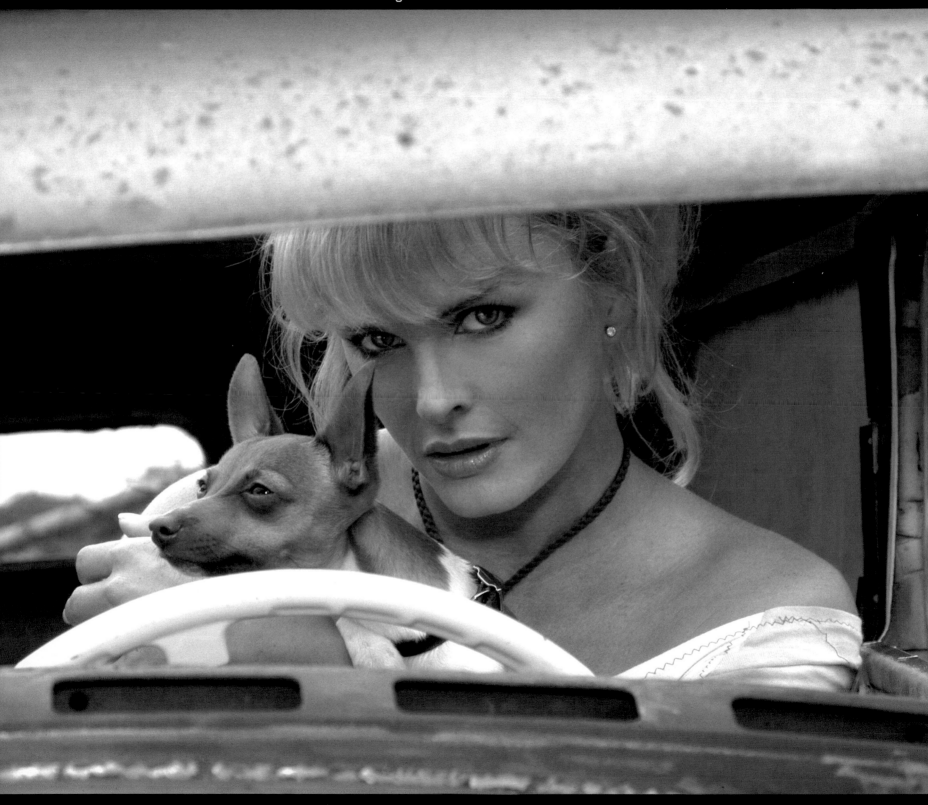

"Fendi goes to shoots with me. He likes to be in front of the camera."

Kylie Bax & Fendi

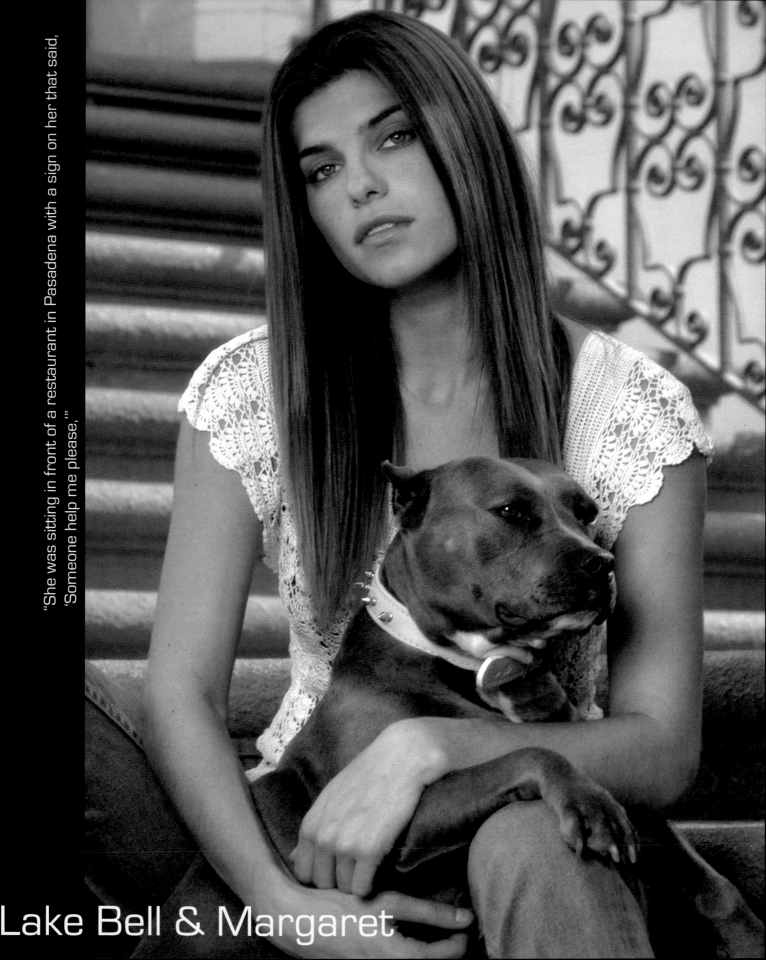

"She was sitting in front of a restaurant in Pasadena with a sign on her that said, 'Someone help me please,'"

Lake Bell & Margaret

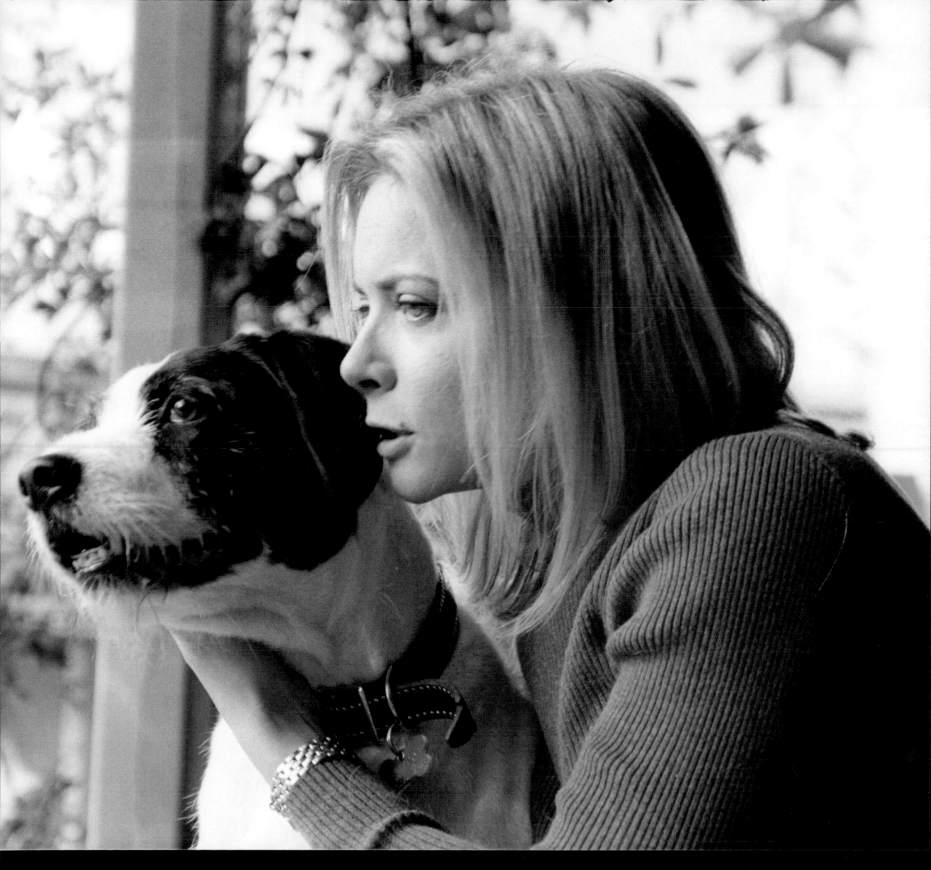

Faith Ford & Bosco

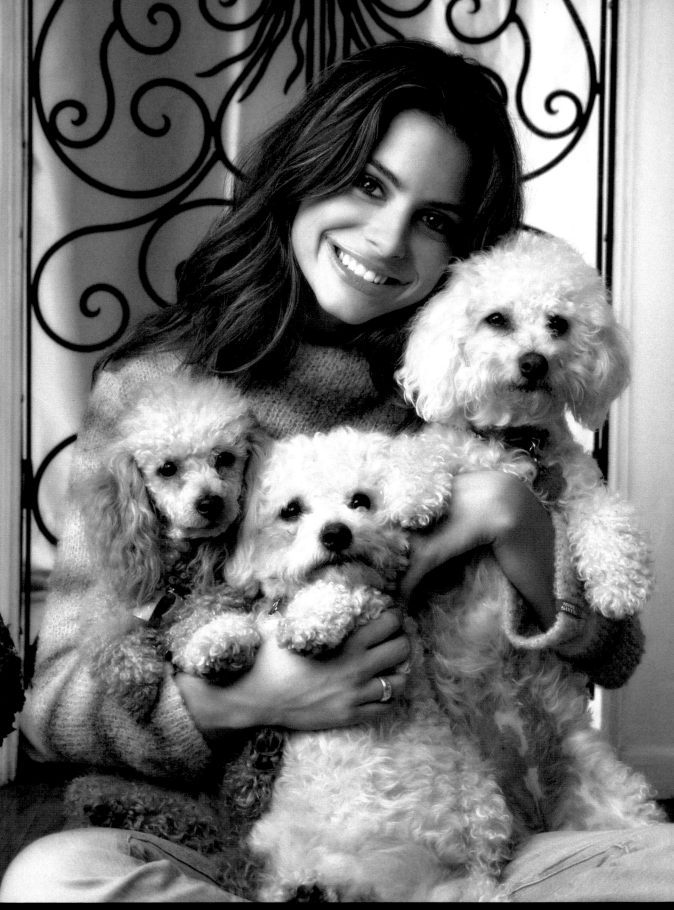

"The art of parenting-preparing breakfast and dinner, arranging potty breaks and scheduling visits to the vet for four dogs-is a lot of work. My rescue poodle, Noelle's health condition requires that I blend 6 different supplements into her meals. She can no longer walk so she swims in my heated pool three times a week to keep her circulation going. Baby, my rescue Bichon, has a bladder condition that also requires a special diet and supplements.

As is the case with any art form (including parenting), there is tremendous appreciation and joy received in return. I don't know how I'd live without Baby's gentle kisses, Noelle and Benny's bedtime cuddles or my giant sized hugs from my rescue shepherd, Apollo."

"I wish I could adopt more pets, but at some point it's unfair to the rest of them."

"She's got integrity, and she's always self-contained."

"Any man would have to love reptiles and respect my relationship with my pets."

"I was upset when I got a ticket. My first instinct was to dial my house phone and tell Abby. I talk to her by myself a lot, and she listens like she cares."

Amy Acker & Abby

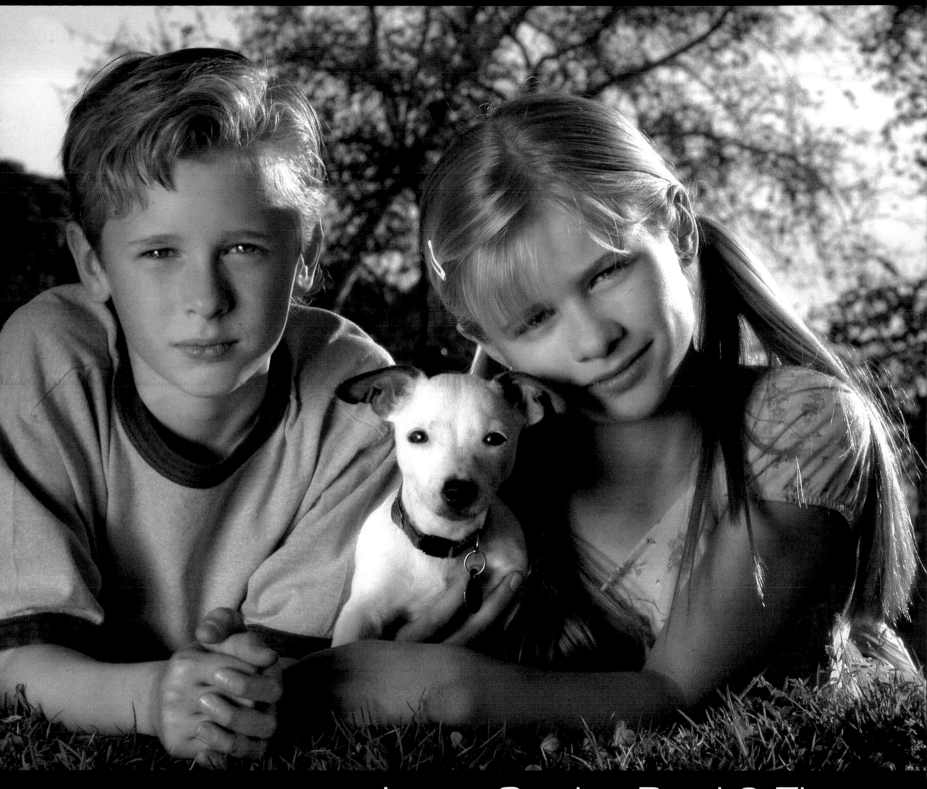

"When she gets really hyper it's called turbo mode."

Jenna, Cayden Boyd & Tippy

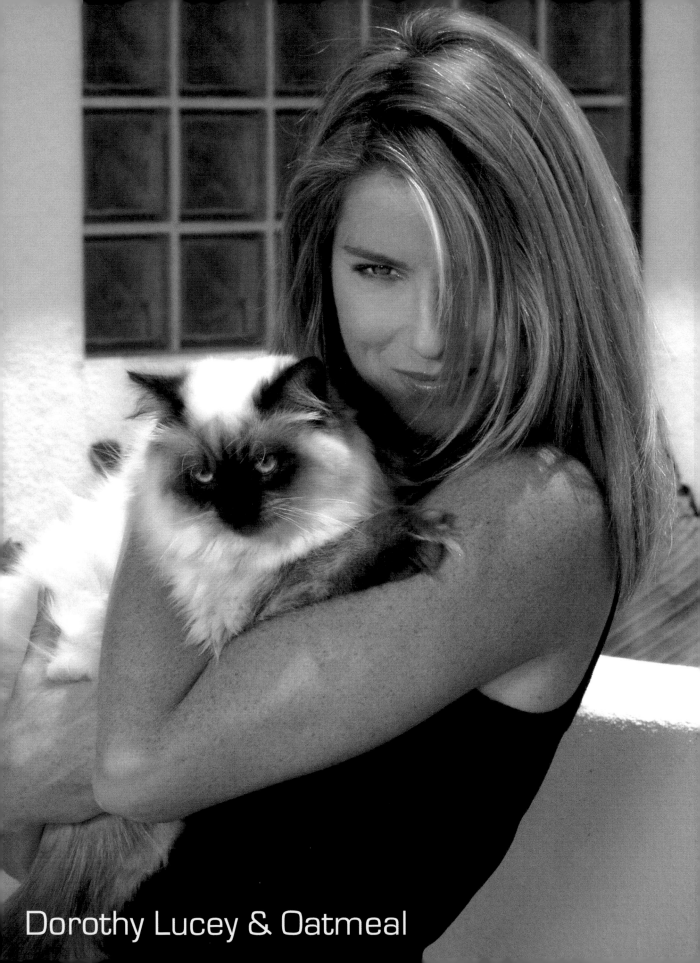

Dorothy Lucey & Oatmeal

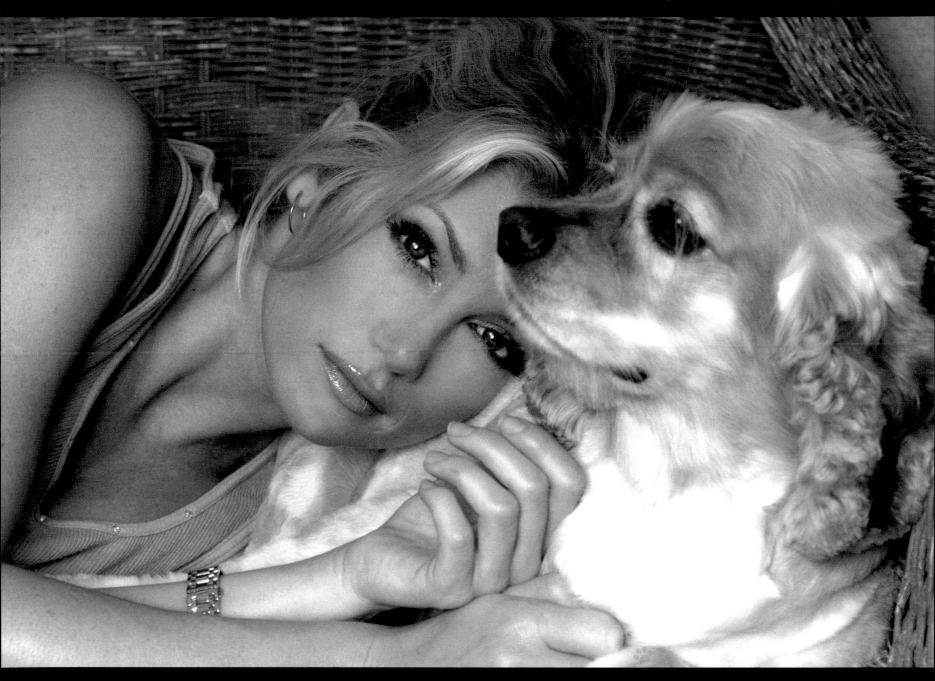

"Mercedes is my friend, sister and daughter."

Brande Roderick & Mercedes

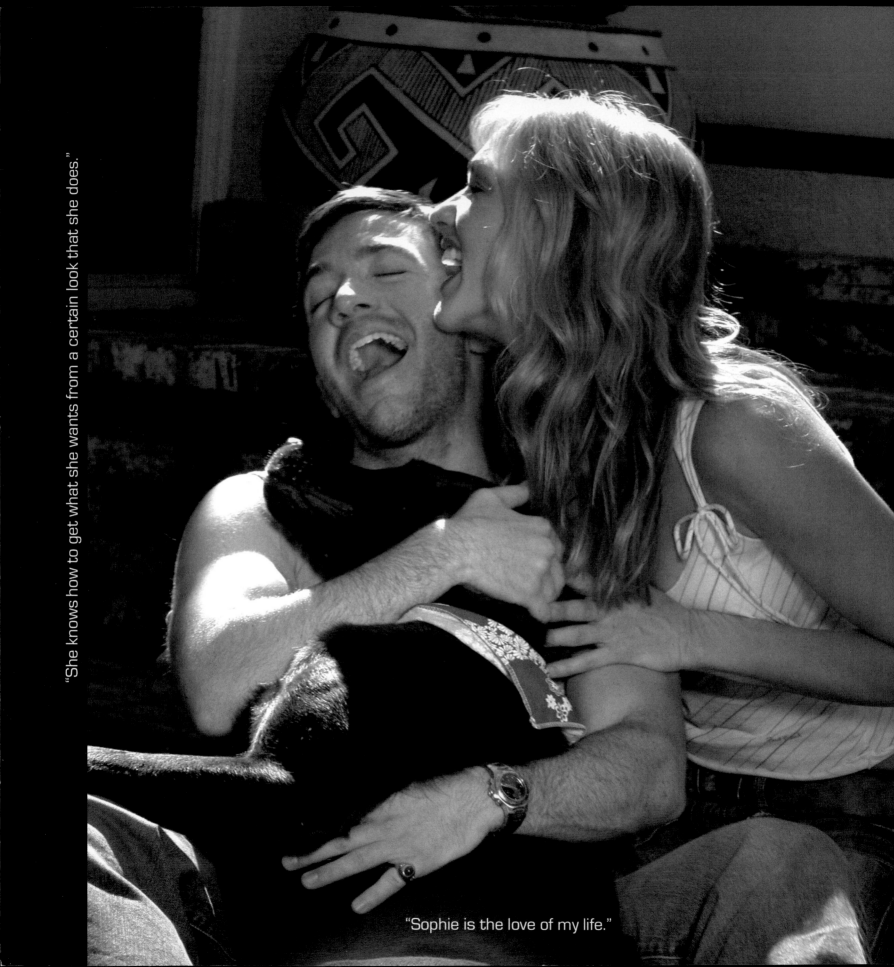

"She knows how to get what she wants from a certain look that she does."

"Sophie is the love of my life."

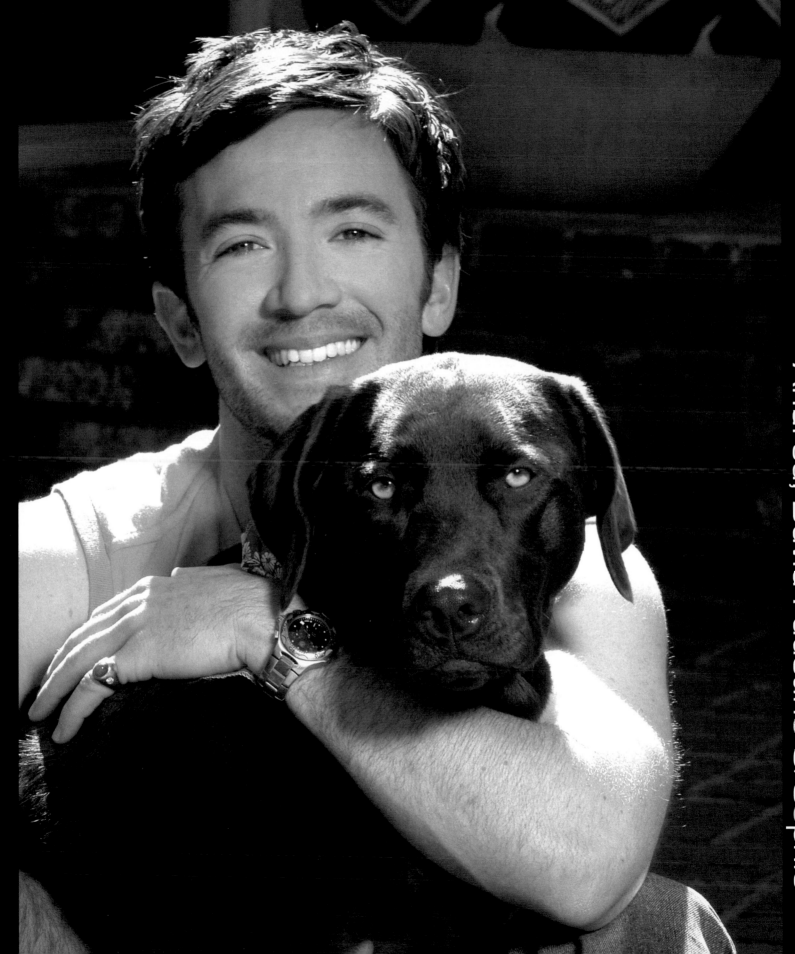

Andrea, David Faustino & Sophie

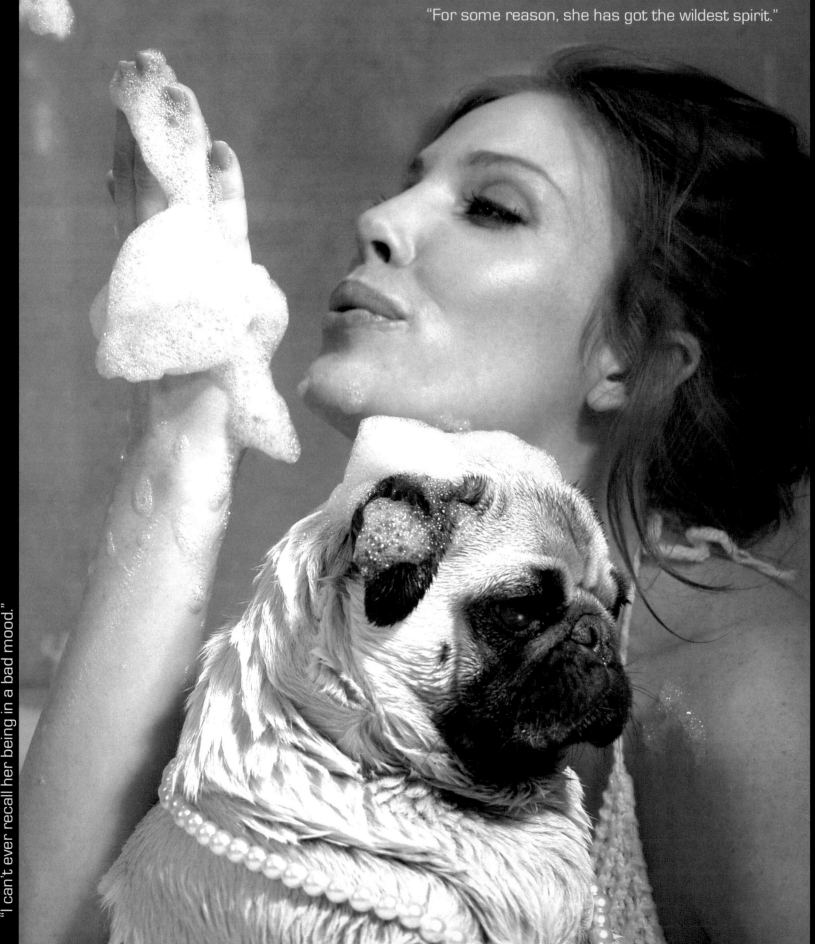

"For some reason, she has got the wildest spirit."

"I can't ever recall her being in a bad mood."

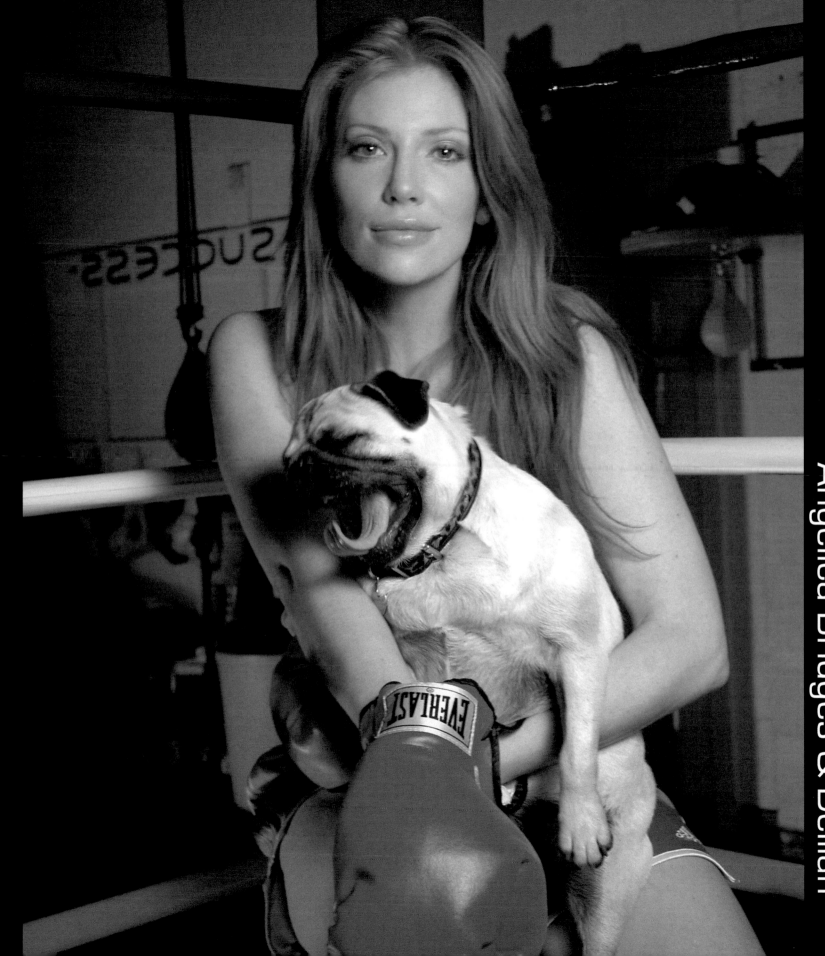

Angelica Bridges & Delilah

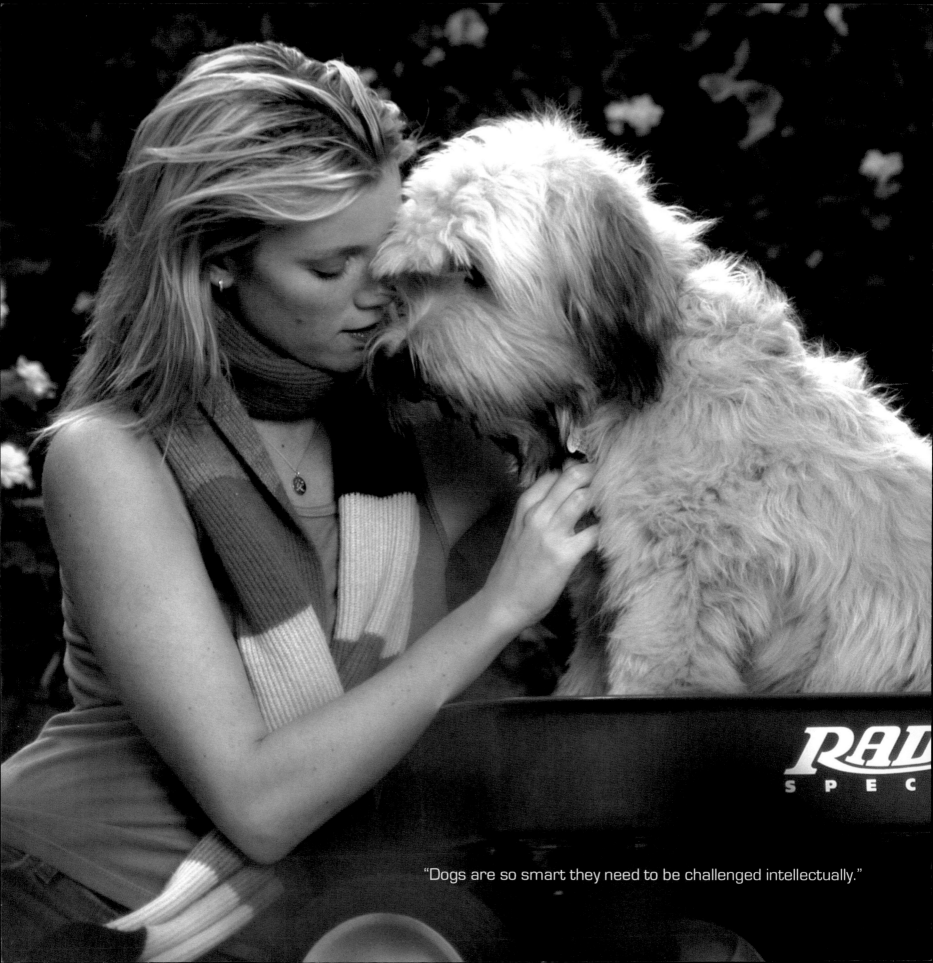

"Dogs are so smart they need to be challenged intellectually."

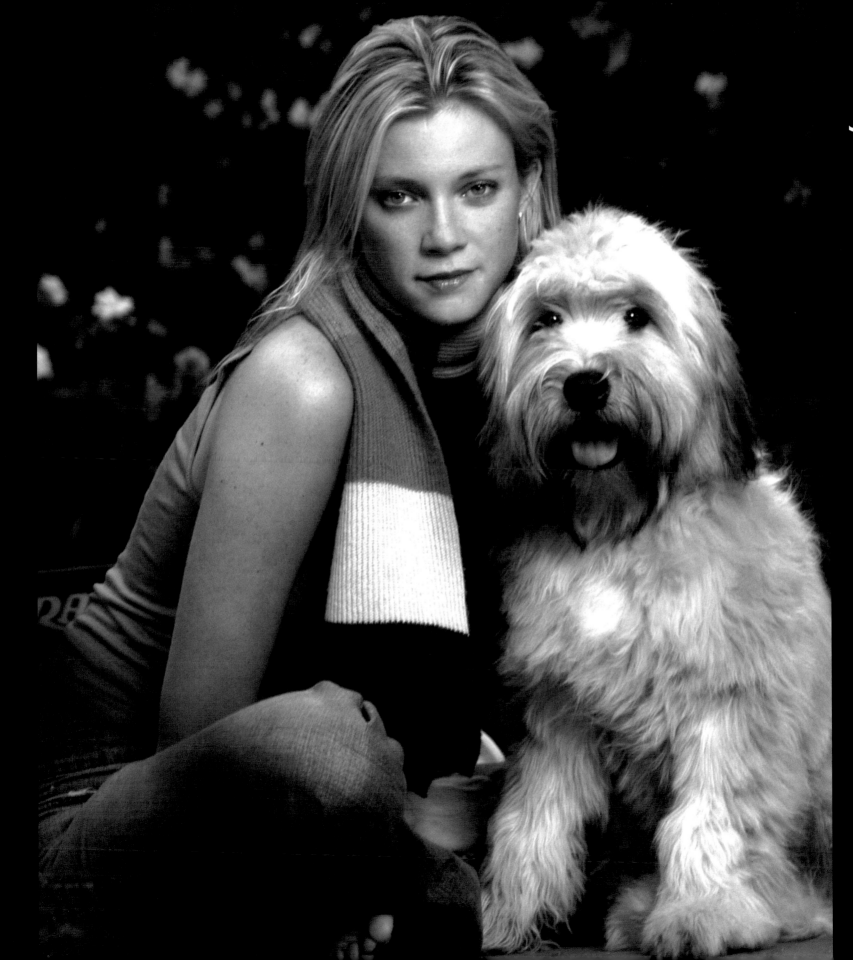

Amy Smart & Oscar

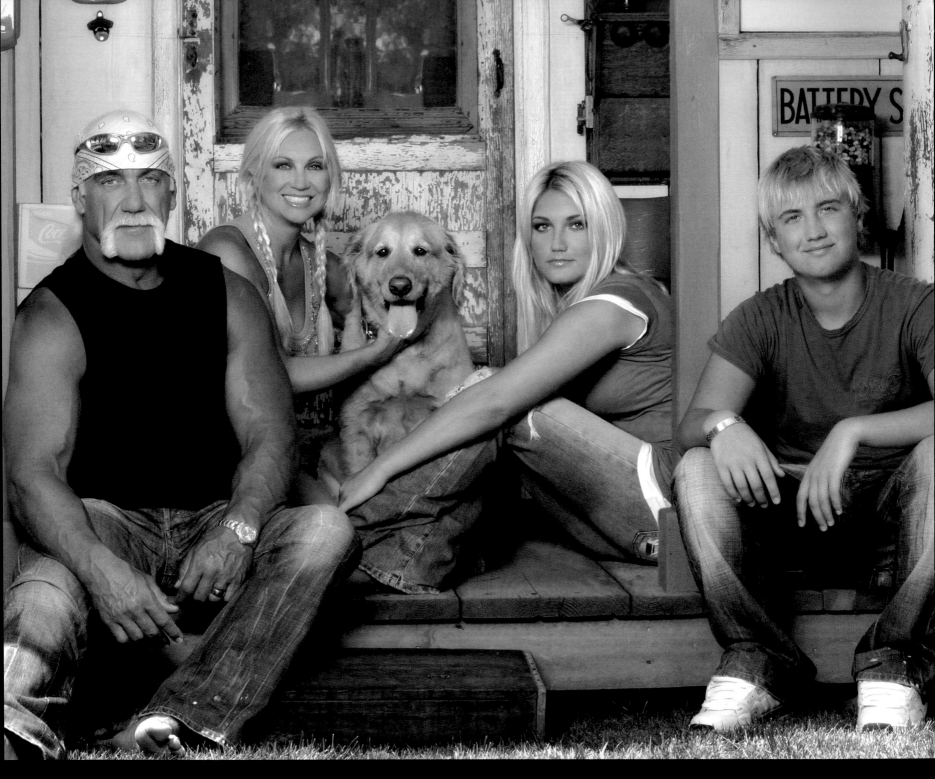

Hulk, Linda, Brooke, Nick Hogan & Rosala

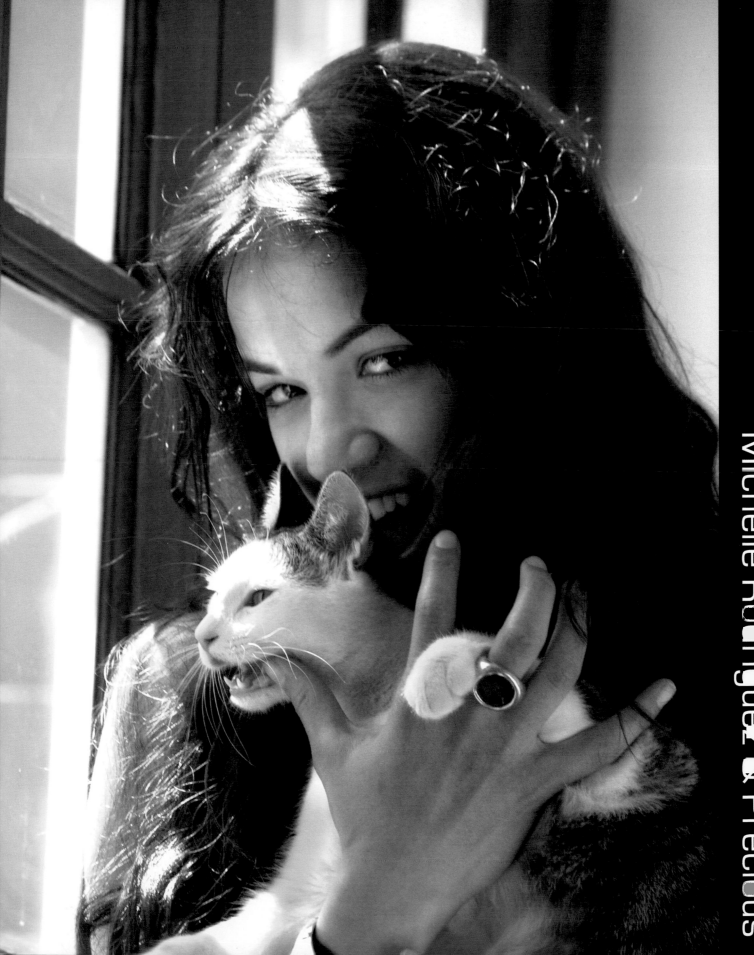

Michelle Rodriguez & Precious

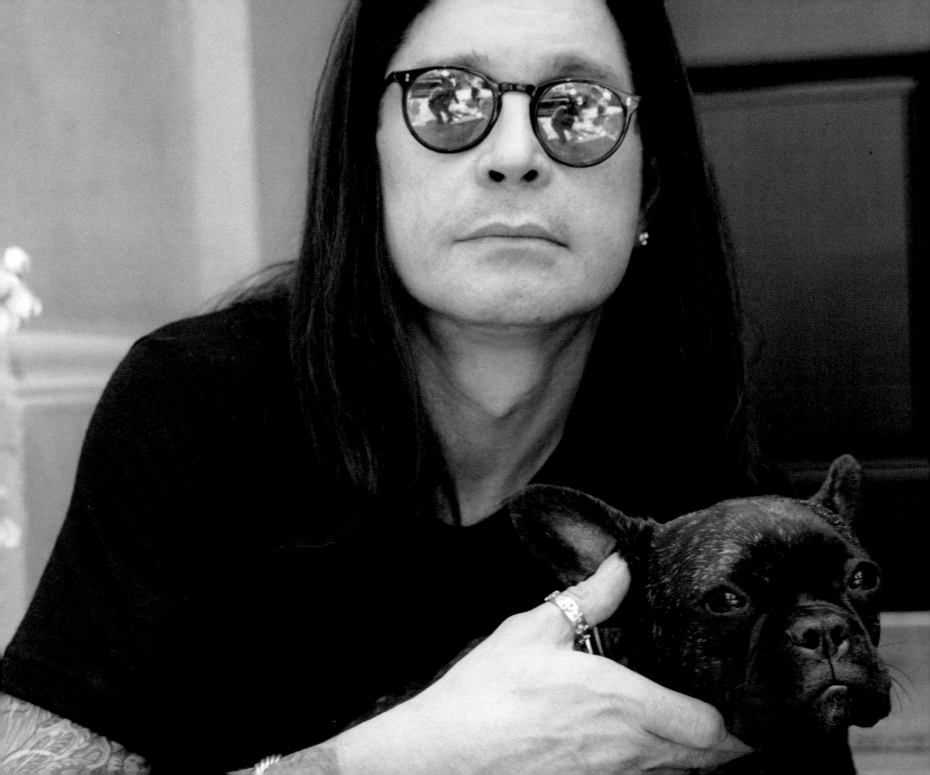

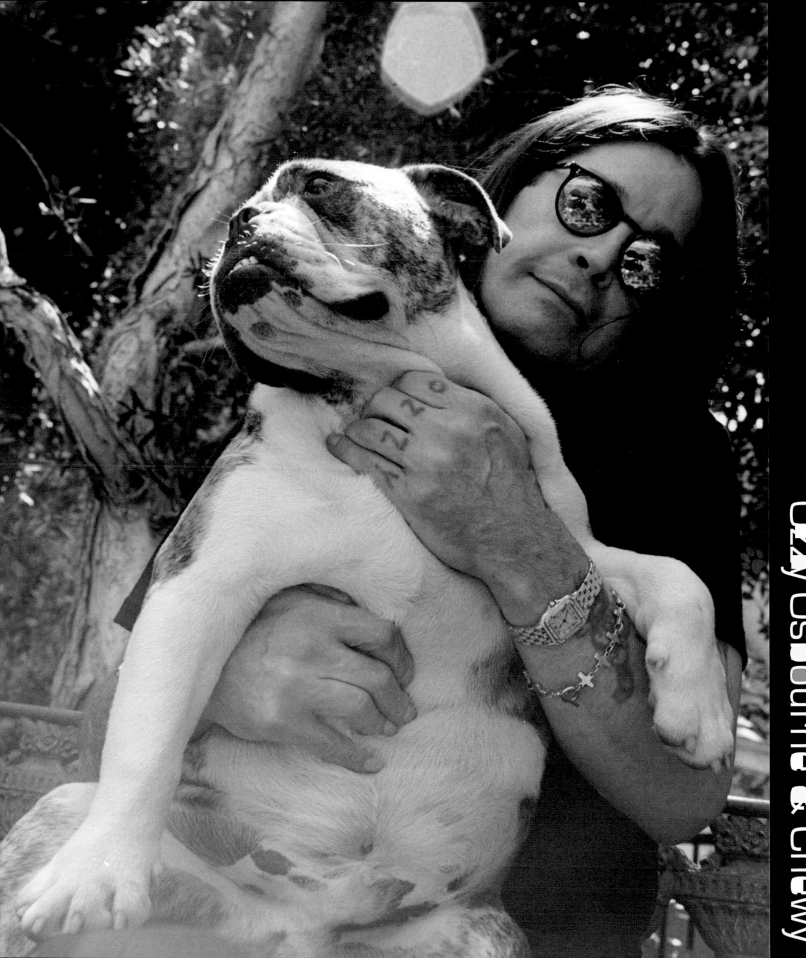

Ozzy Osbourne & Chewy

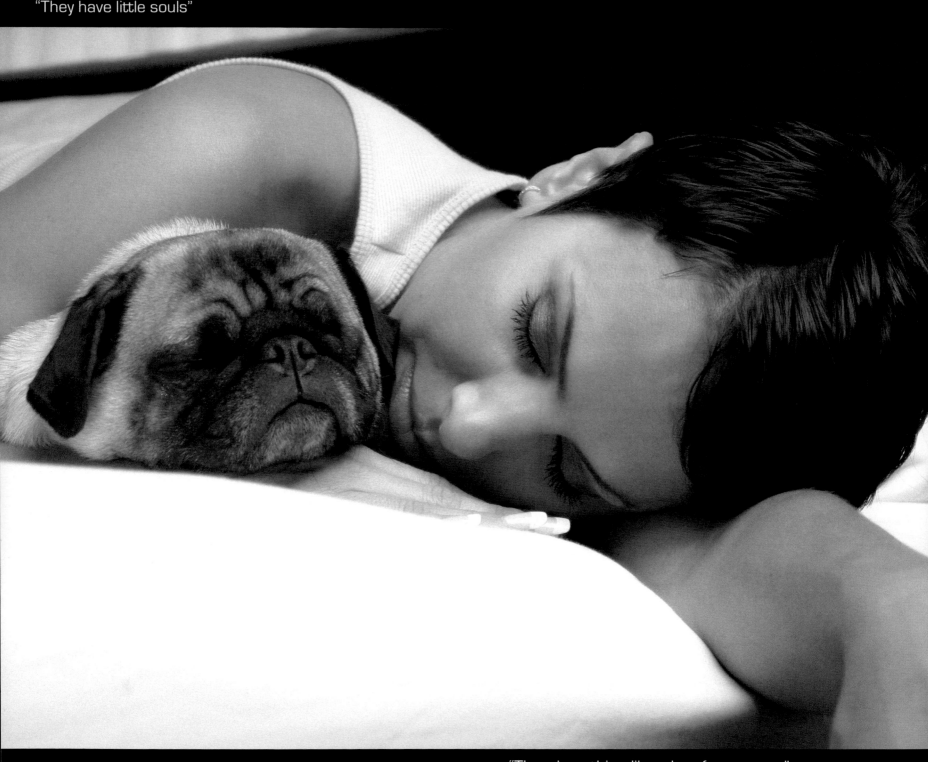

"They have little souls"

"There's nothing like a hug from a pug."

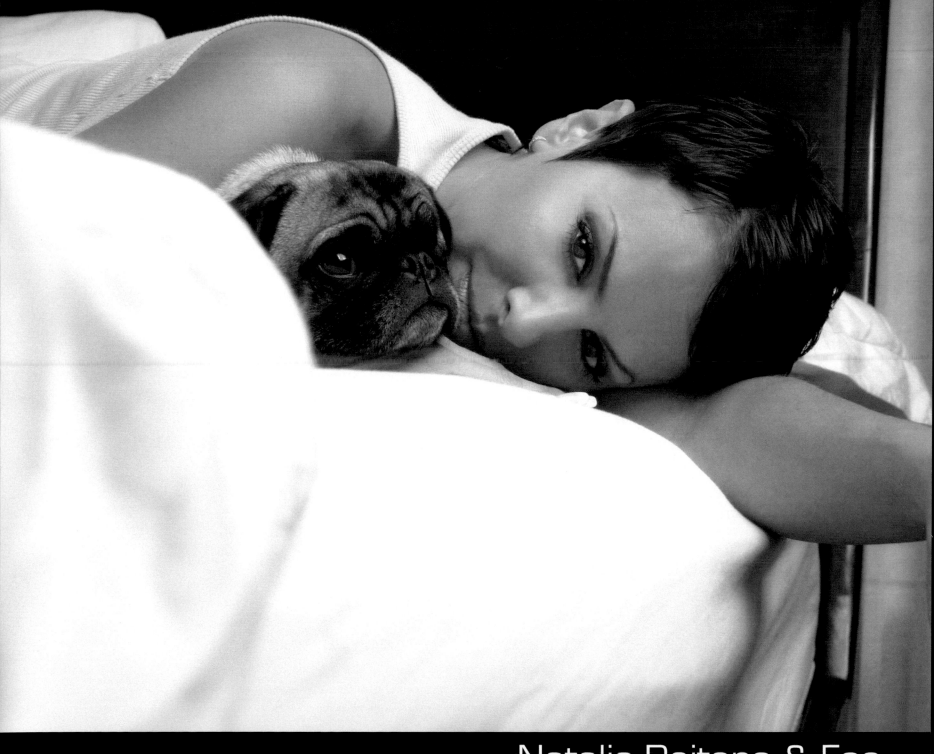

Natalie Raitano & Foo

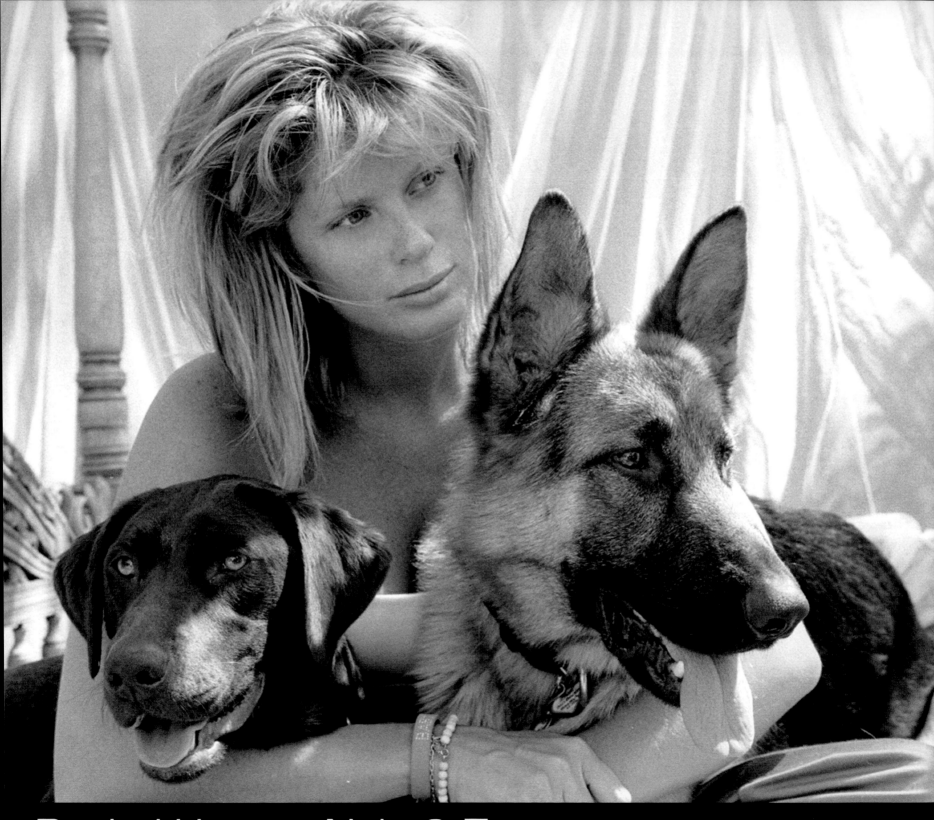

Rachel Hunter, Nala & Zac

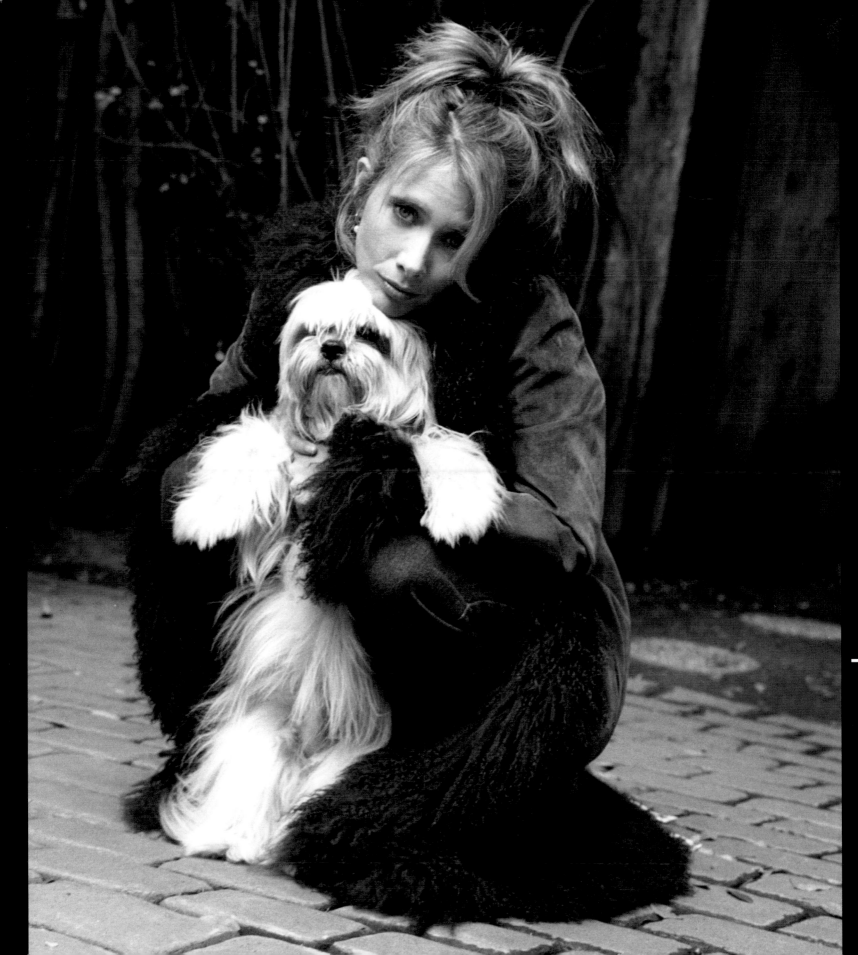

Rosanna Arquette & Bisou

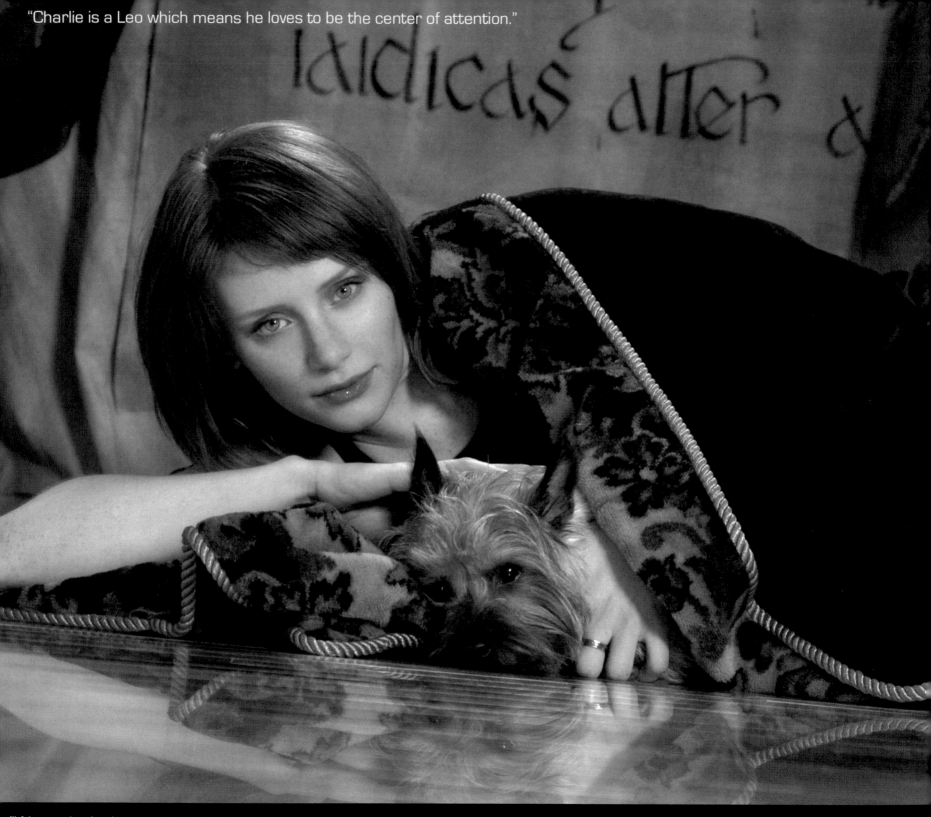

"Charlie is a Leo which means he loves to be the center of attention."

"We are both obsessed with food and sleep. When we are awake, we have a lot of energy and we are spunky, scruffy and stubborn."

"Charlie took a long time to become pottie trained and what I've been told, I had the same problem."

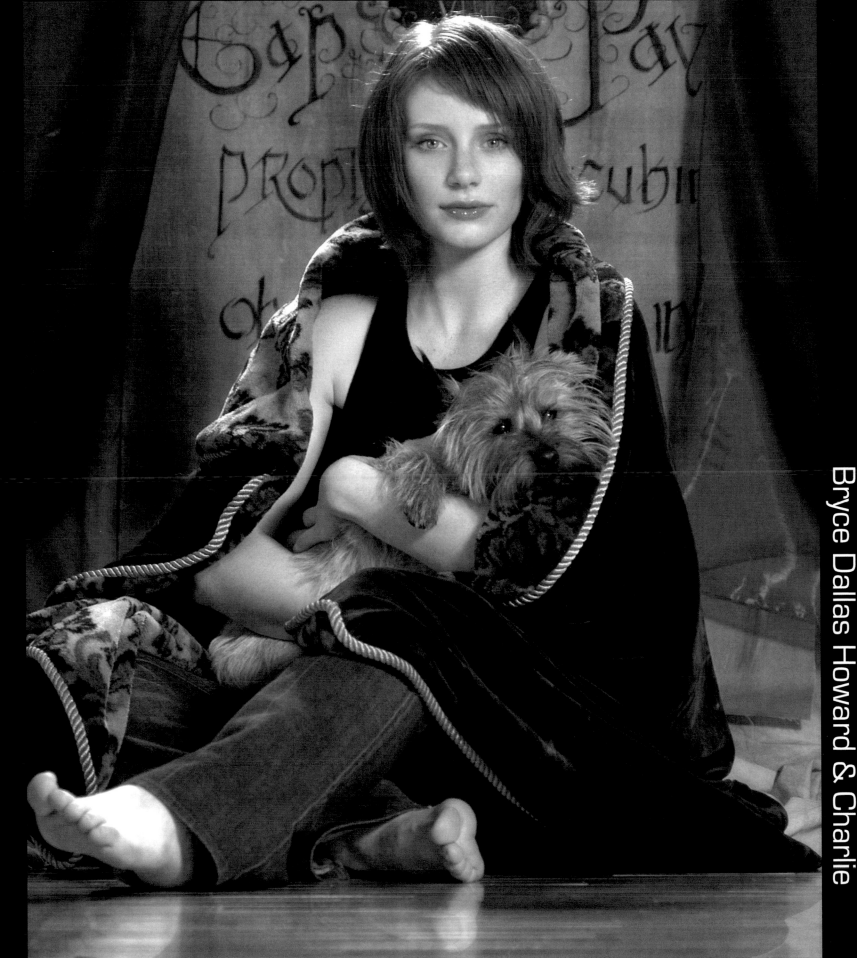

Bryce Dallas Howard & Charlie

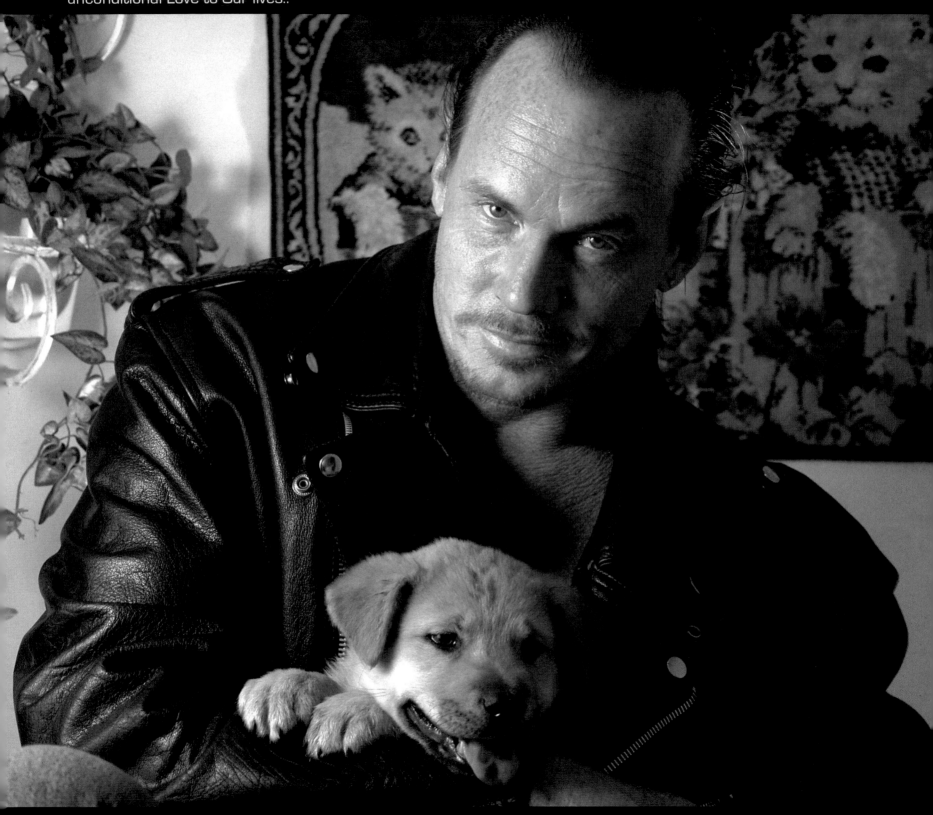

"Nitros rescued me and my other dog Chevy from being alone, and added joy, pleasure, happiness and unconditional Love to Our lives.."

David 'Shark' Fralick & Nitros

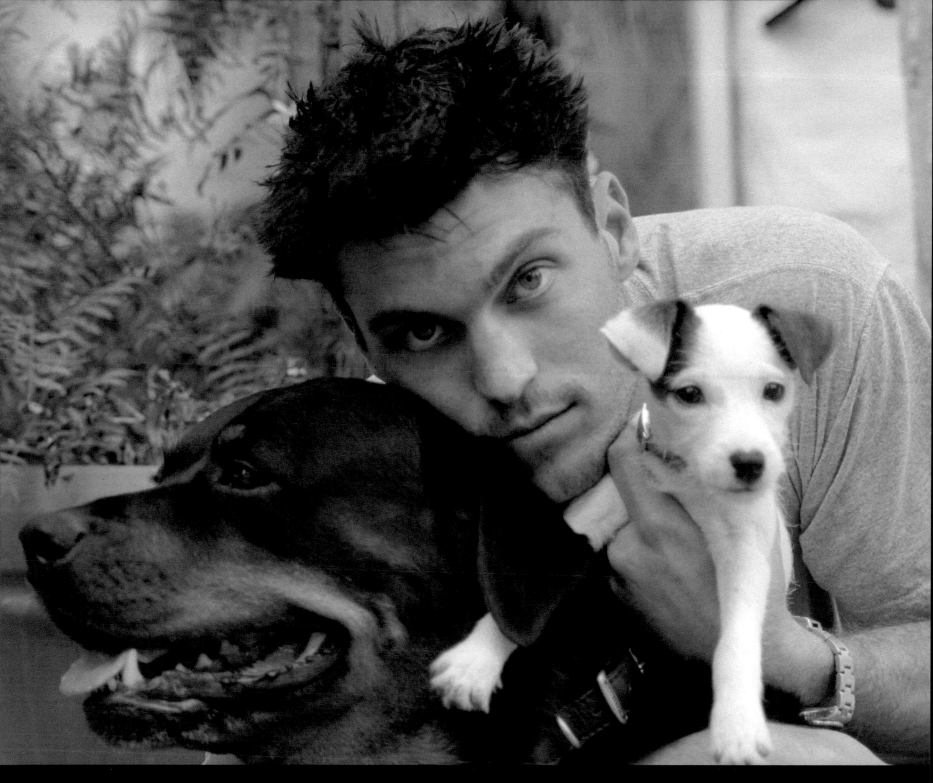

Brian Green, Alik & Lila

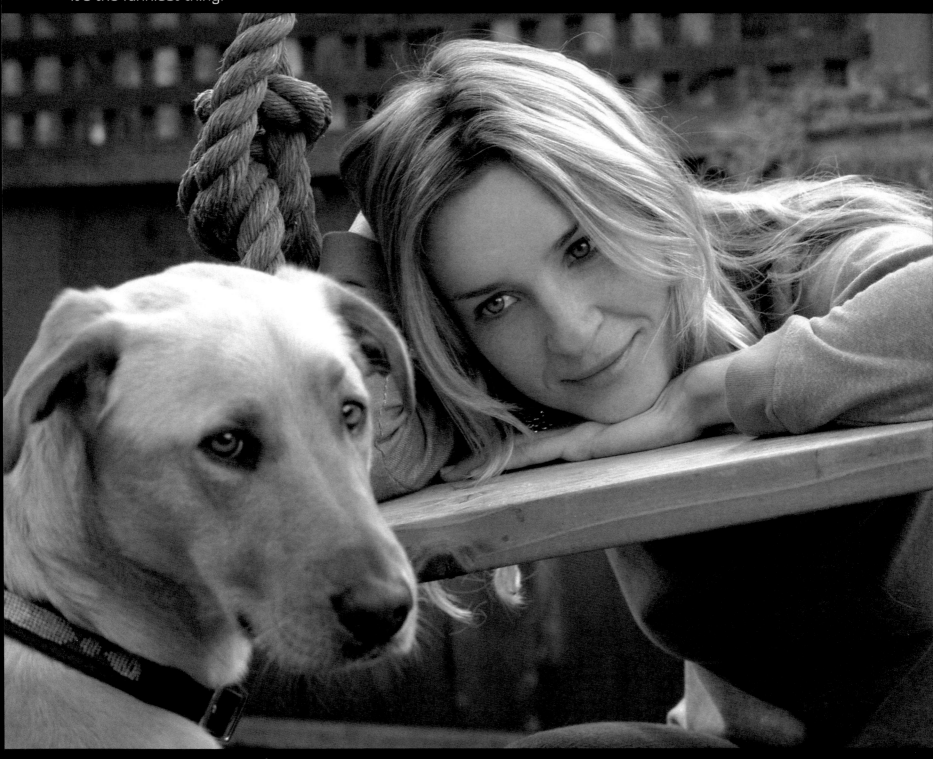

"Sammy likes to keep me amused, I'll be sitting and reading and he'll chase his tail until he gets dizzy and falls down. It's the funniest thing."

Ever Carradine & Sammy

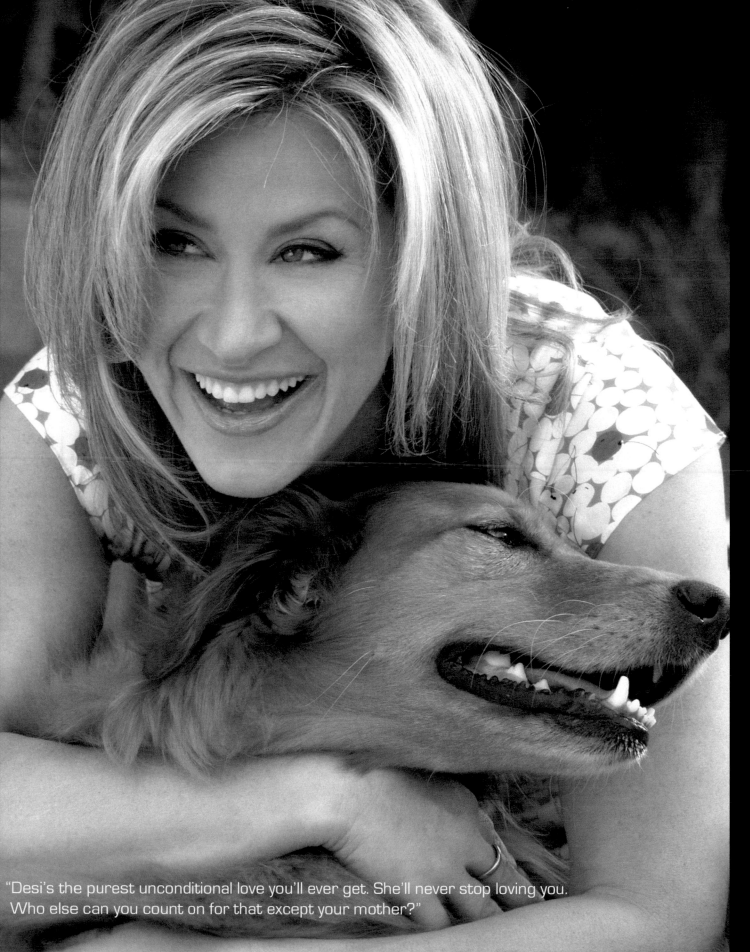

Lisa Ann Walter & Desi

"Desi's the purest unconditional love you'll ever get. She'll never stop loving you. Who else can you count on for that except your mother?"

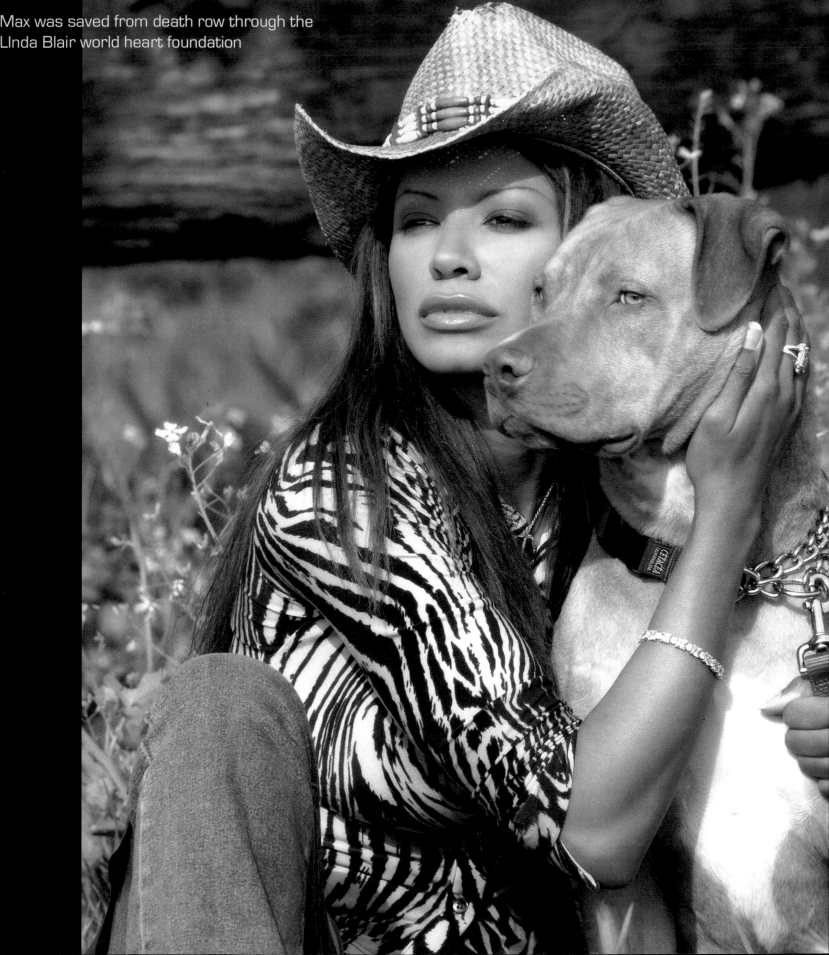
Max was saved from death row through the
LInda Blair world heart foundation

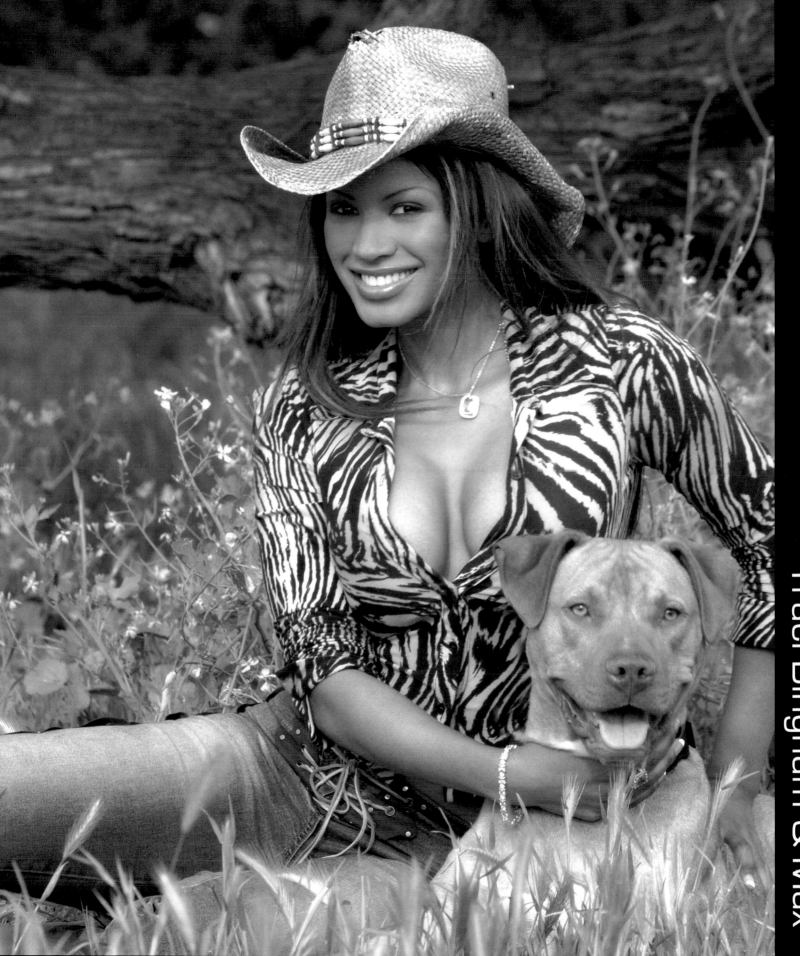

Traci Bingham & Max

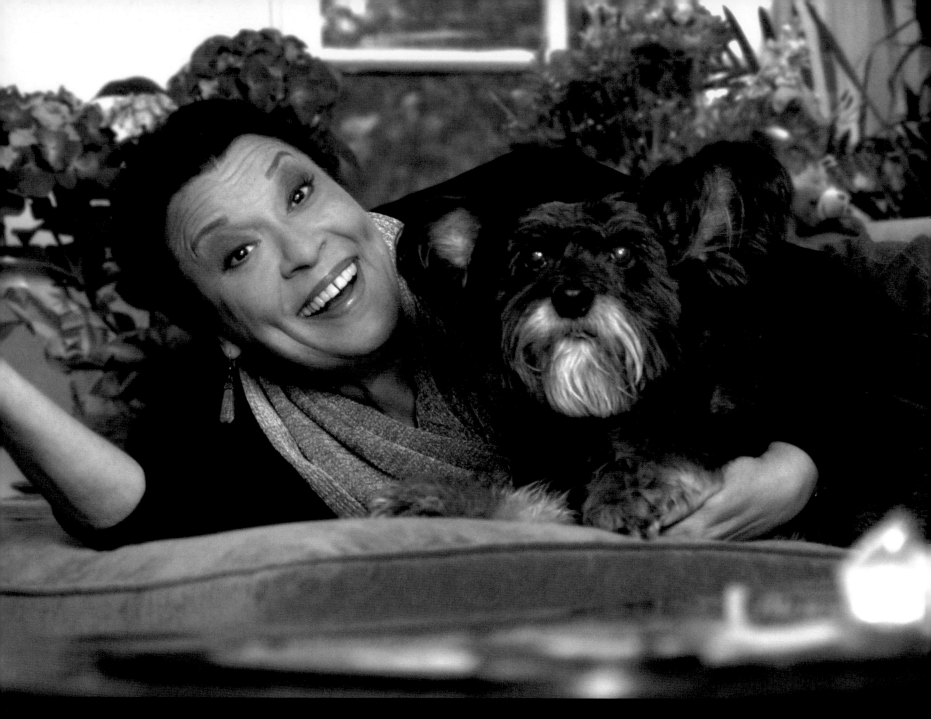

Shelly Morrison & Katie

"Animals are our teachers. They teach us unconditional love. They're our 'fur children.'"

"There's a doggie bakery that's by my house. We take Madorie there and let her pick out what she wants."

Camille Winbush & Madorie

Geri Haliwell & Hugg

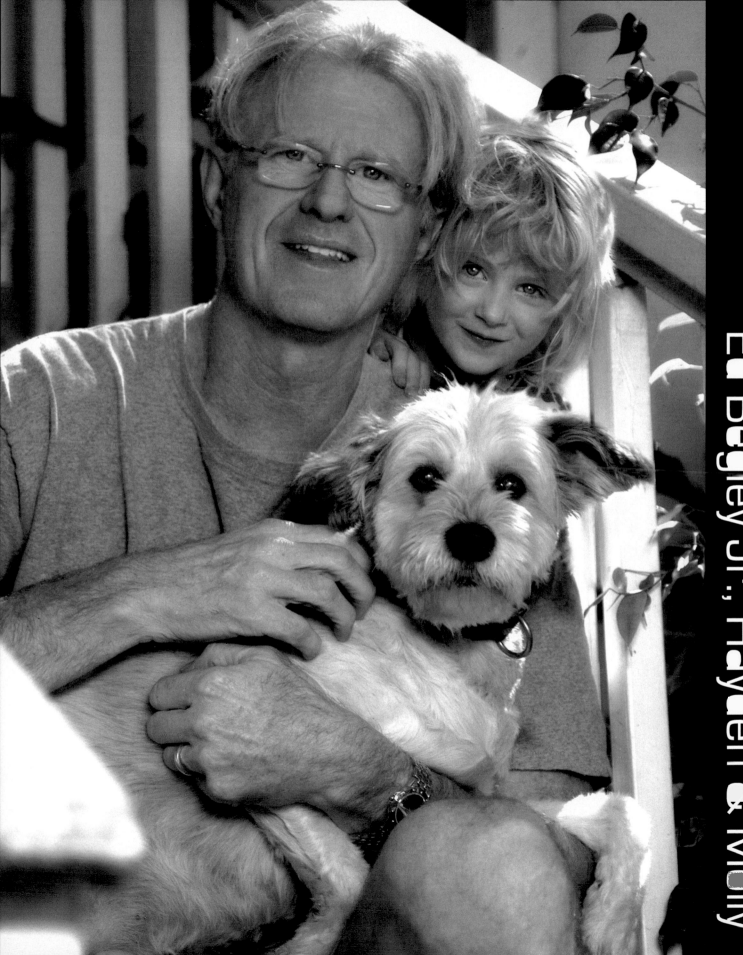

Ed Begley Jr., Hayden & Molly

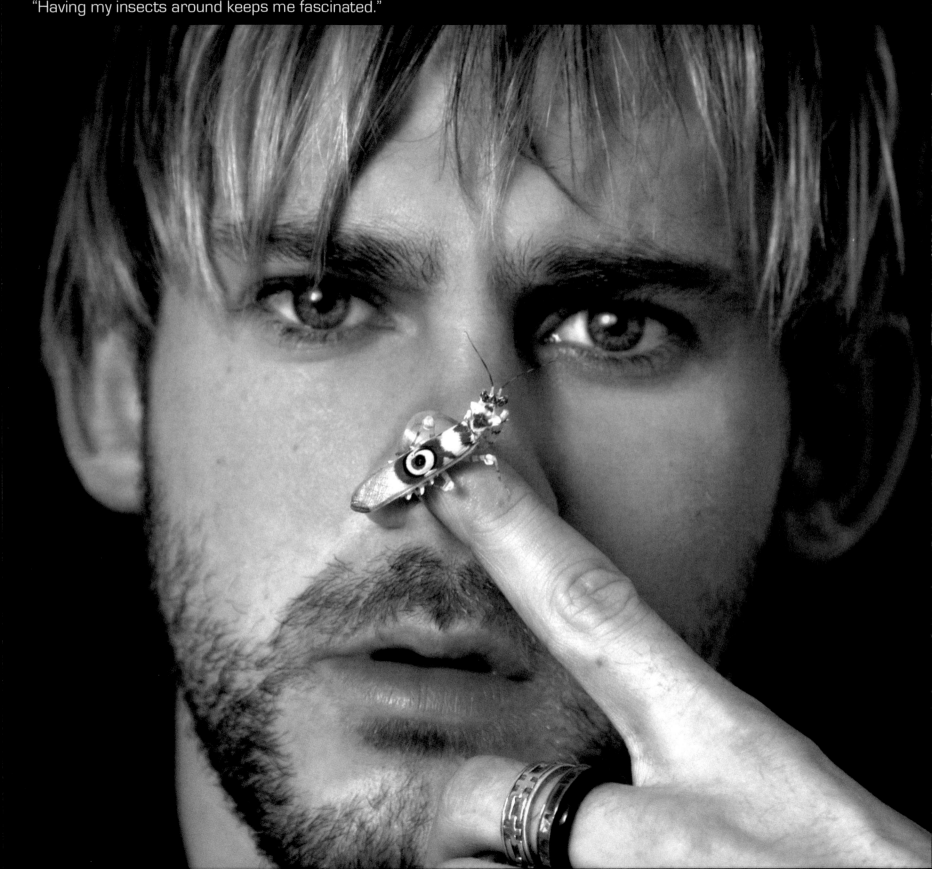

"Having my insects around keeps me fascinated."

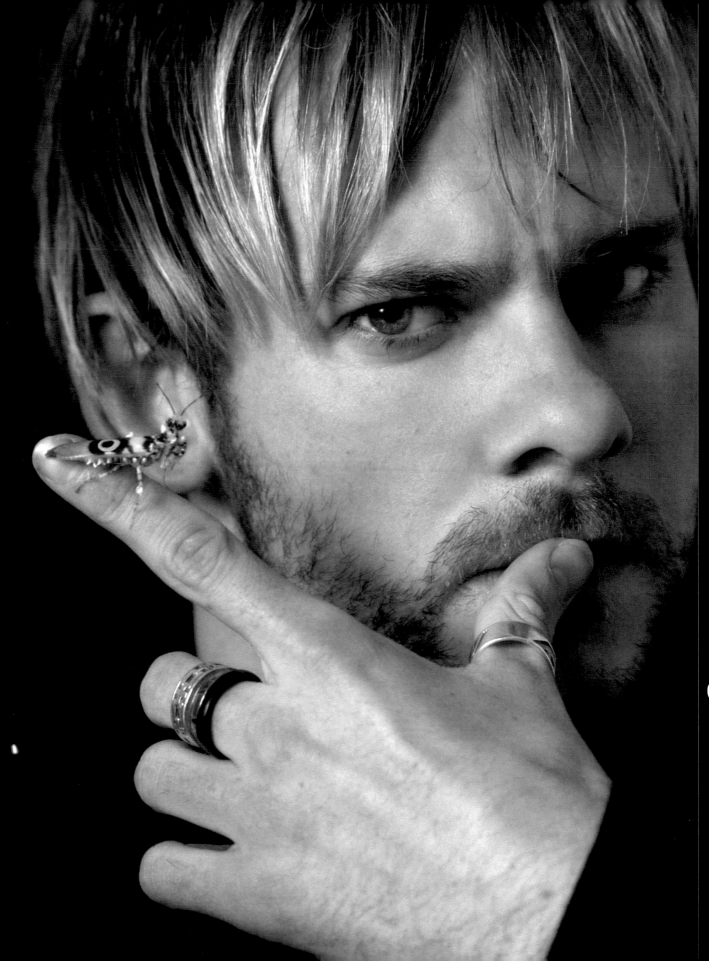

Dominic Monaghan & Gizmo

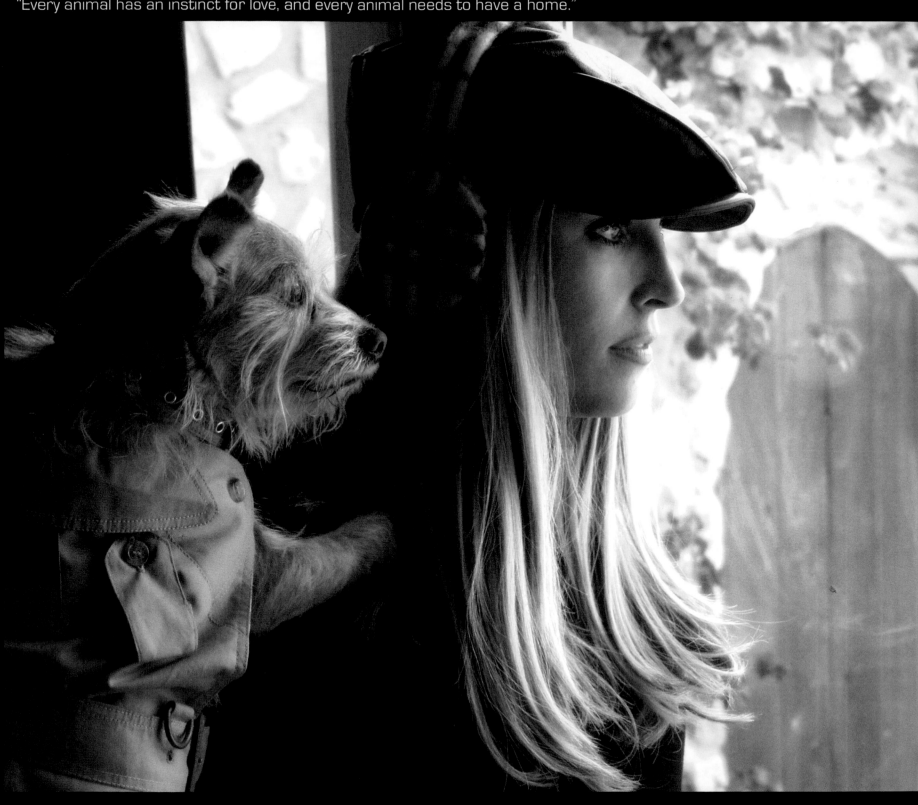

"Every animal has an instinct for love, and every animal needs to have a home."

"I try to create a haven that's filled with love for my animals."

Jillian Barberie & Willy

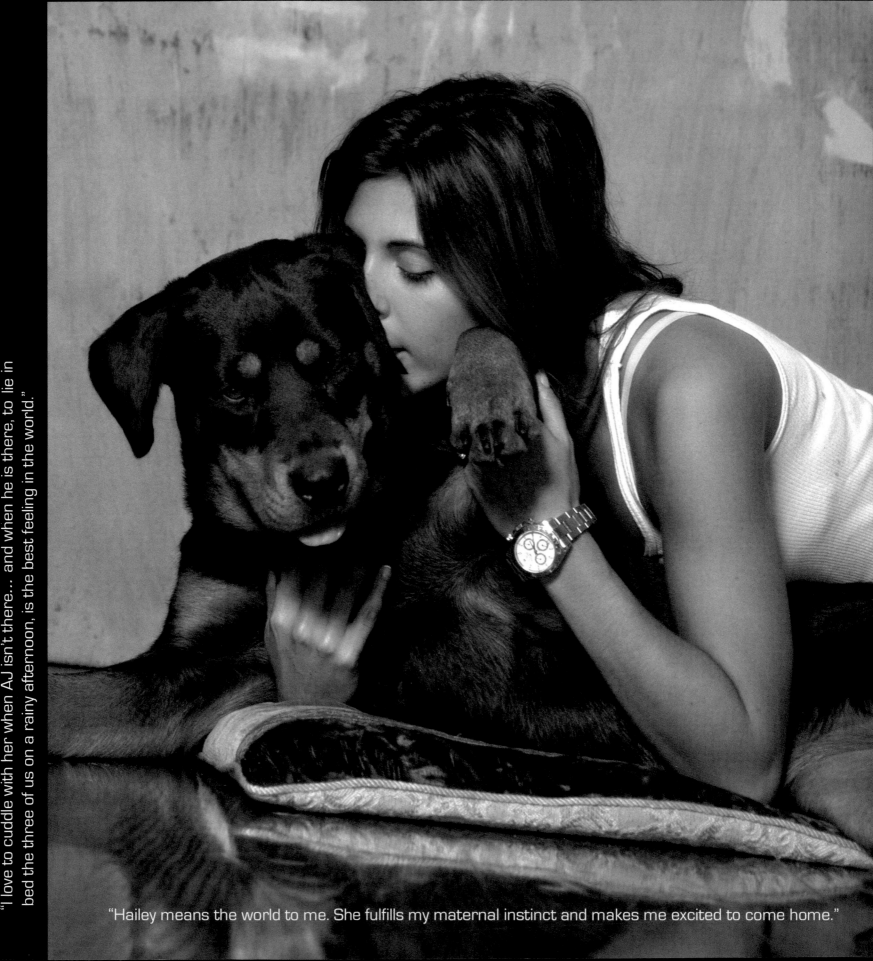

"I love to cuddle with her when AJ isn't there… and when he is there, to lie in bed the three of us on a rainy afternoon, is the best feeling in the world."

"Hailey means the world to me. She fulfills my maternal instinct and makes me excited to come home."

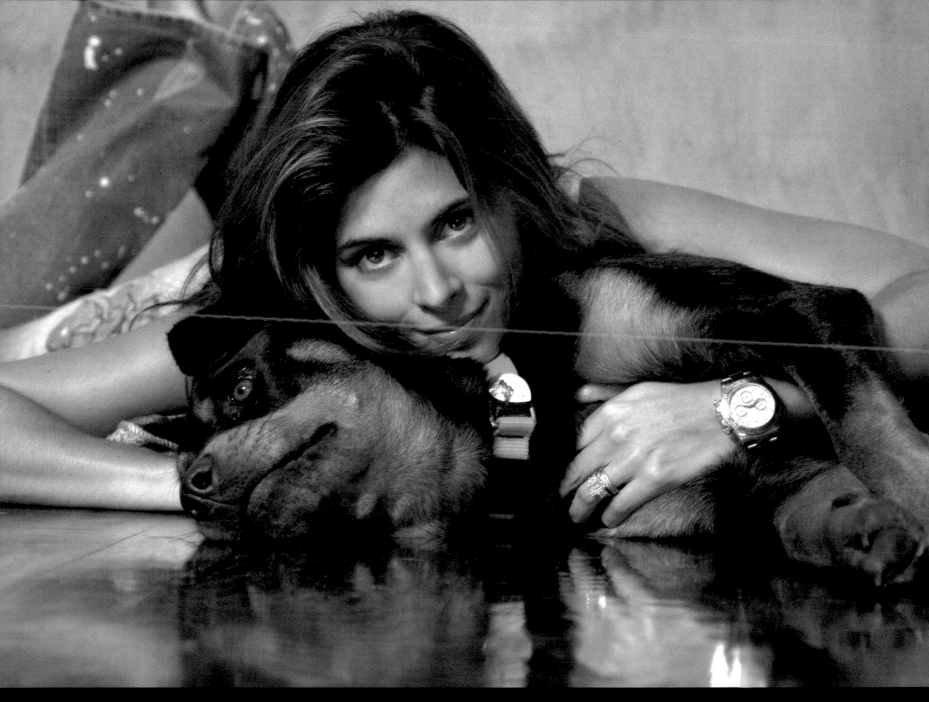

Jamie-Lynn Discala & Hailey

"My two favorite people in the world."

"They always give you a sense of peace."

John O'Hurley, Betty & Scoshi

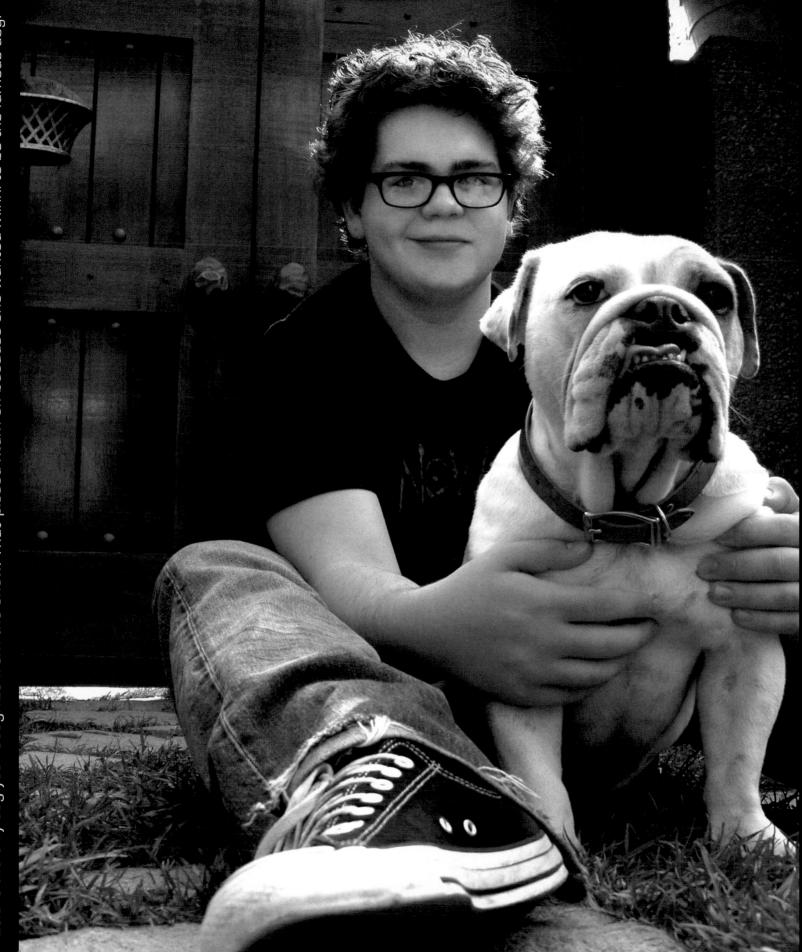

"Lola is the only dog you recognize from the show. That pissed Mum off because she wanted Minni to be the famous dog."

Jack Osbourne & Lola

"Dogs are like therapists... They show you how simple and uncomplicated life really can be... They're just cheaper, more loving, and give you way more than an hour a day."

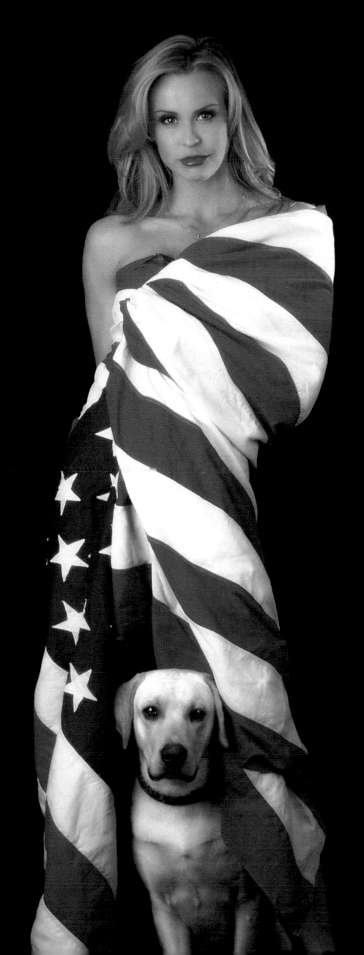

Natasha Allas, Sandy & Chester

Miss World 2000

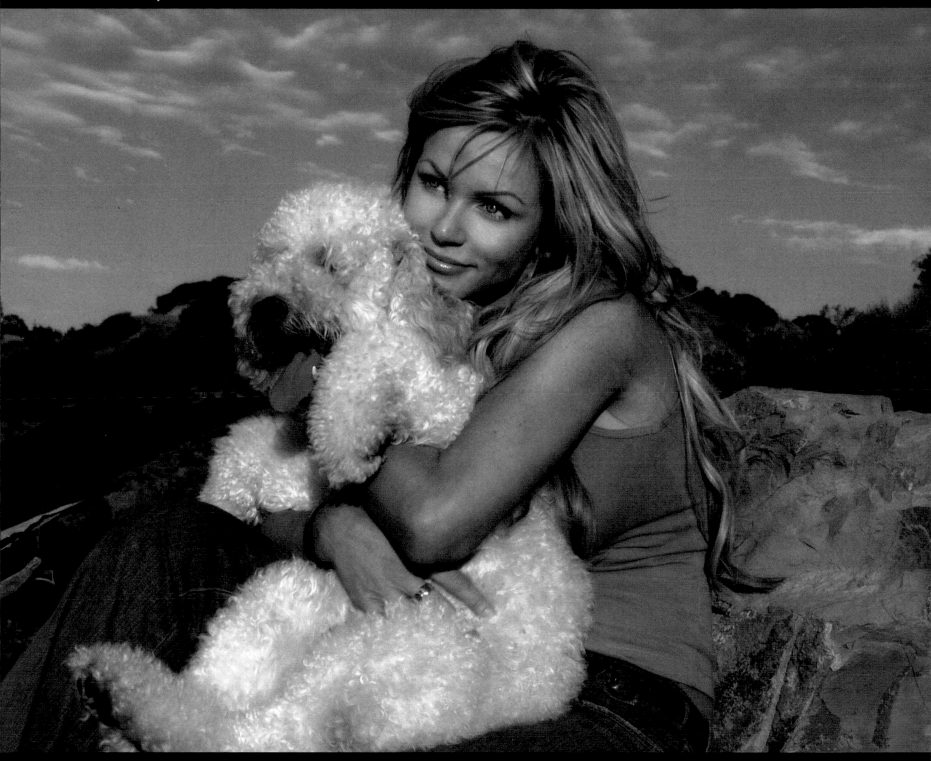

"I would be so lonely if I didn't have him."

"We are so similar. We are both Diva's"

Nikki Ziering & Monkey

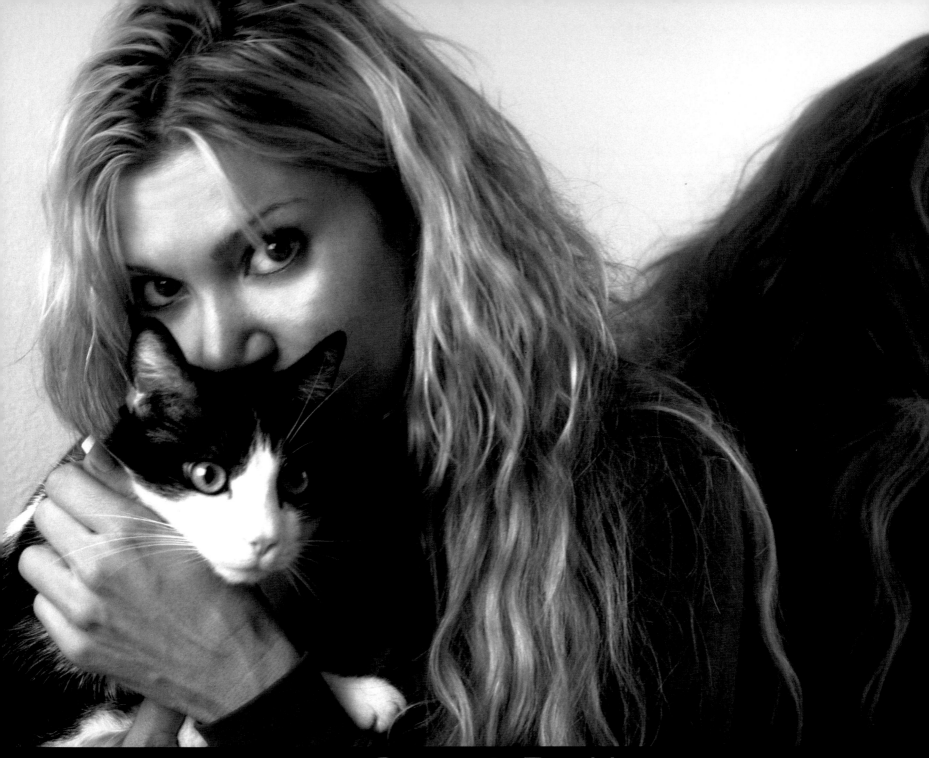

# Lara Scott & Barkley

"He was born with a taste for the high life—his mom crawled through the open window of a limousine to give birth to her kitten. However, when someone opened the door a few days later, she ran off and left them.
I got Barkley when he was just a few days old, and had to bottle feed him every few hours for weeks.
This "bottle baby" is now the sweetest, cuddliest cat in the world—he especially loves spooning."

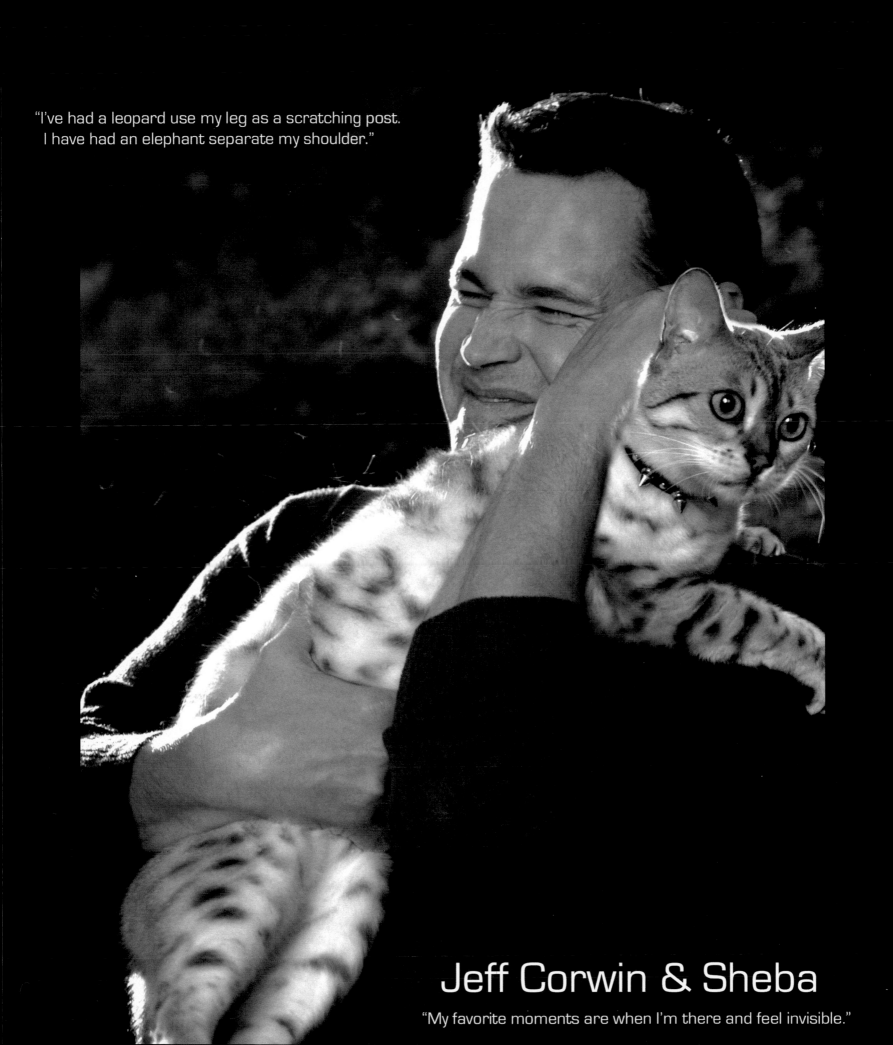

"I've had a leopard use my leg as a scratching post.
I have had an elephant separate my shoulder."

## Jeff Corwin & Sheba

"My favorite moments are when I'm there and feel invisible."

Victor Webster, Harley & Buddha

"Harley doesn't know any tricks, but he plays on command."

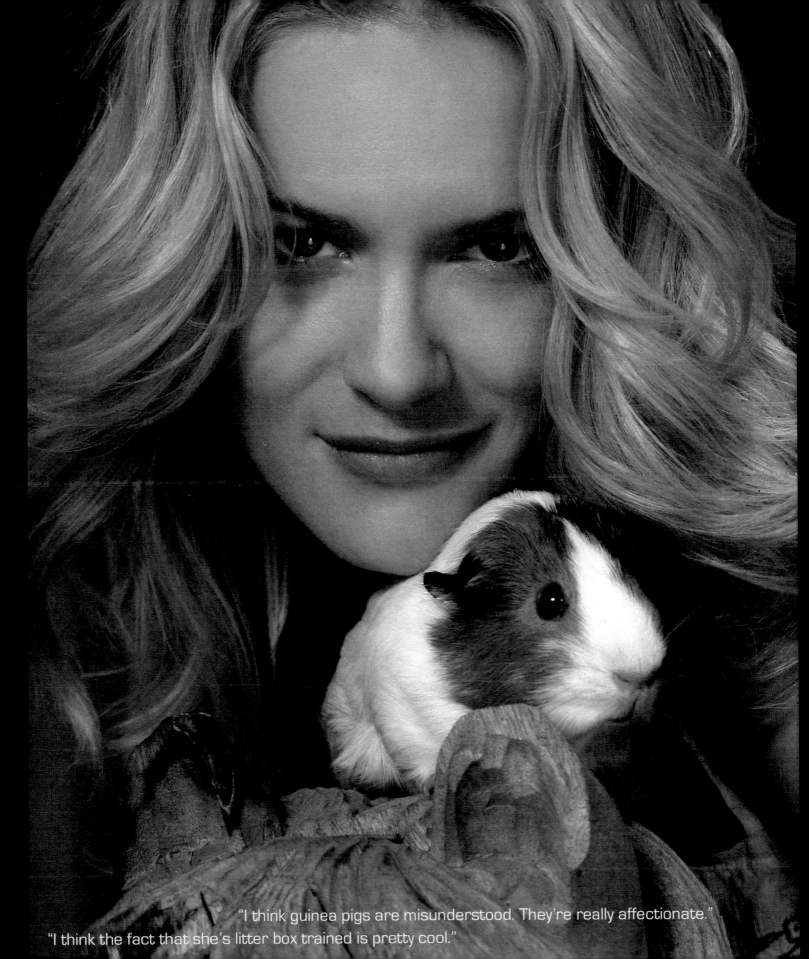

Victoria Pratt & Luella

"I think guinea pigs are misunderstood. They're really affectionate."

"I think the fact that she's litter box trained is pretty cool."

"He's a four legged flea bag. I can't imagine my life without him."

# Enrico Colantoni & Mortie

"I like redheads but Mortie is partial to blondes."

"Idaho has taught me so much. How to commit, how to relax and be playful. She is so devoted it's crazy. Things will come and go, but I love that I have her through it all."

"Idaho is more of a person than a dog. She has never been very interested in other dogs."

Daphne Zuniga & Idaho

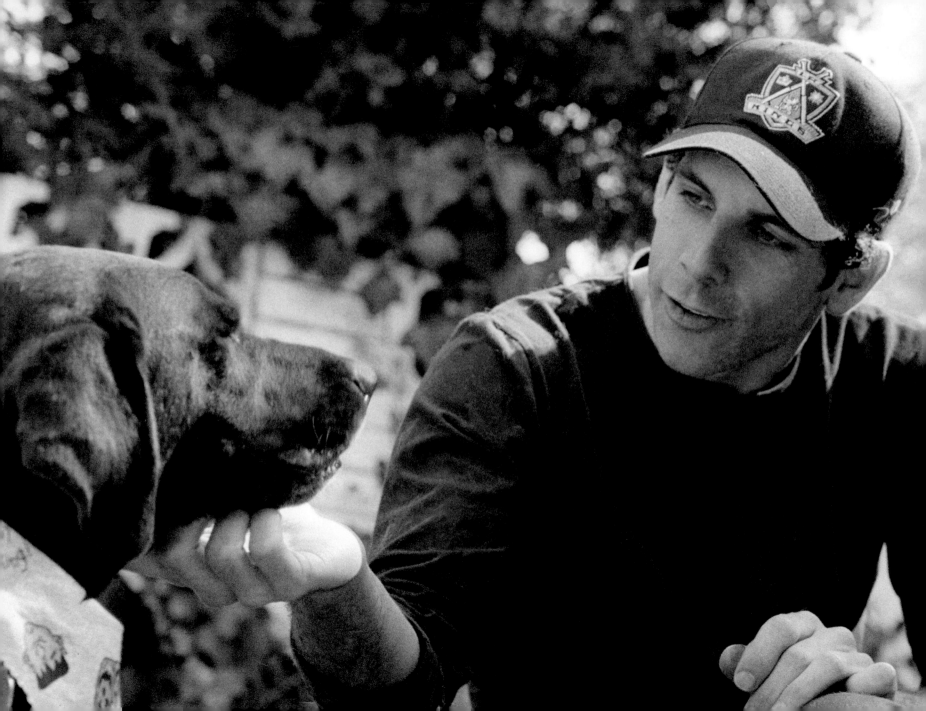

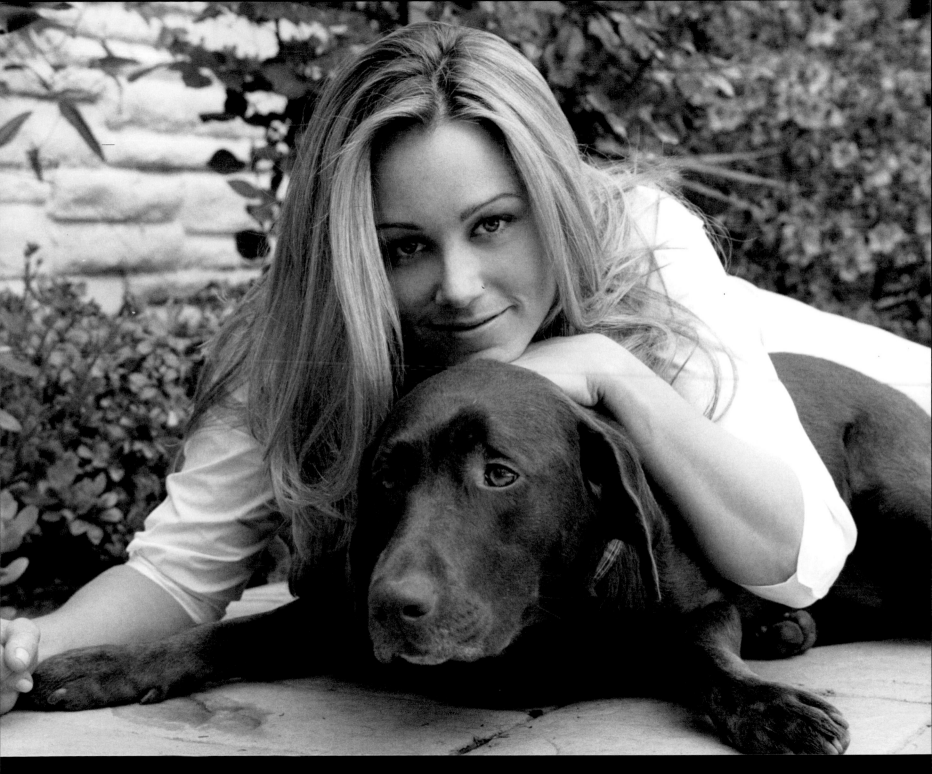

Christine Taylor, Ben Stiller & Kahlua

Vincent Schiavelli & Orsin

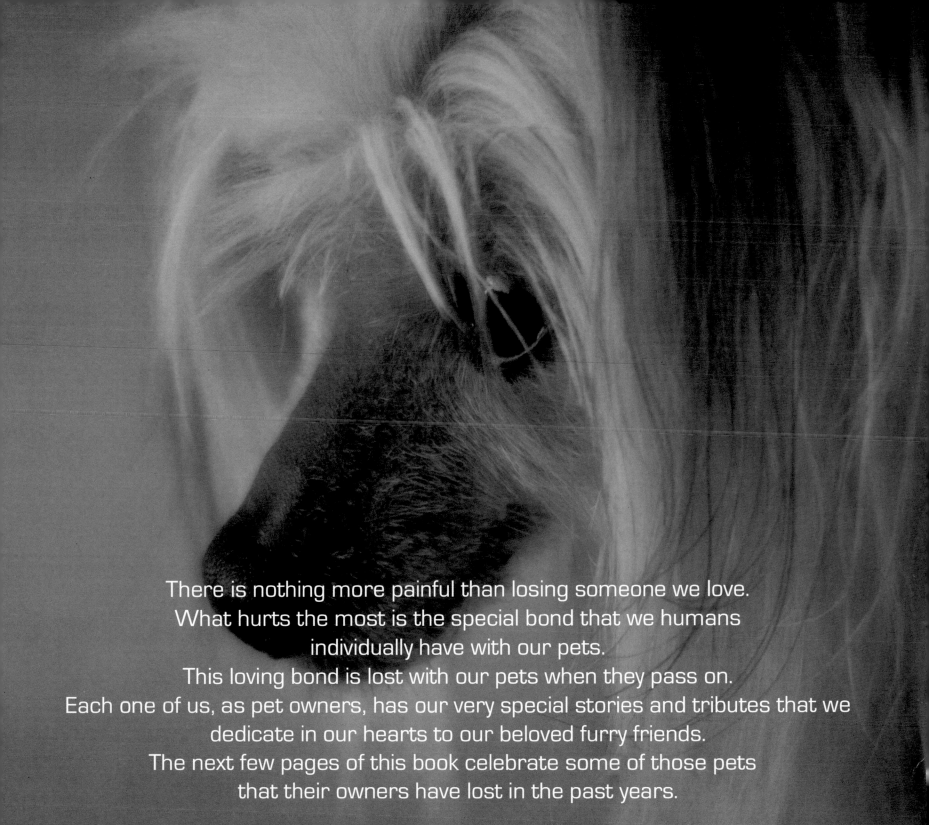

There is nothing more painful than losing someone we love.
What hurts the most is the special bond that we humans
individually have with our pets.
This loving bond is lost with our pets when they pass on.
Each one of us, as pet owners, has our very special stories and tributes that we
dedicate in our hearts to our beloved furry friends.
The next few pages of this book celebrate some of those pets
that their owners have lost in the past years.

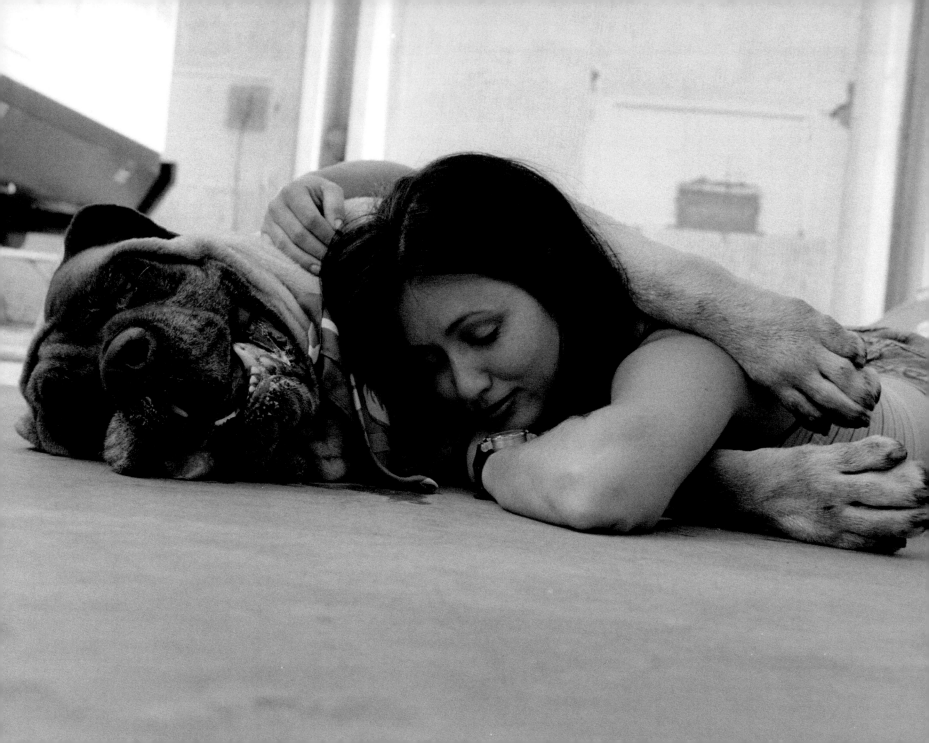

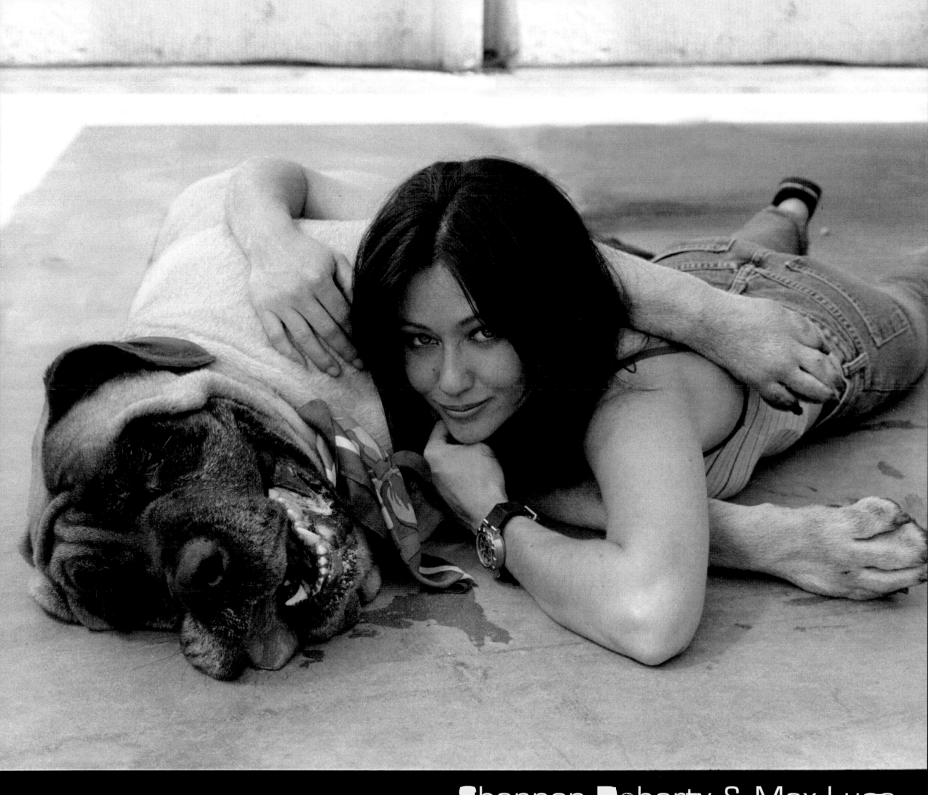

Shannen Doherty & Max Luca

"I am convinced he was a very small man. A very small man with thumbs."

"I am so happy Christopher was able to capture these pictures of Mousey for me.
This cat was the most amazing animal I ever came in contact with. I miss him dearly,
and though his death was a painful experience, I still have this photo to remind me of the joy he brought to my life."

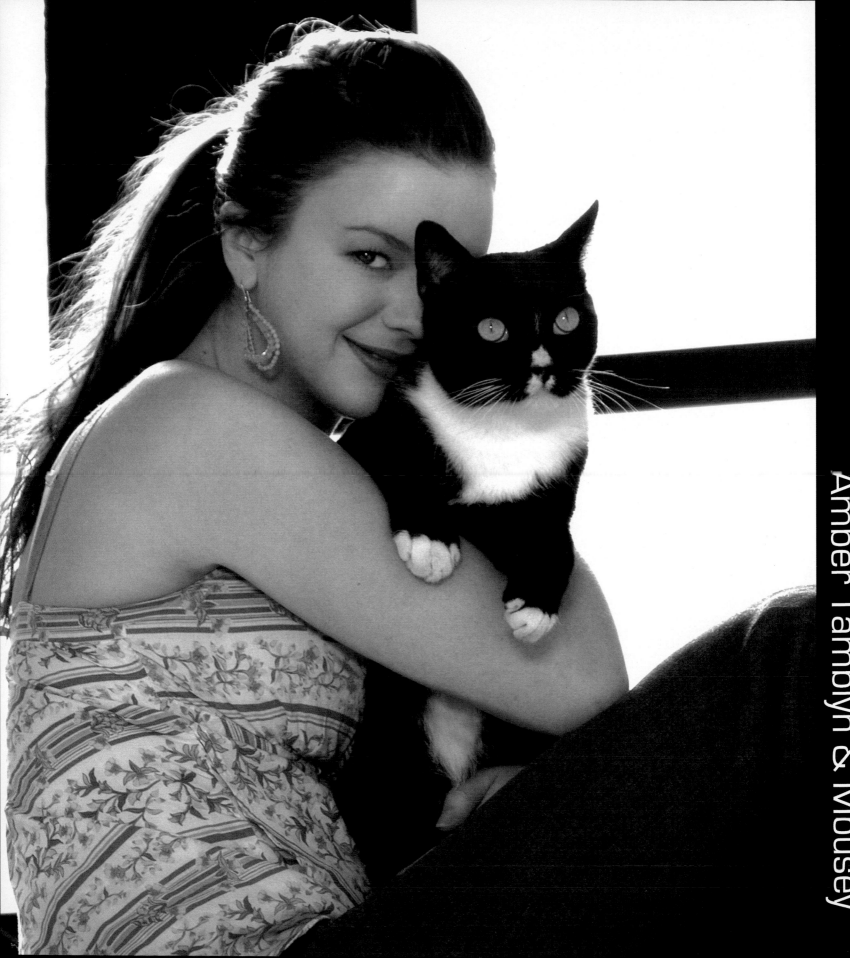

Amber Tamblyn & Mousey

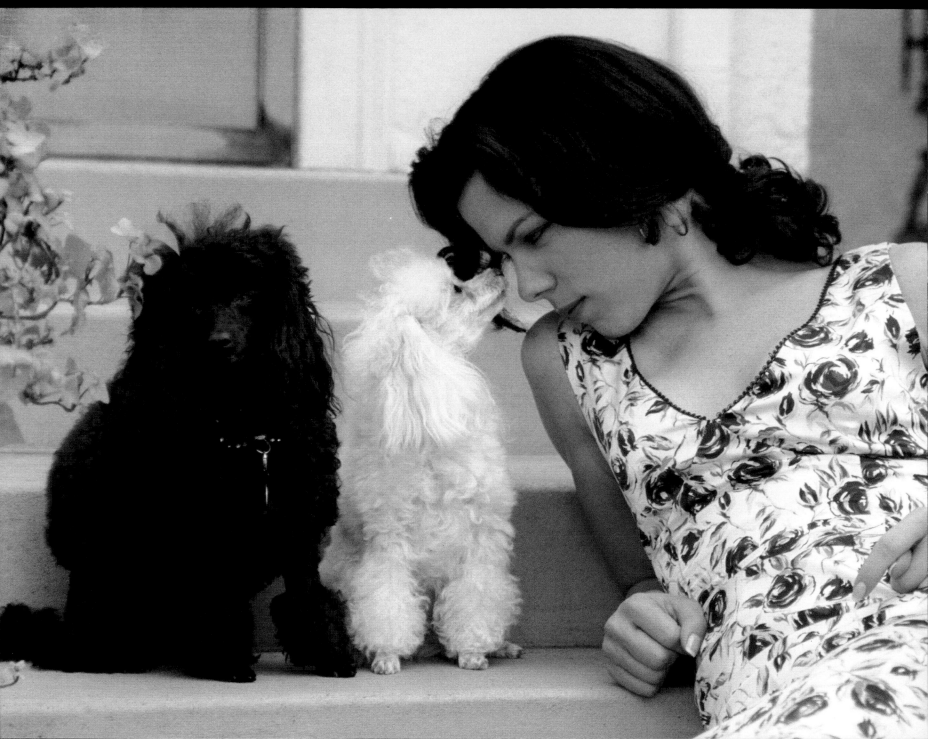

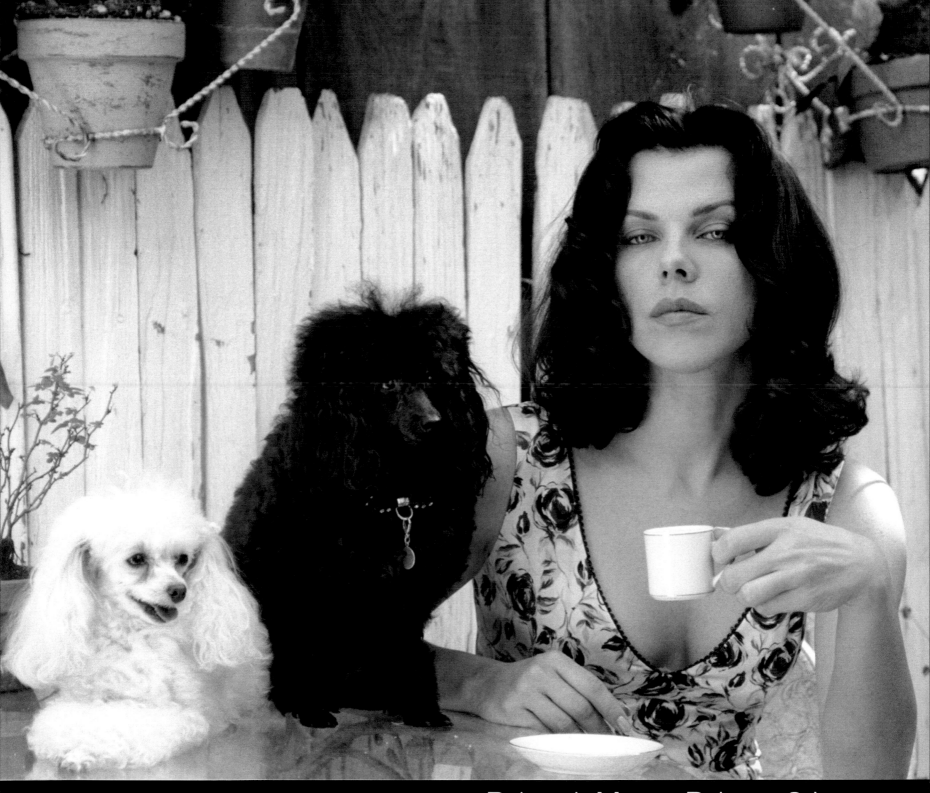

Deborah Mazar, Delores & Loretta

## Bone

With Spring in the air and our boy at our side,
in search of a dog we went for a ride
to the animal shelter..the "pound", if you will.
It wasn't that far–just over the hill.

He took his time looking, for he said he'd know
the right dog when he saw it, and then we could go.
But he didn't find one that he thought was quite right.
And so we decided to call it a night.

Just then Rhyan's eyes lit up like a light,
"How about that dog over there–she's just right!"
There was an old dog being taken away.
He said he'd like to see her, if it was okay.

He went over to her and she wagged her bobbed tail.
He could see she was old, and a little bit frail.
"She needs me," he said, "and her eyes are so kind.
I'd like to have her, if you don't mind"

It was then that we realized where she'd been being led.
We looked at the worker and she nodded her head.
"Well it looks like today is her lucky day."
She handed Rhyan the leash and sent us on our way.

Bone loved her new home–lots of kids, land, and love.
And we loved her, too, like a gift from above.
Whenever we would walk out on our property
Bone walked out in front, her mind on safety.

She always watched over the kids like a mom
with a sense for the things to protect them from.
Her eyes were not sharp, and her hearing was bad
but a keener sense of smell was not to be had.

You always knew when Bone was around
'cause her nails on the floor made a clicking sound.
You knew she was coming down the hall for a drink
(or sometimes for a snack, which were kept by the sink.)

We always felt safe with old Bone around,
and no gentler dog could ever be found.
She was there to watch all our kids grow
but as they got bigger, our Bone got more slow.

We'd go out for our walks, but she would not go.
She preferred now to sleep on her soft pillow.
But no matter how tired or how weak she felt
that bobbed tail would wag, and our hearts she would melt.

At first it was tremors, then seizures came.
Bone no longer could bark, but she still knew her name.
Toes still clicked down the hall when she wanted a snack
which we knew she loved, so we never held back.

She slept more and more.  She could see less and less.
She had accidents now, but we'd clean up her mess
with a tear, for we knew the day neared
that we'd be without her.  The day that we feared.

The shelter had told us that they didn't know
but that she must have been about twelve years or so
when we got her.  So if that was true,
then Bone was now eighteen and her days left were few.

We got her some pills that could make her last days
more comfortable, and in less of a haze.
Every day after school Rhyan would go to her
and lay with her awhile, gently stroking her fur.

I think she must have, quite deliberately,
waited until Rhyan was not home to see
her draw her last breath, then peacefully go
as she lay sleeping on her favorite pillow.

We buried her here where she loved to run
and play with the children out in the warm sun.
I can still see her there, keeping her watchful eye
on the children she loved from up there in the sky.

I've found it so hard to let go of her
the sound of her toes, the smell of her fur.
Oh, what I would give to see her again .
Goodbye, Bone. We miss you.  Sleep well in heaven.

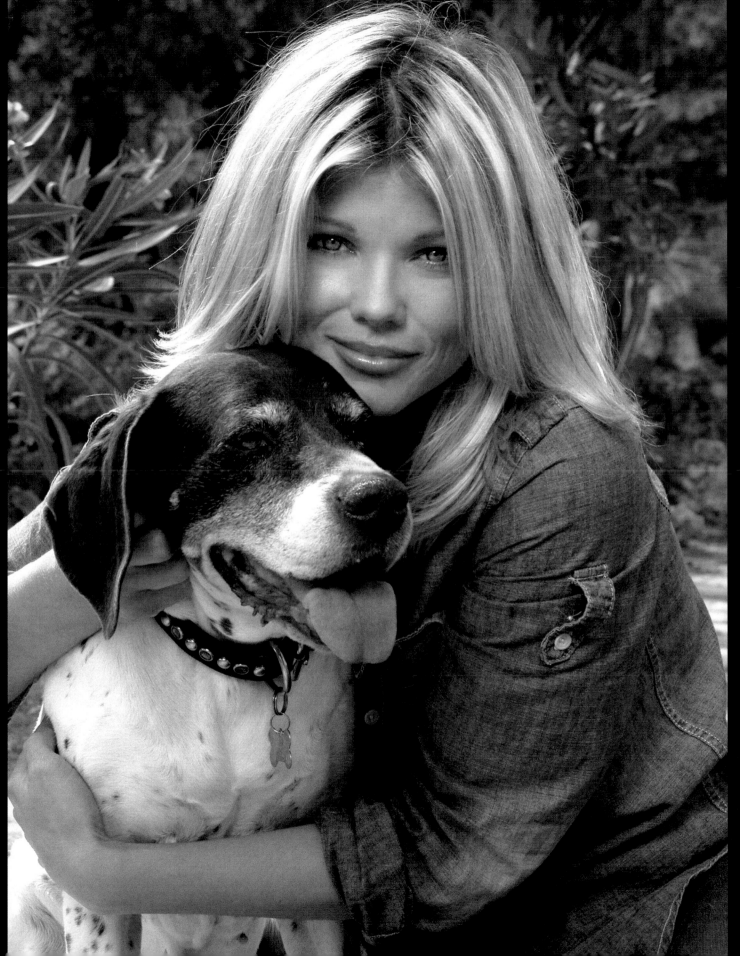

Donna D'Errico & Bone

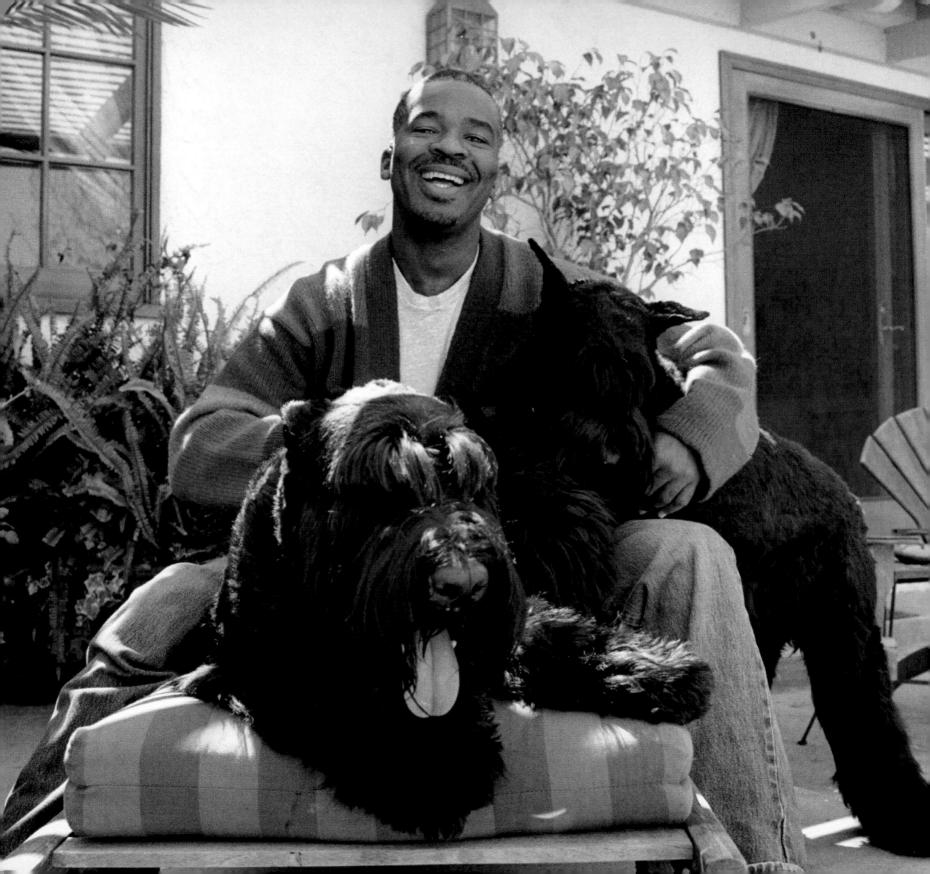

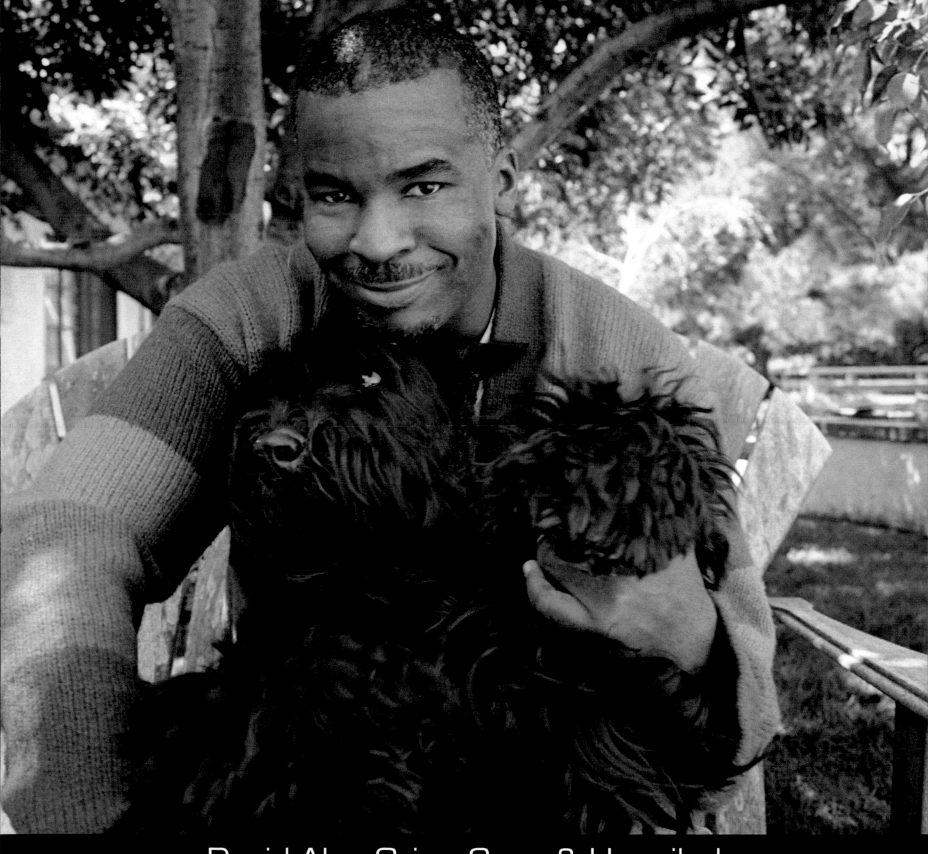

David Alan Grier, Cuca & Hannibal

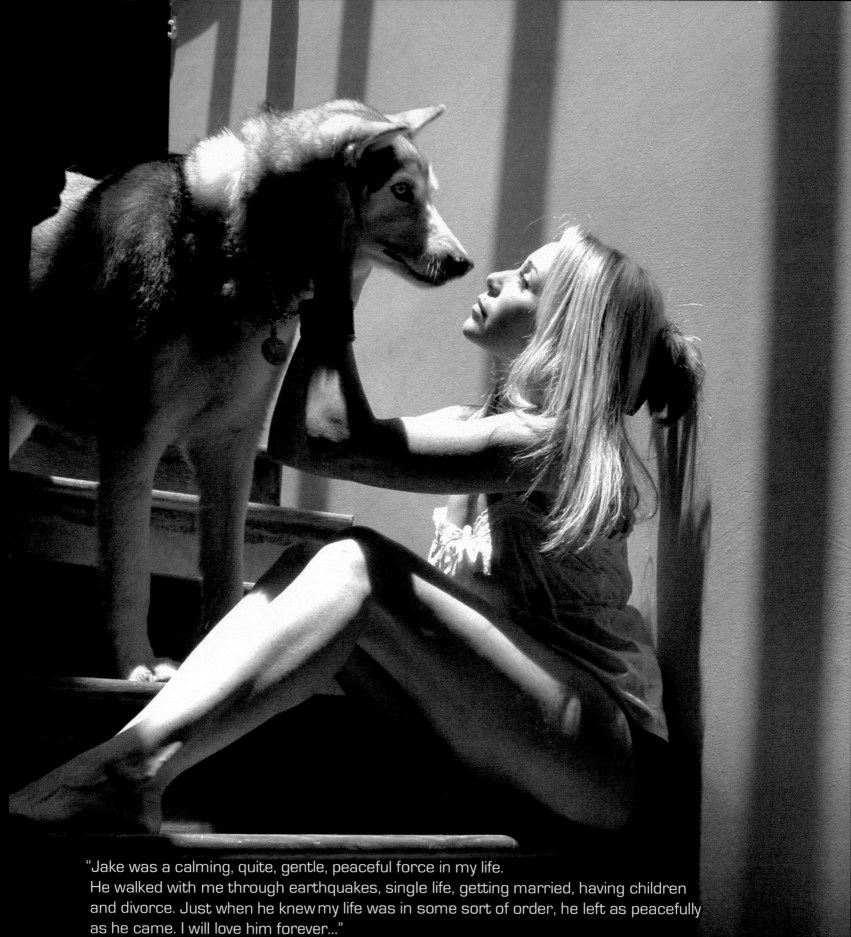

"Jake was a calming, quite, gentle, peaceful force in my life.
He walked with me through earthquakes, single life, getting married, having children
and divorce. Just when he knew my life was in some sort of order, he left as peacefully
as he came. I will love him forever..."

E.G. Daily, Cassius & Jake

"He wants to be right in the middle of the action."

On September 11, 2001,
we suffered one of the most tragic disasters in history.
One month after that unforgettable day,
I had the honor of photographing some of the true heroes of the recovery efforts.

The next few pages celebrate the search and rescue dogs at ground zero.

Some of New York's finest actors and search and rescue dogs took part in this memorable day.

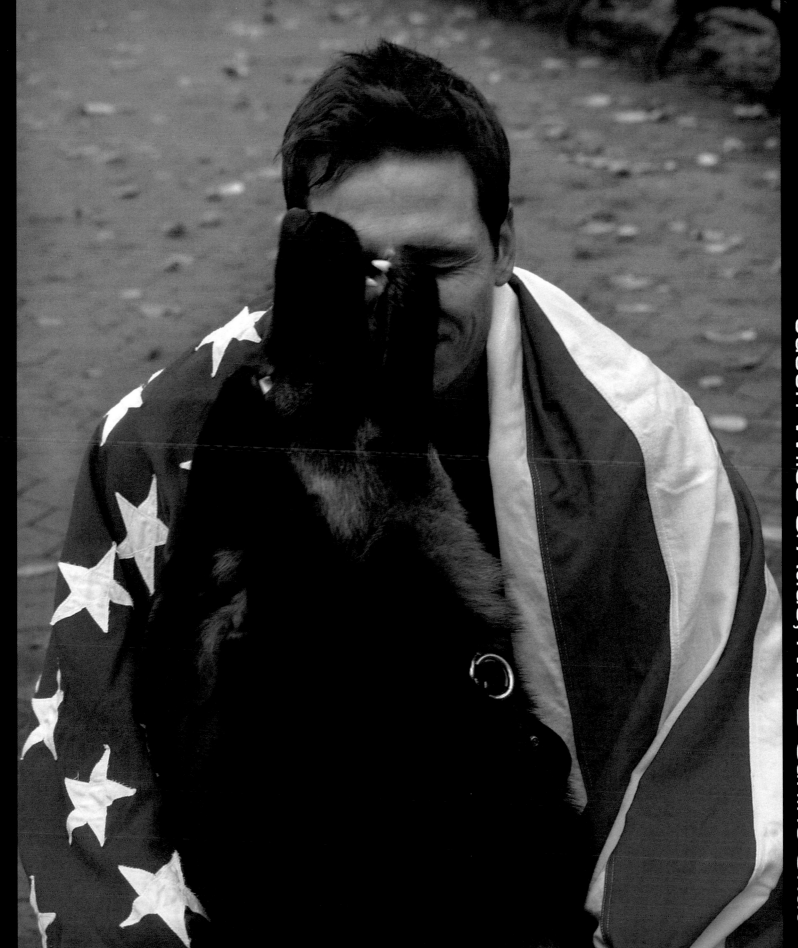

Jason Wiles & Atlas, NYPD Canine Unit

Angie Harmon, Jason Sehorn & Bandit, NYPD Canine Unit

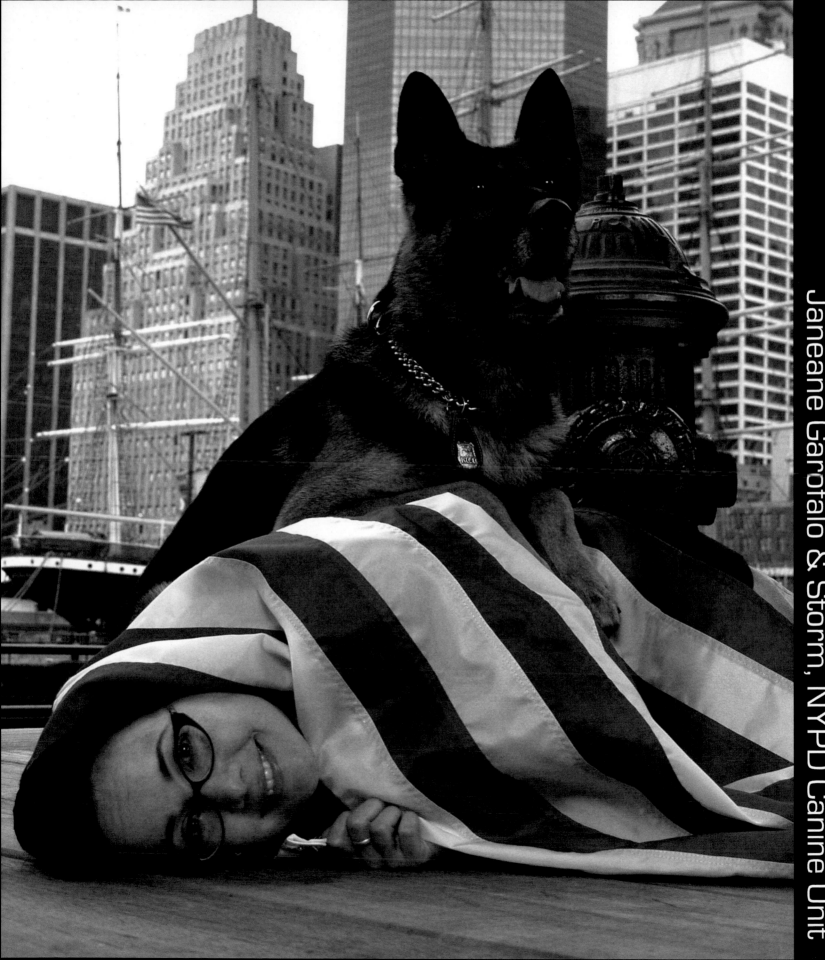

Janeane Garofalo & Storm, NYPD Canine Unit

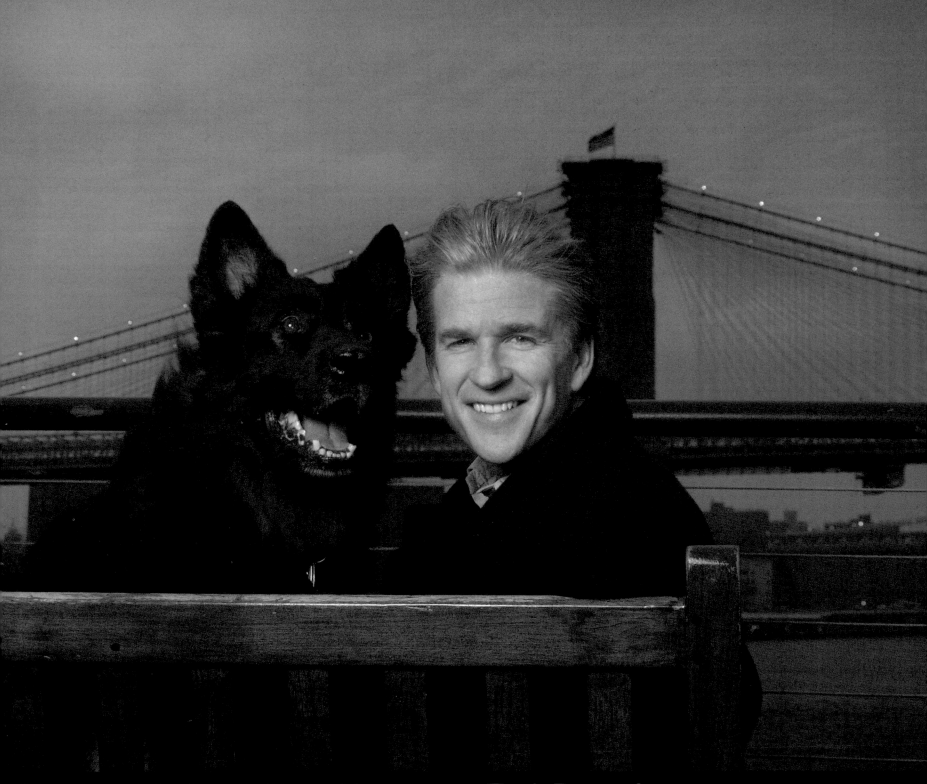

Matthew Modine & Piper, New Jersey Task Force 1

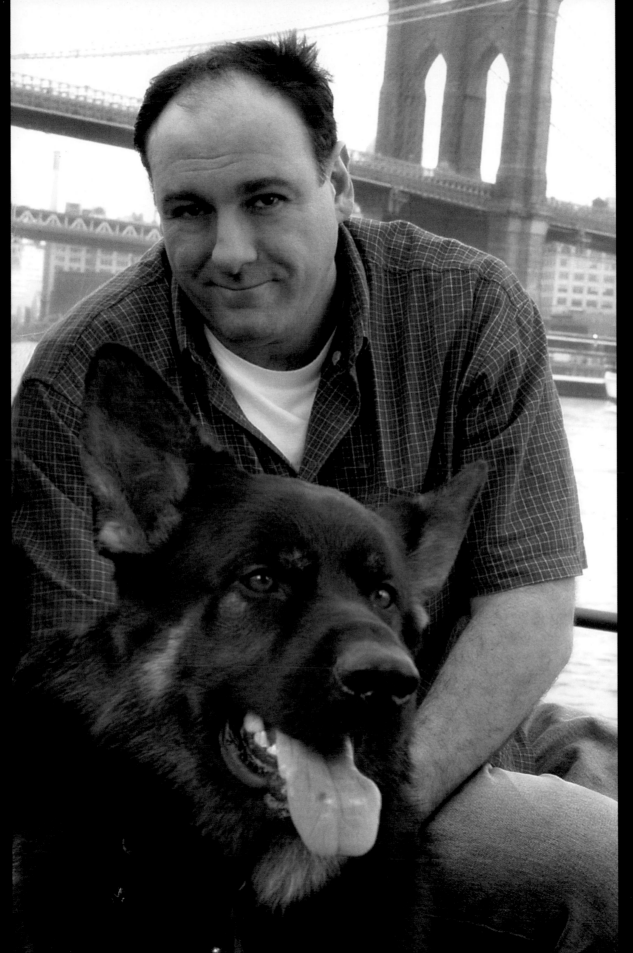

James Gandolfini & Atlas, NYPD Canine Unit

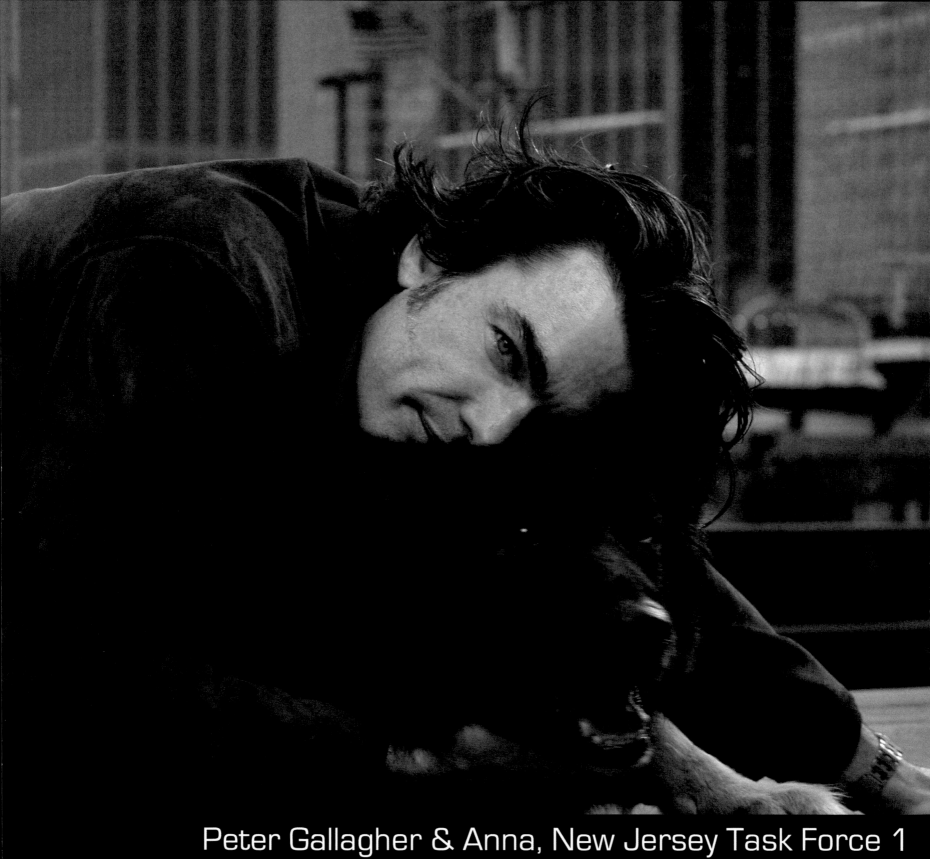

Peter Gallagher & Anna, New Jersey Task Force 1

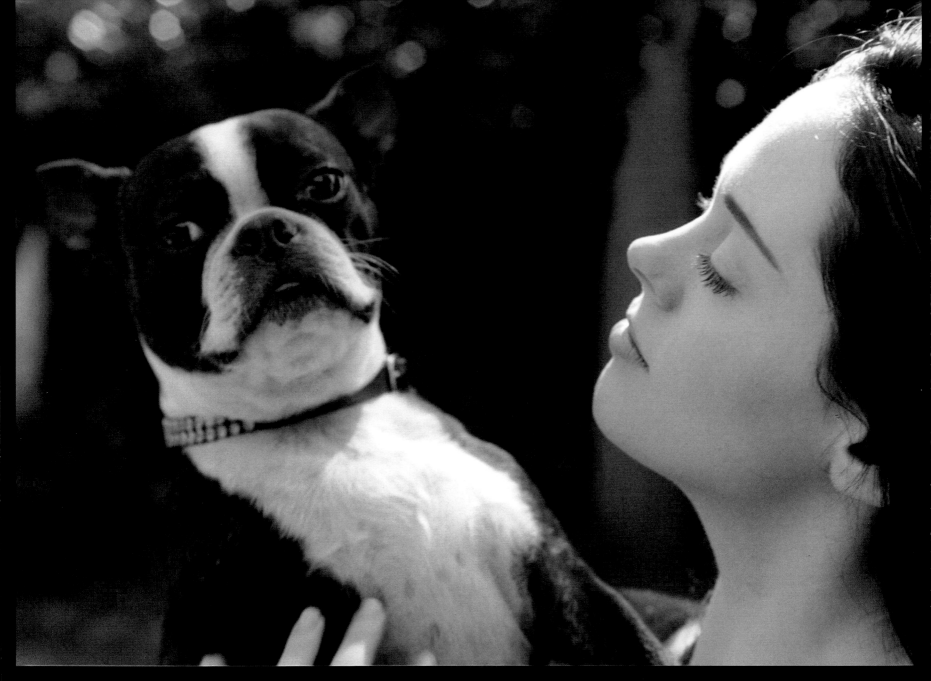

"Babyish, Sweet, Humper"

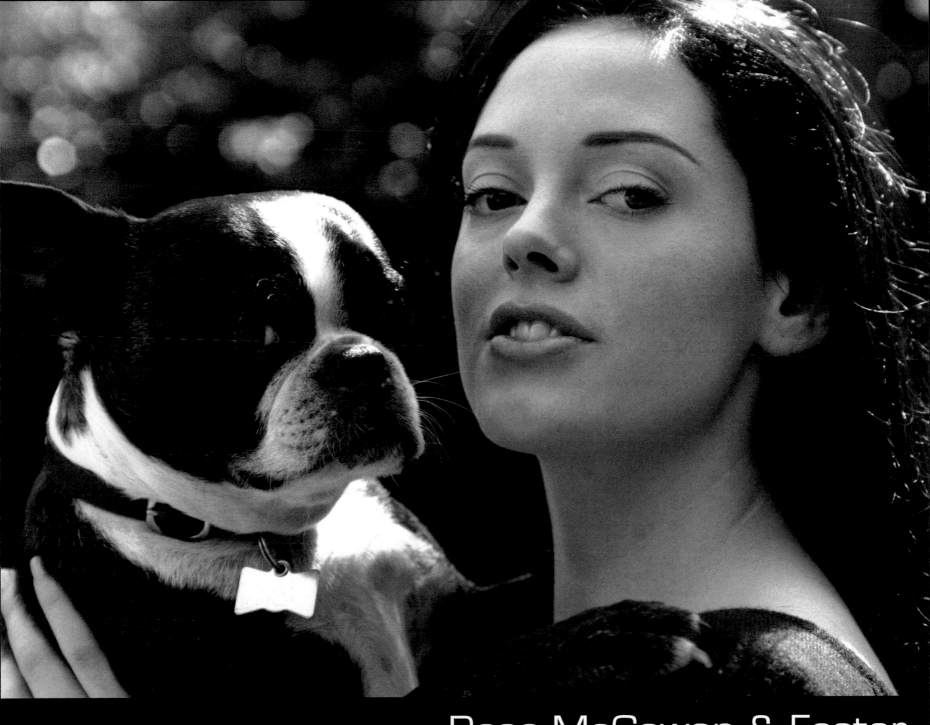

Rose McGowan & Fester

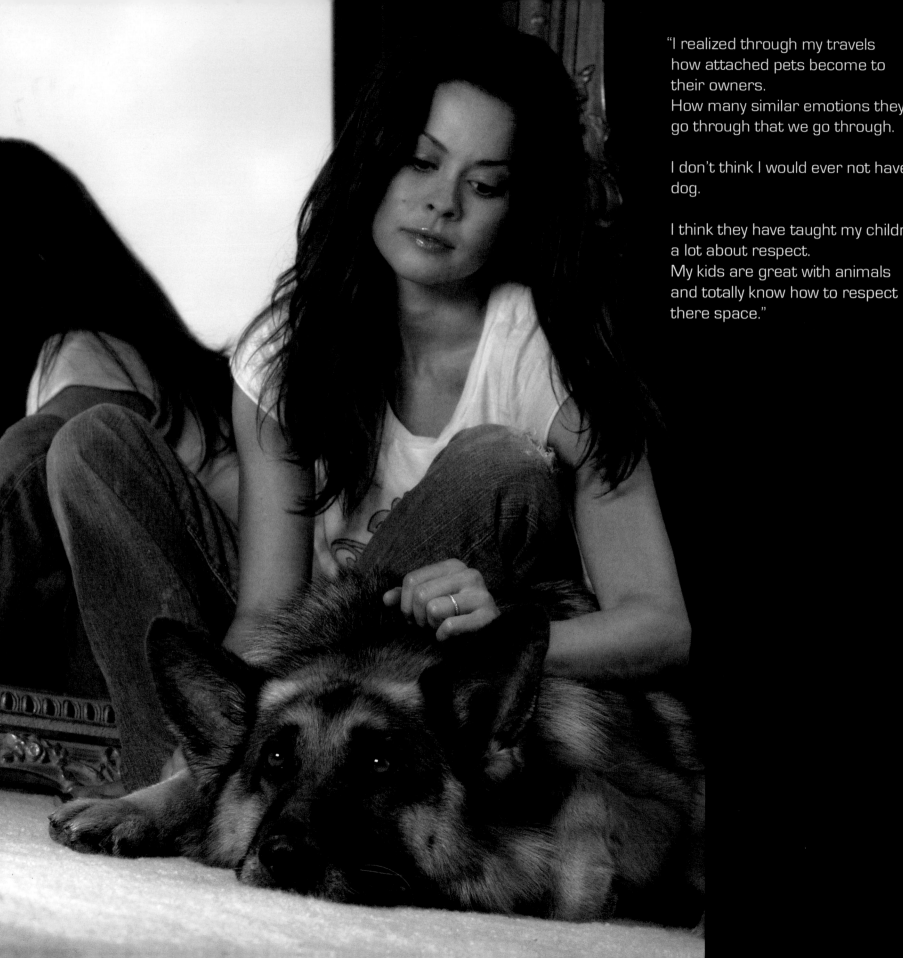

"I realized through my travels
how attached pets become to
their owners.
How many similar emotions they
go through that we go through.

I don't think I would ever not have a
dog.

I think they have taught my children
a lot about respect.
My kids are great with animals
and totally know how to respect
there space."

Brooke Burke & Pitt

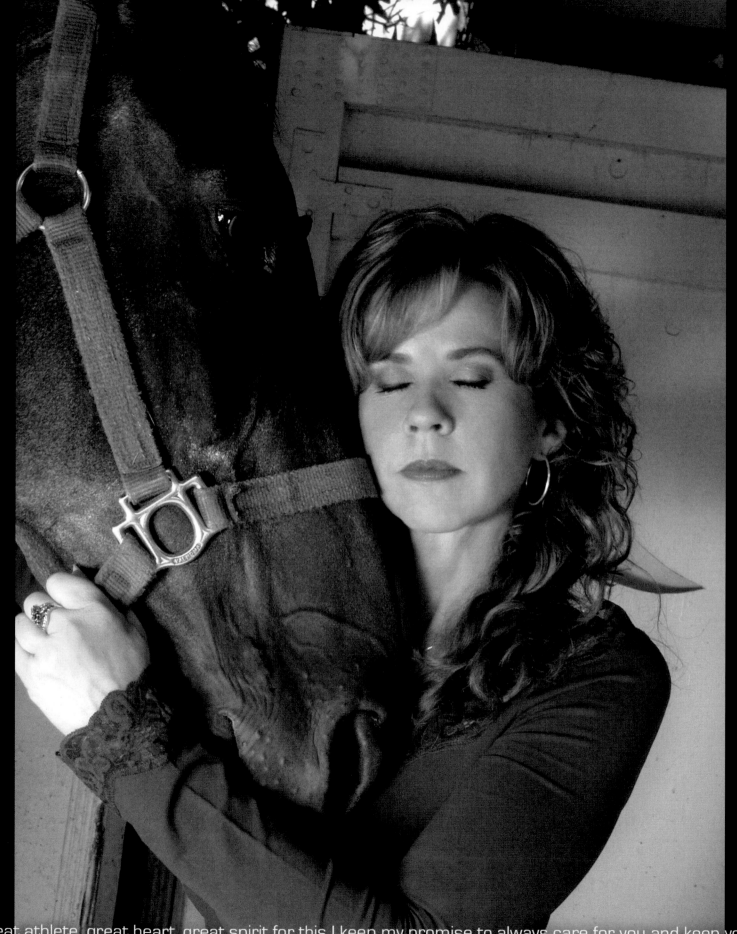

"Great athlete, great heart, great spirit for this I keep my promise to always care for you and keep you safe."

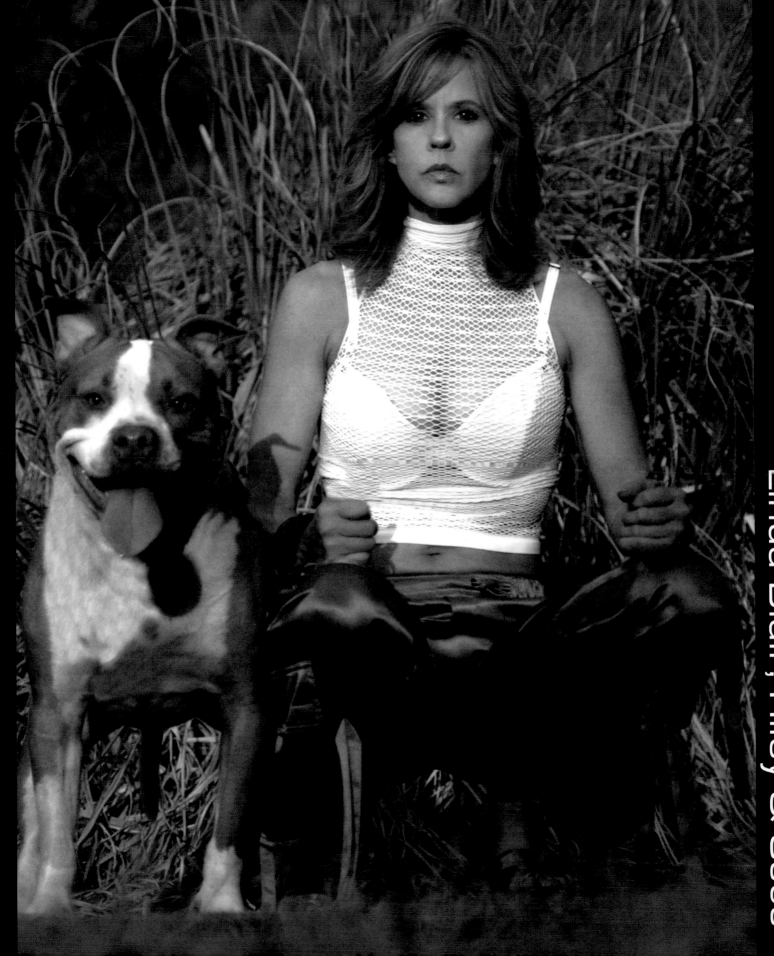

Linda Blair, Riley & Coco

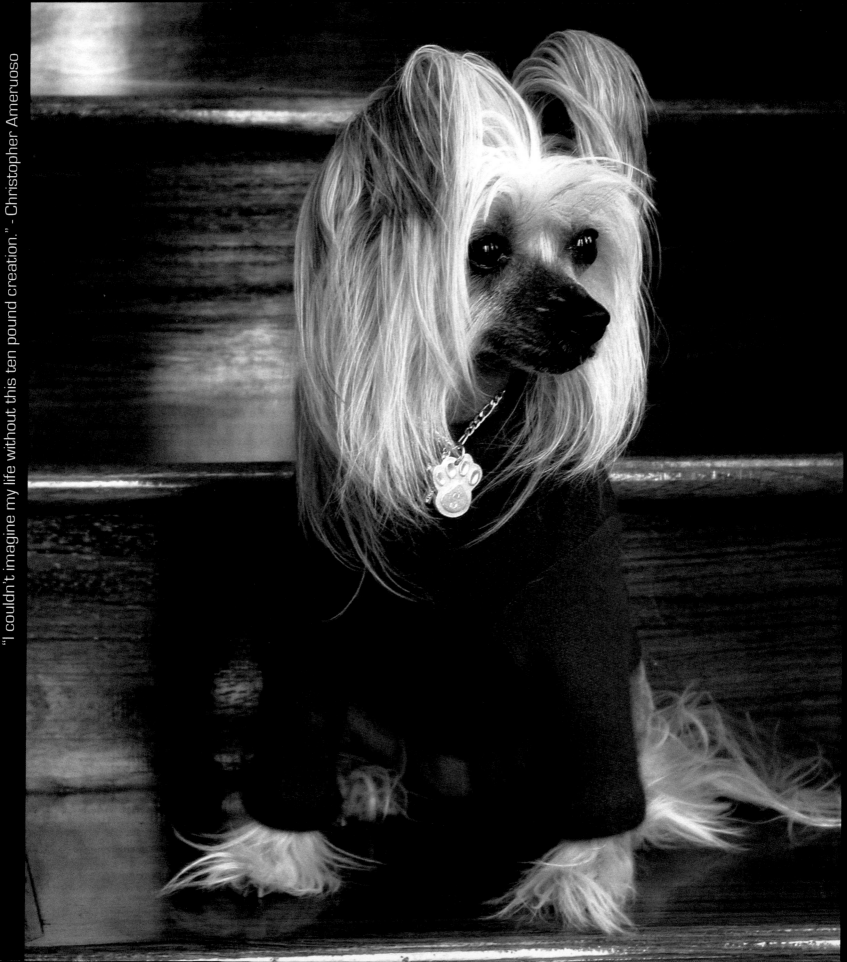

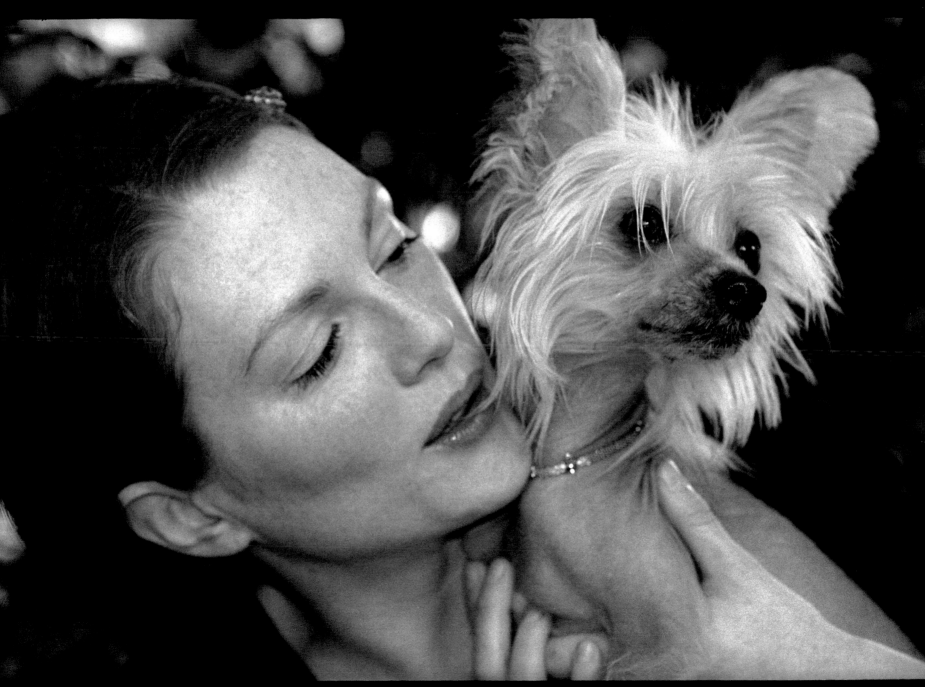

"I can truly say this is a photo that I'm very proud of. One of the greatest leading actors, and my leading lady, Stella." -Christopher Ameruoso

# Julianne Moore & Stella Blue

Stella's owner is Christopher Ameruoso

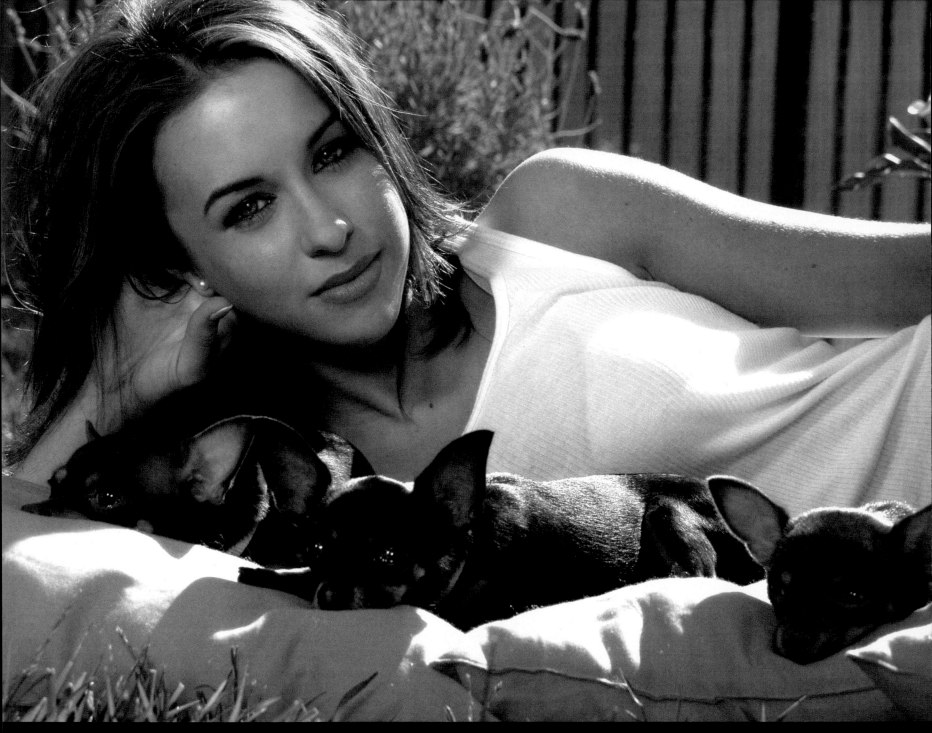

"My dogs chew everything! I don't have anything in one piece, I no longer have any straps on my shoes, but I can't get mad at them."

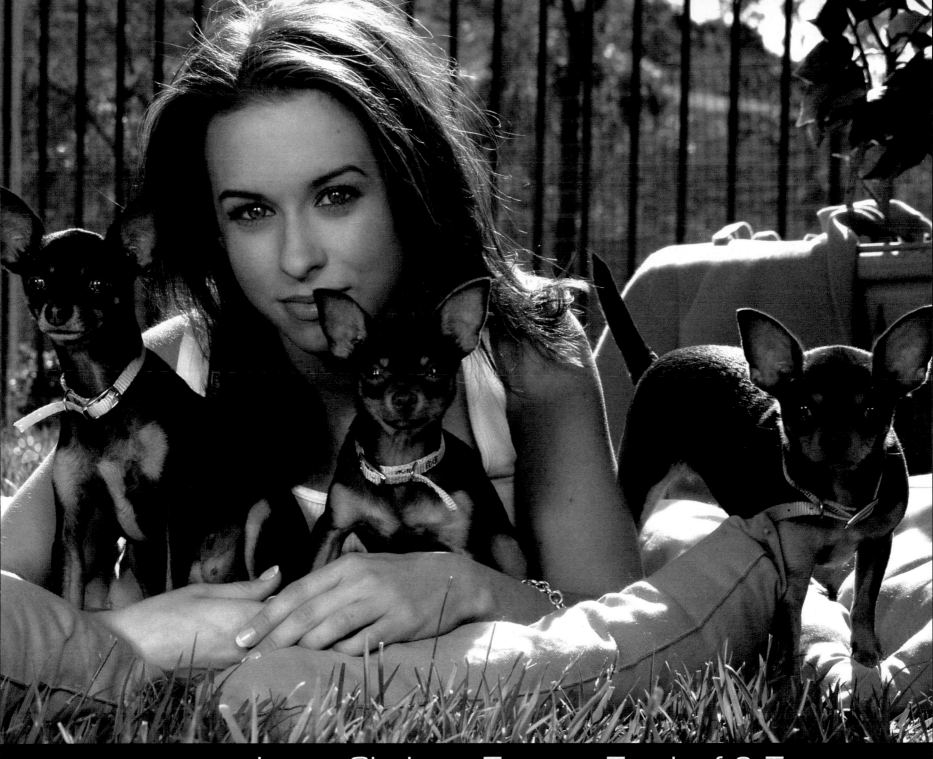

Lacey Chabert, Teacup, Tea leaf & Teaspoon

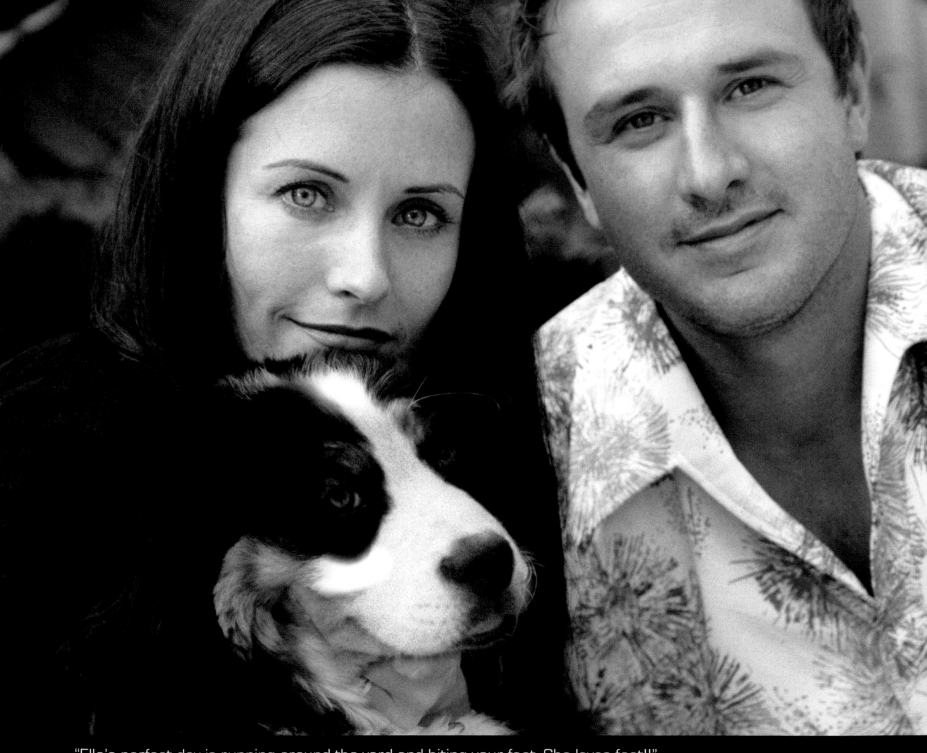

"Elle's perfect day is running around the yard and biting your feet. She loves feet!!"

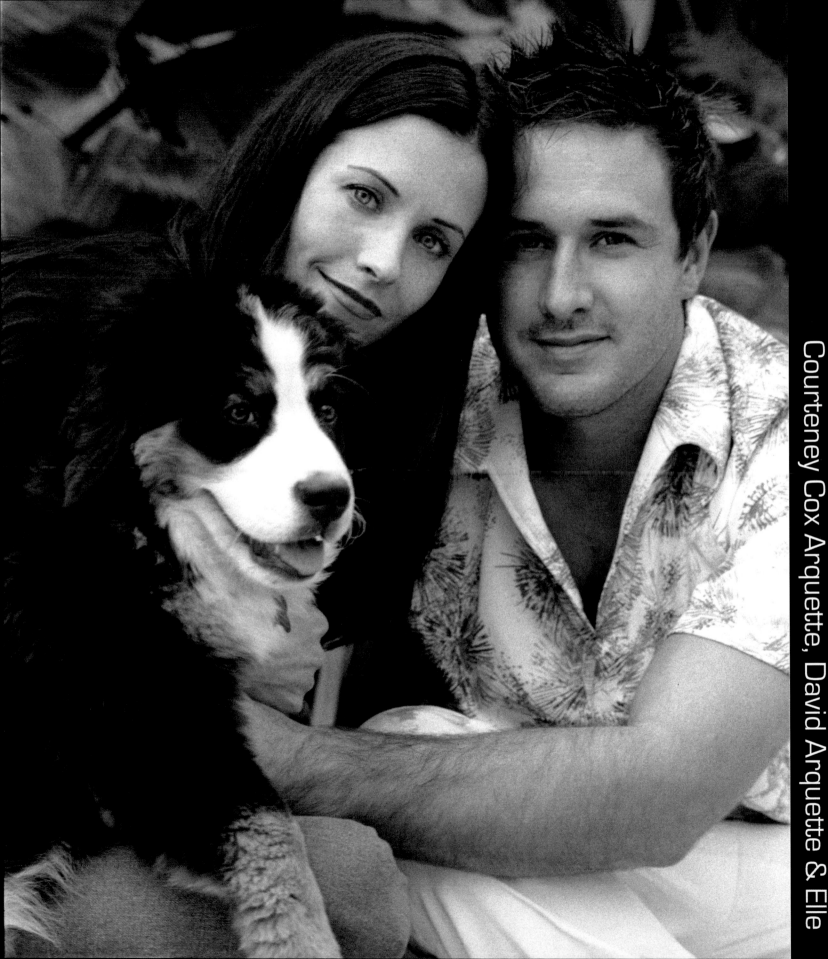

Courteney Cox Arquette, David Arquette & Elle

They remind me that the simplest pleasures in life are enough to make a day great.
They get me to the park almost every day.
They play nicely with each other."

"They are a part of my family, an extension of myself.
They keep this household lively and make this house feel like a home."

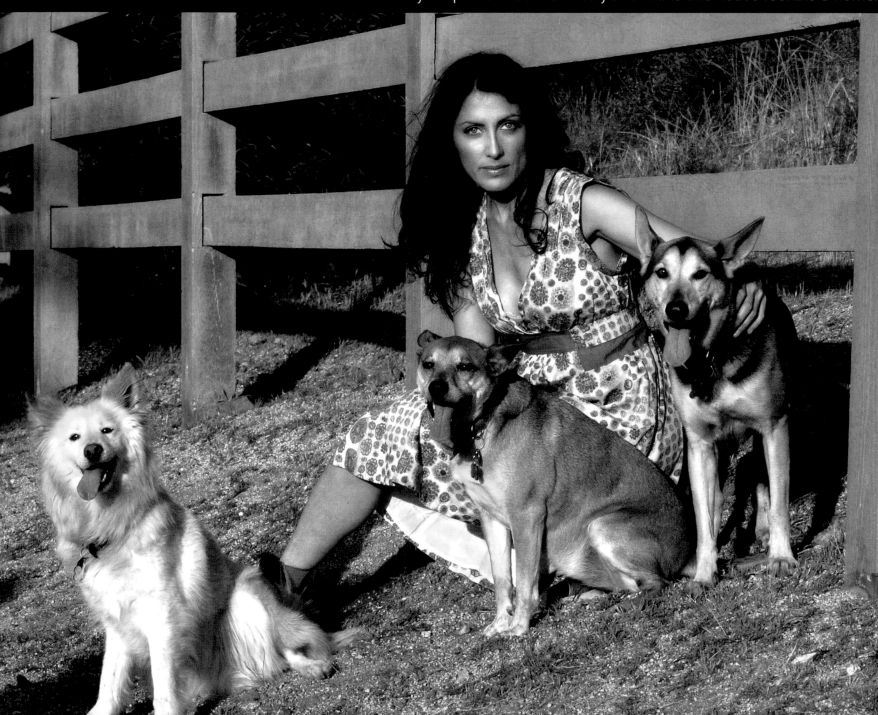

Lisa Edelstein, Sandwich, Bumpa & Wolf E.

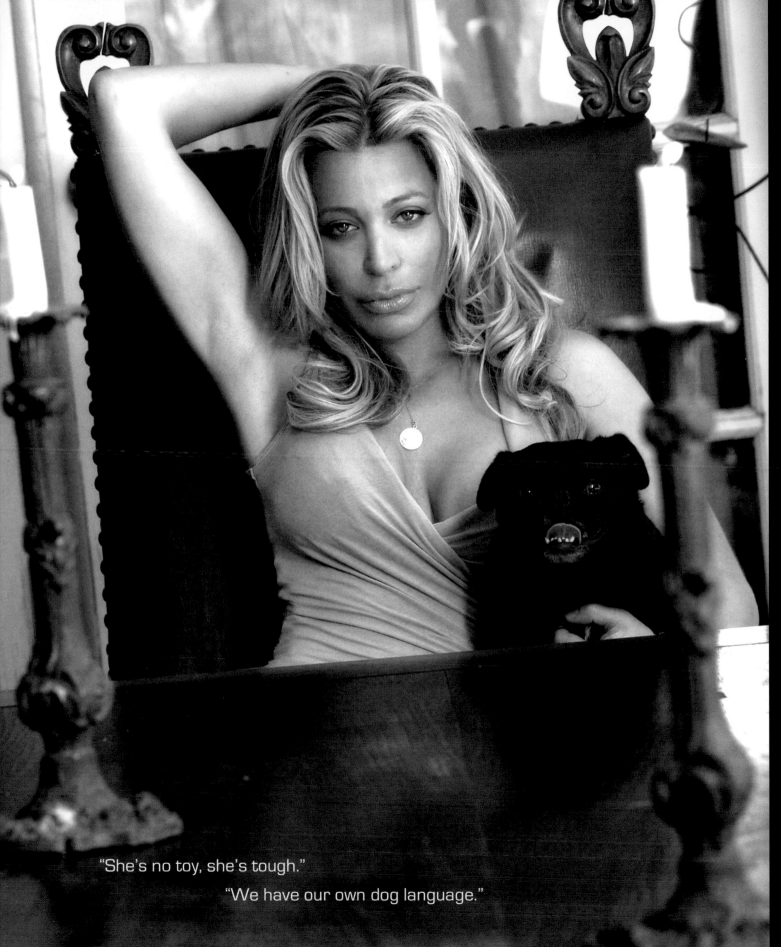

"She's no toy, she's tough."

"We have our own dog language."

Taylor Dayne & Chulabell

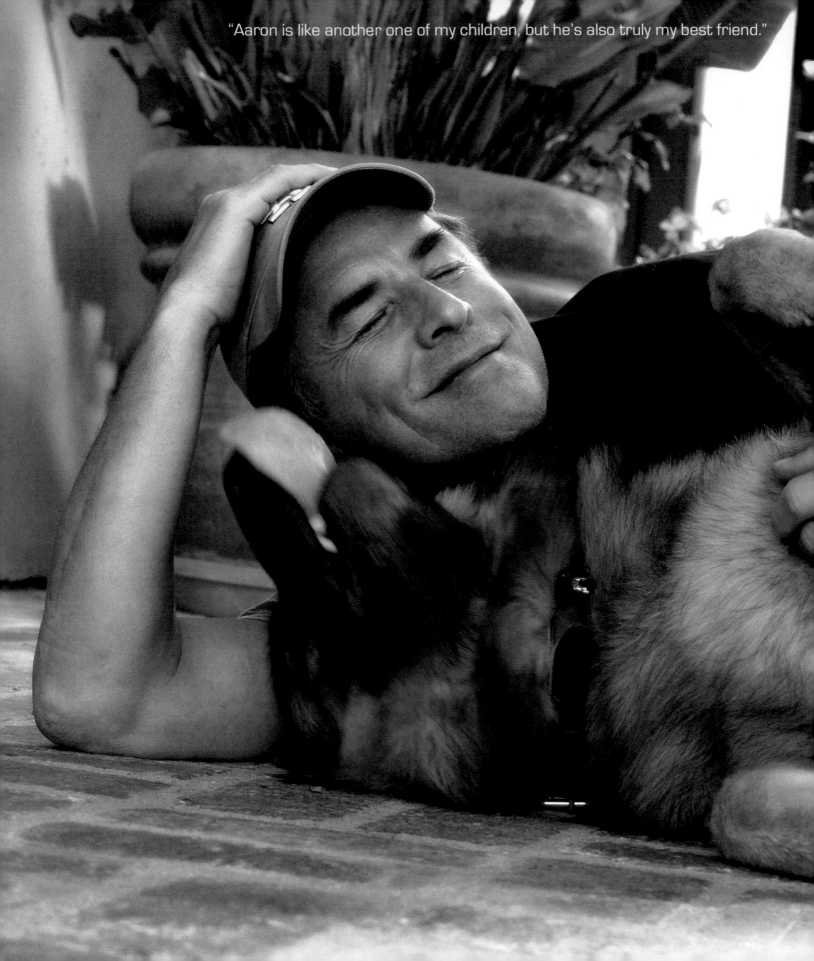

"Aaron is like another one of my children, but he's also truly my best friend."

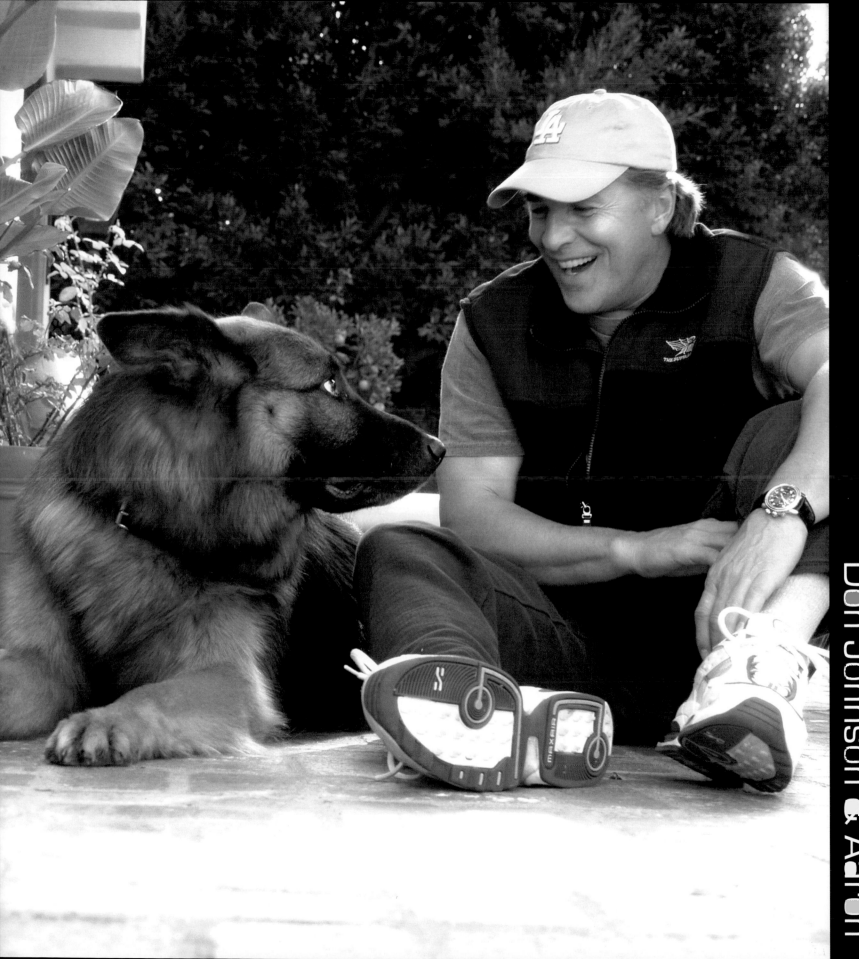

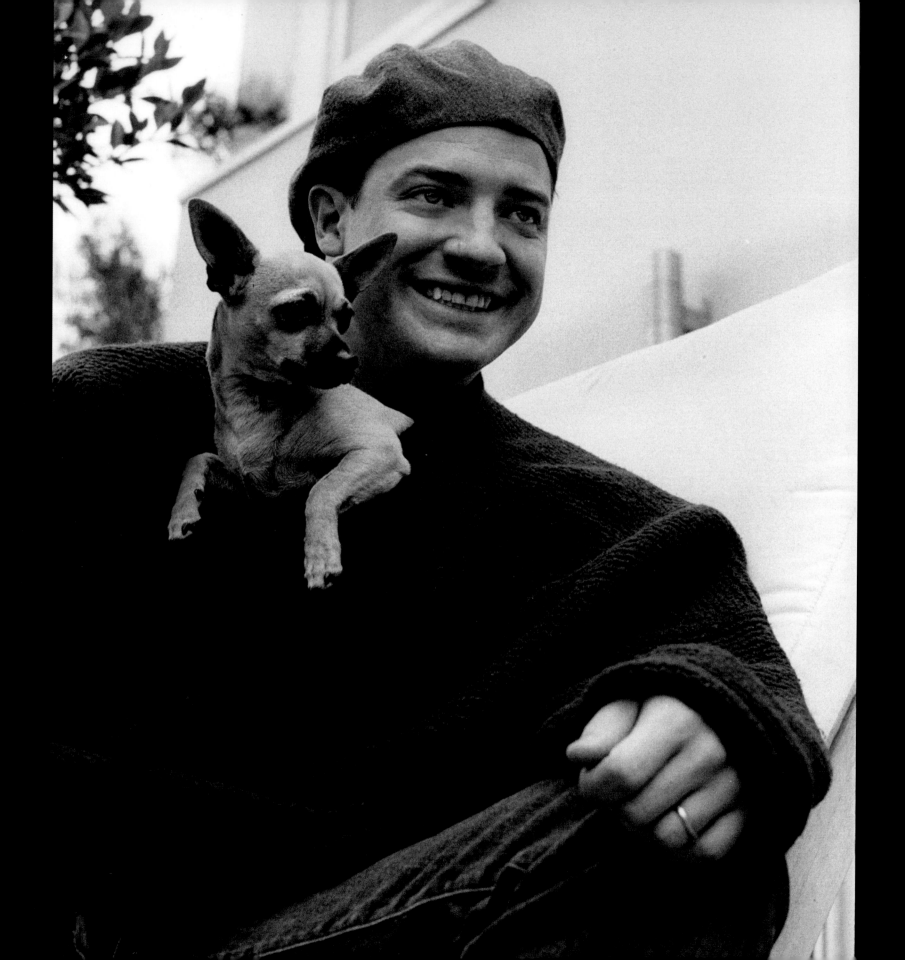

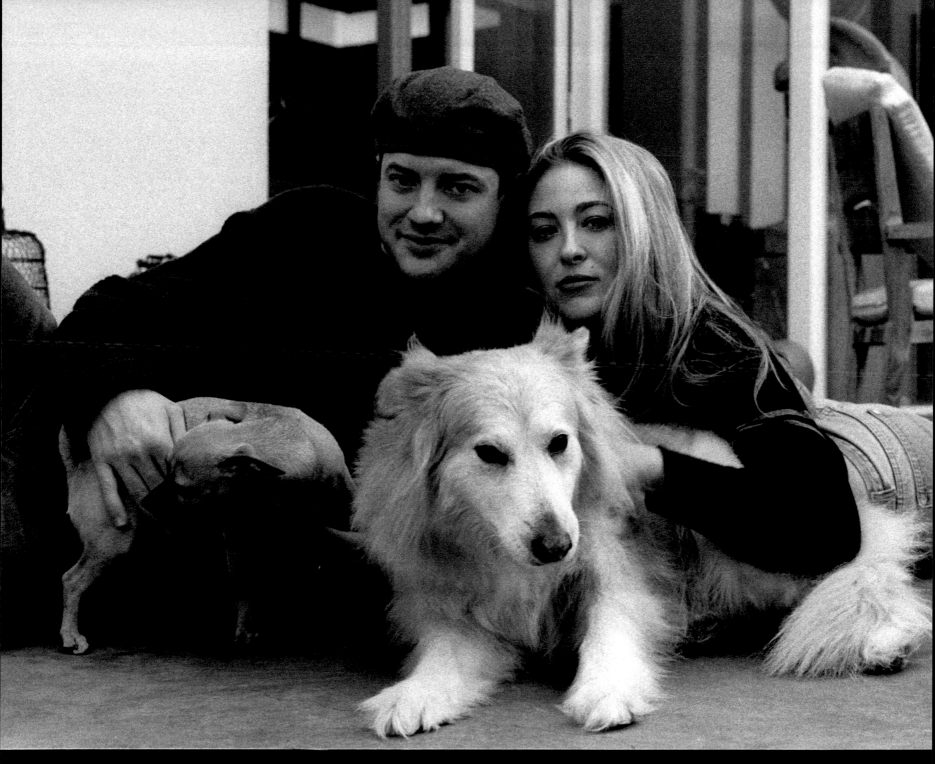

Brendan, Afton Fraser, Lucy & Wiley

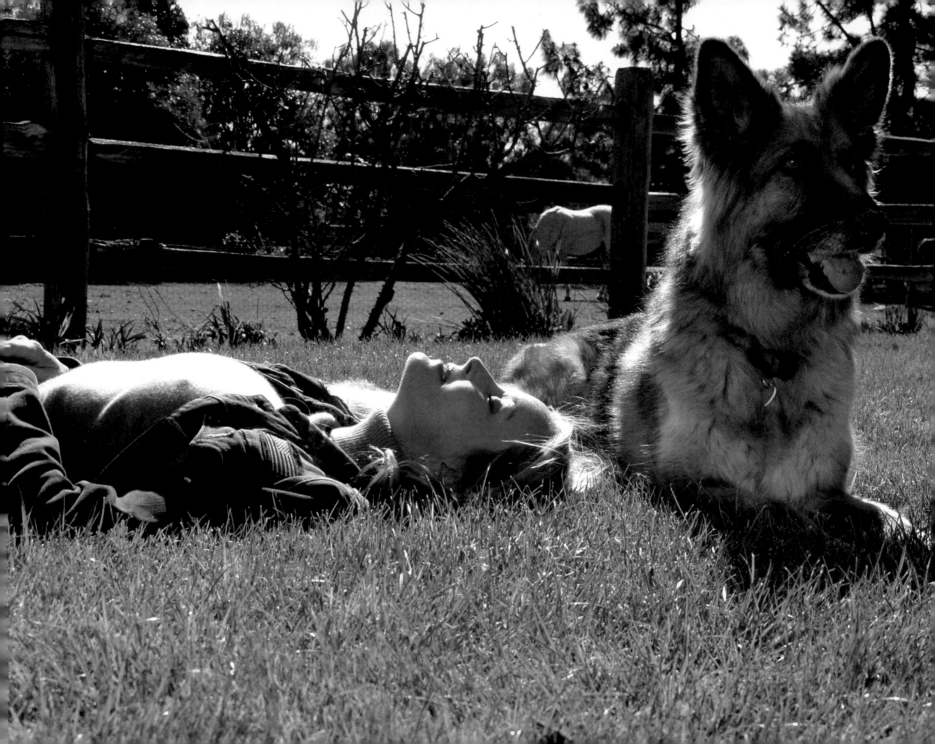

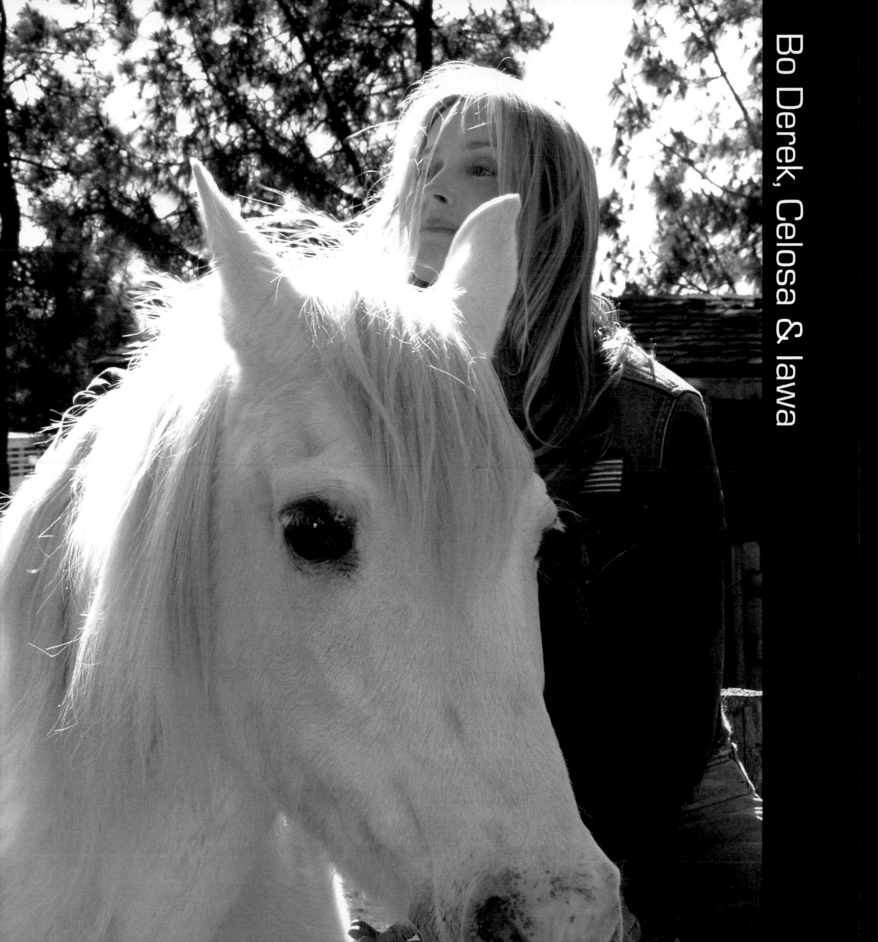

Bo Derek, Celosa & Iawa

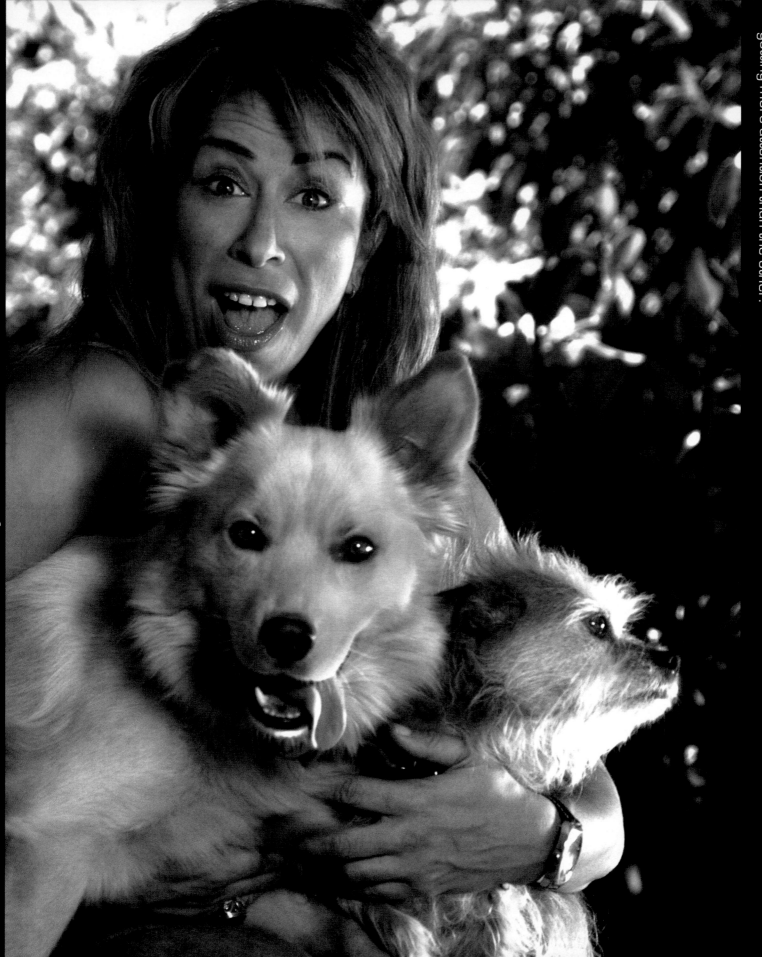

Roma Maffia, LuLu & lucky

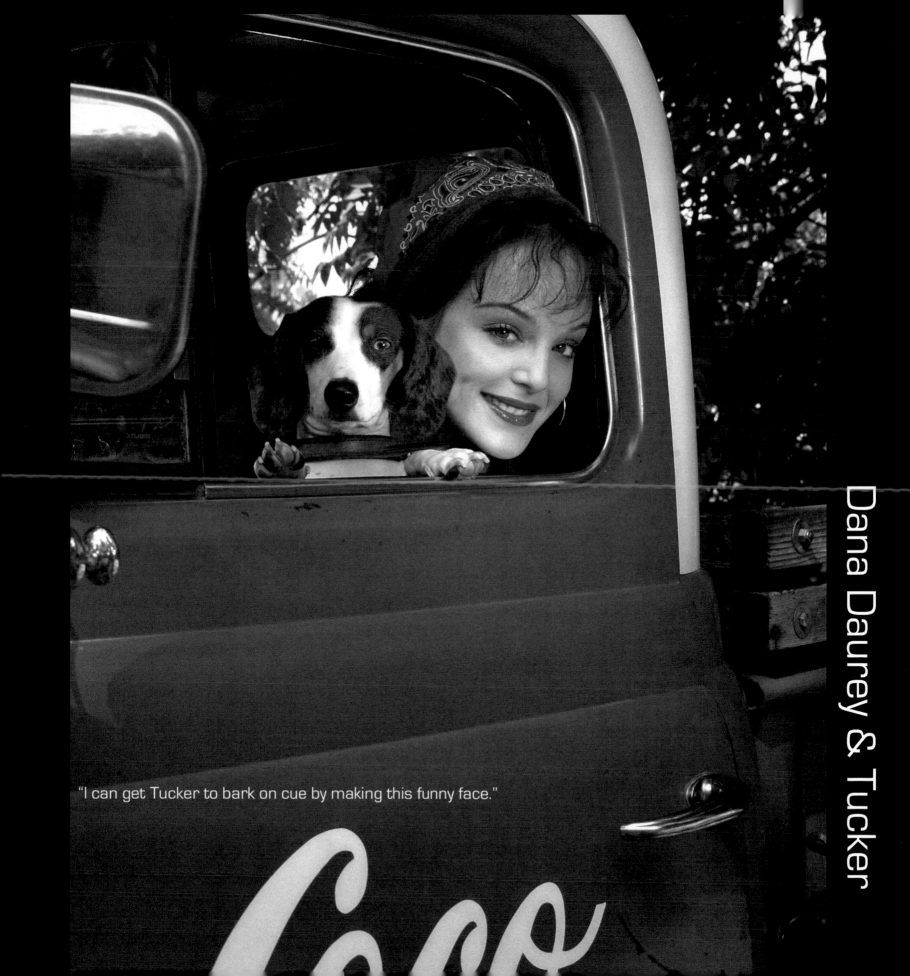

"I can get Tucker to bark on cue by making this funny face."

Dana Daurey & Tucker

I found her on a military base. She was just sitting next to her dad, who was locked up to a chain-linked fence. I picked her up and thought, 'Anybody who is stupid enough to leave a four-week-old puppy on the side of the road doesn't deserve to have her."

"So if you are reading this-I got her."

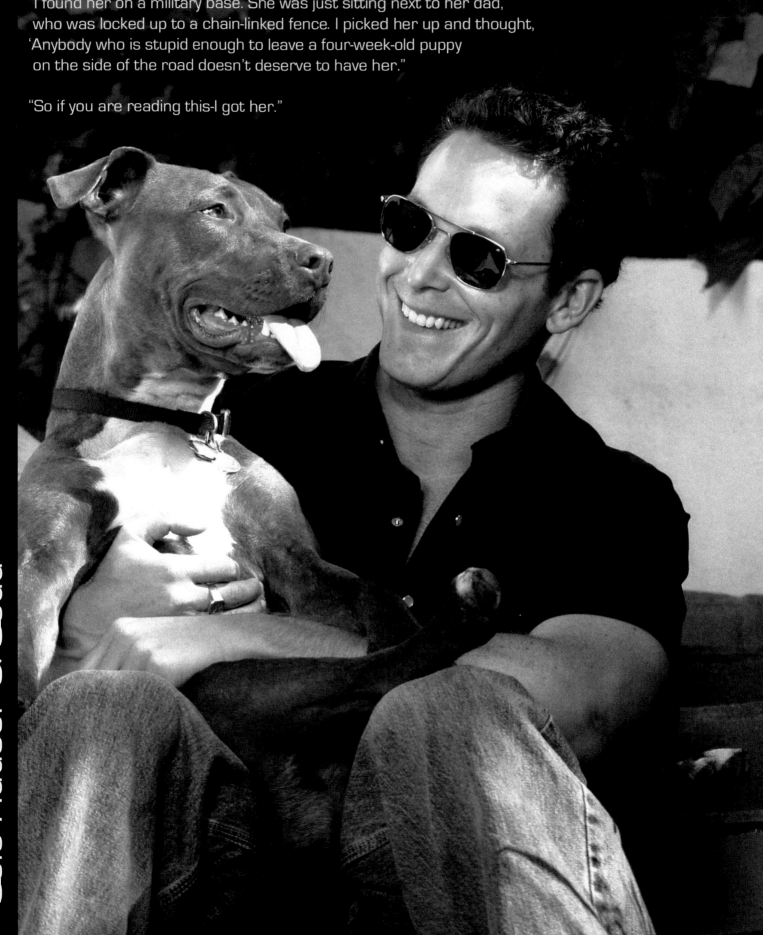

Cole Hauser & Coda

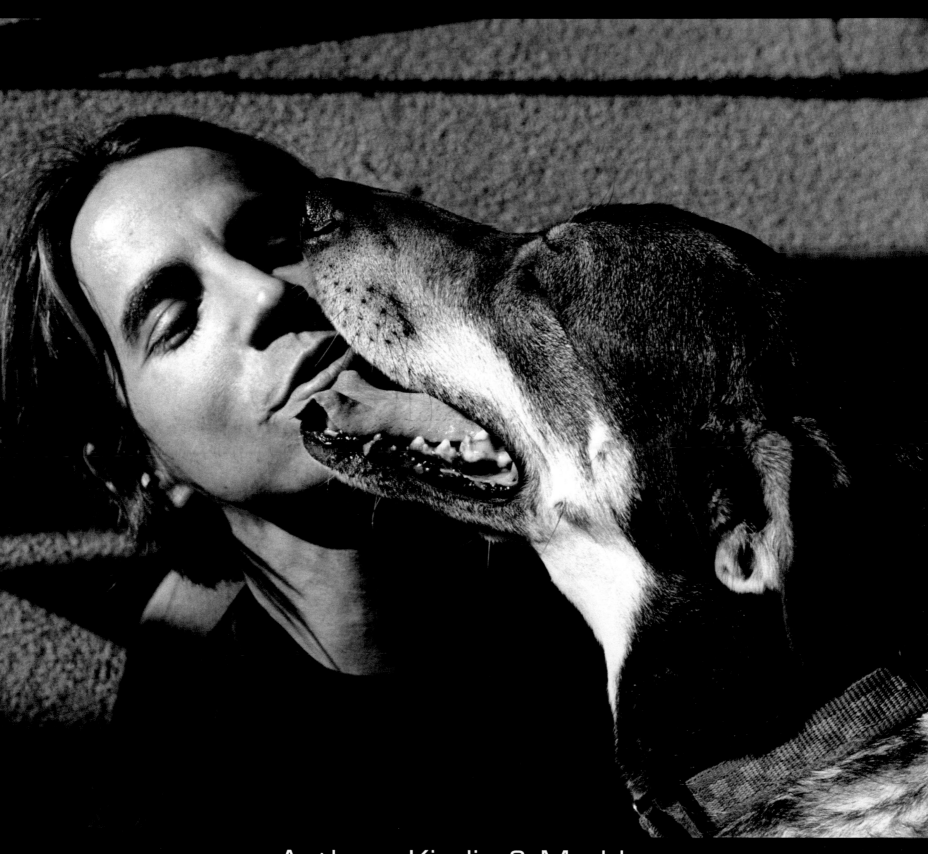

"He was filthy and soulful when I found him on the streets of Hollywood."

Anthony Kiedis & Muddy

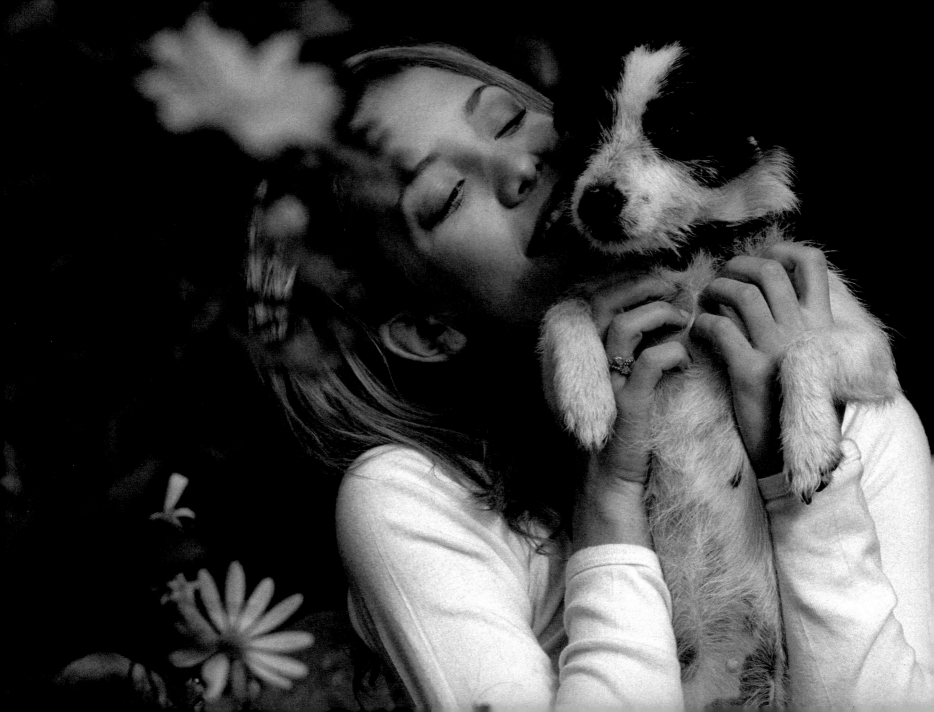

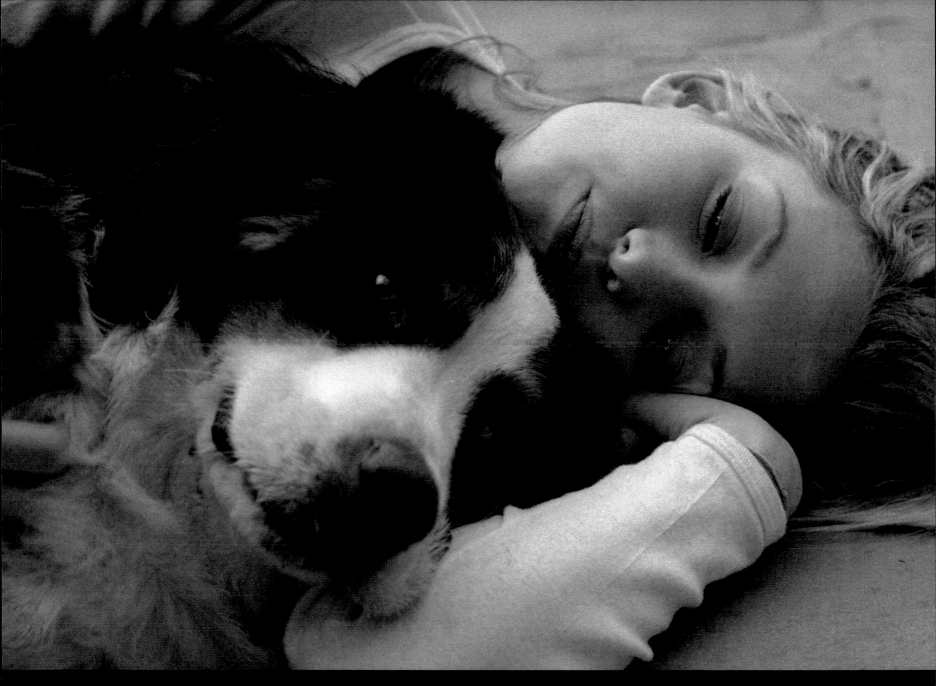

Kate Hudson, Nana & Snoopy

"My wife is married to a little kid. I haven't grown out of anything that I was into as a child."

Slash

Walter Wallingford
He's as clever as a puppy can be
Walter Wallingford
He's got a masters and a Ph.D.

He's got his own web site
Picasso did his collar
He's a mensa scholar

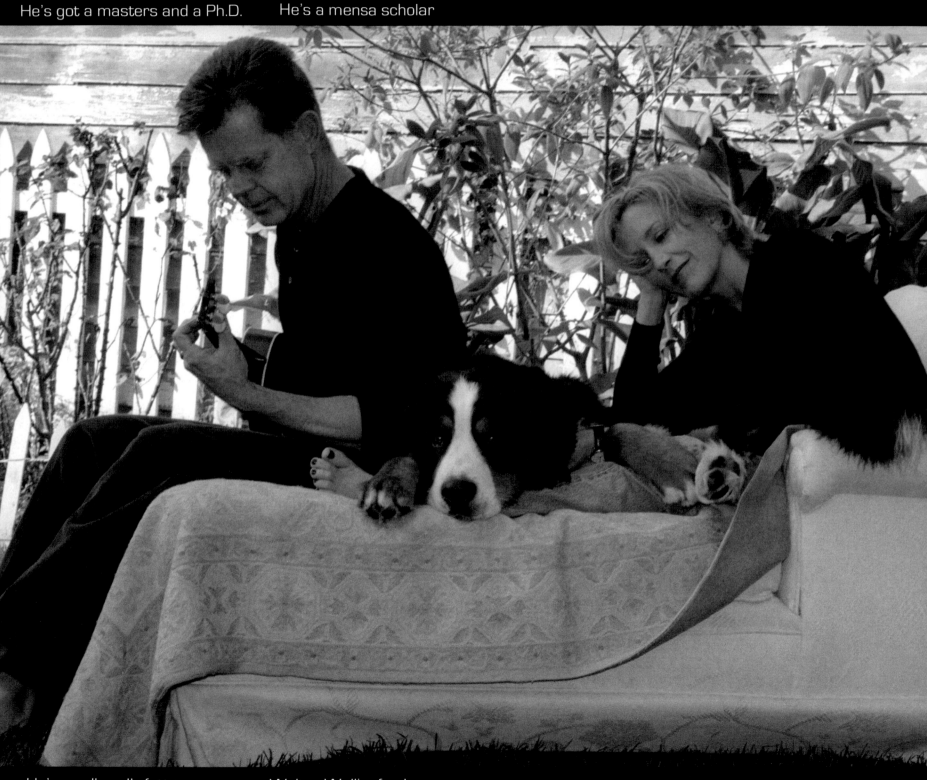

He's a rolly polly fatty
He's a cool dog daddy
Looking sharp in a coat and tail
He's never garrulous or trite

Walter Wallingford
He's got a scholarship to M.I.T.
Majoring in Algebra
With a minor in poop and pee

-W. Macy
-F. Huffman

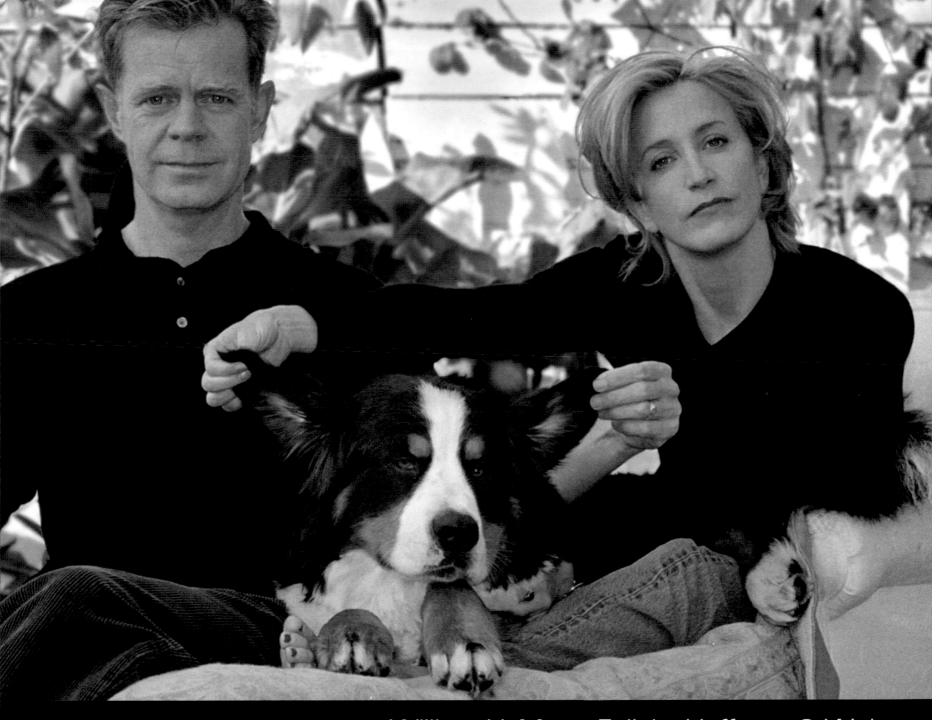

William H. Macy, Felicity Huffman & Walter

'Honey gets an attitude when she gets groomed because she knows she looks cute."

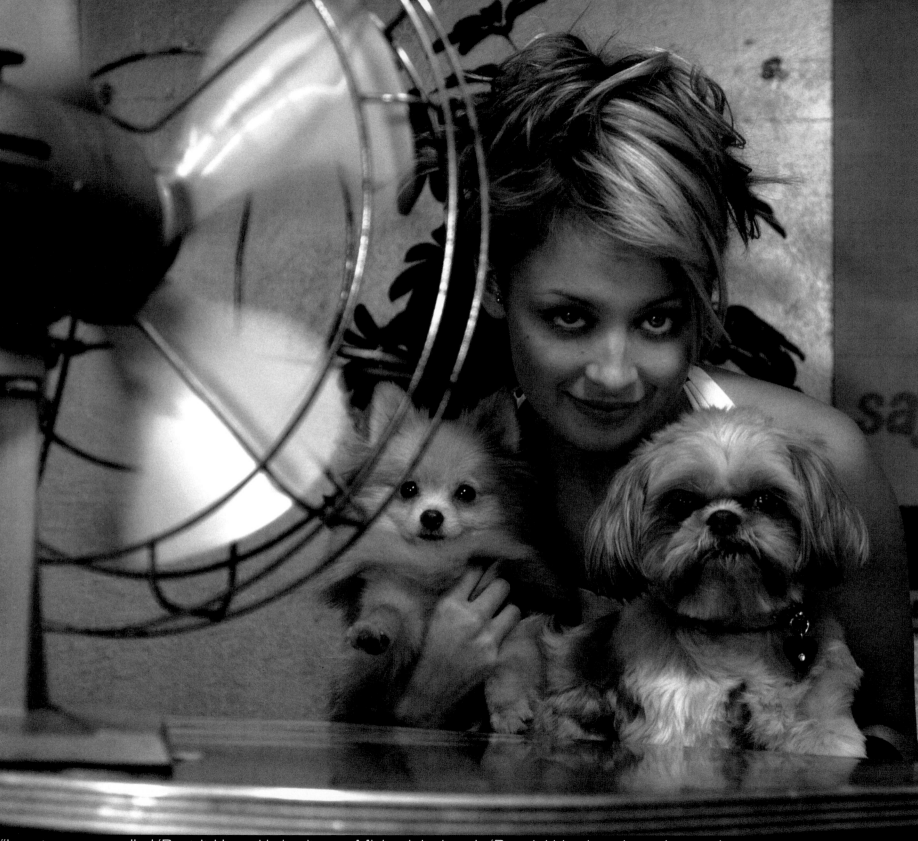

"I wrote a song called 'Beat It Honey' I sing it over Michael Jackson's 'Beat It.' It's about how she needs to pay rent. I always sing to my dogs."

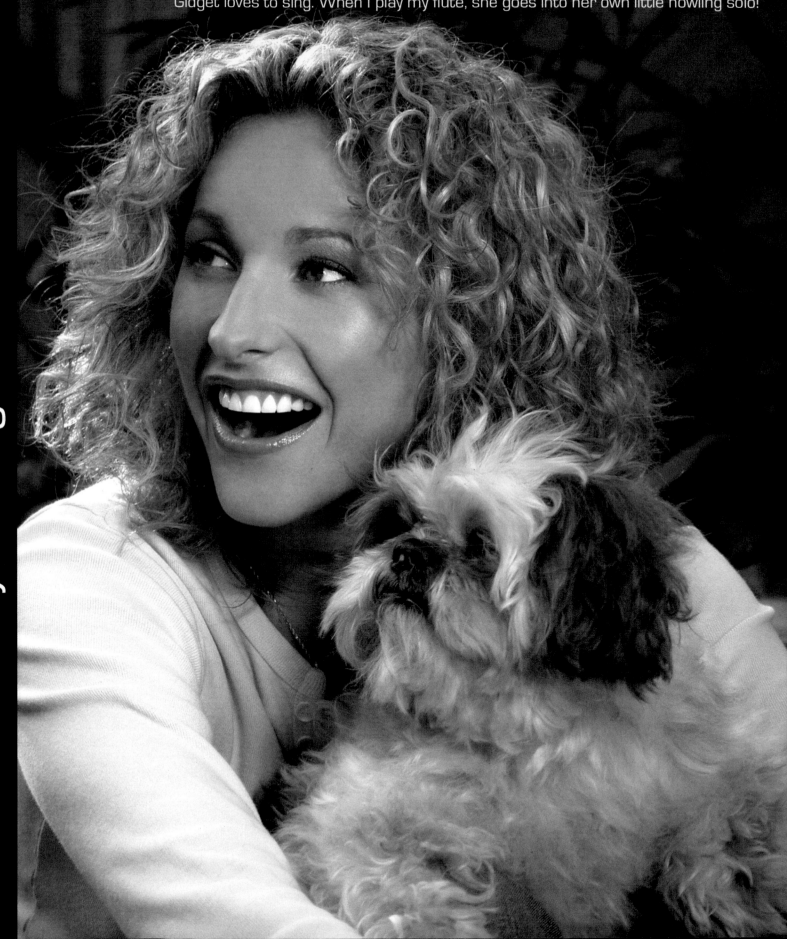

Gidget loves to sing. When I play my flute, she goes into her own little howling solo!

Jerri Manthey & Gidget

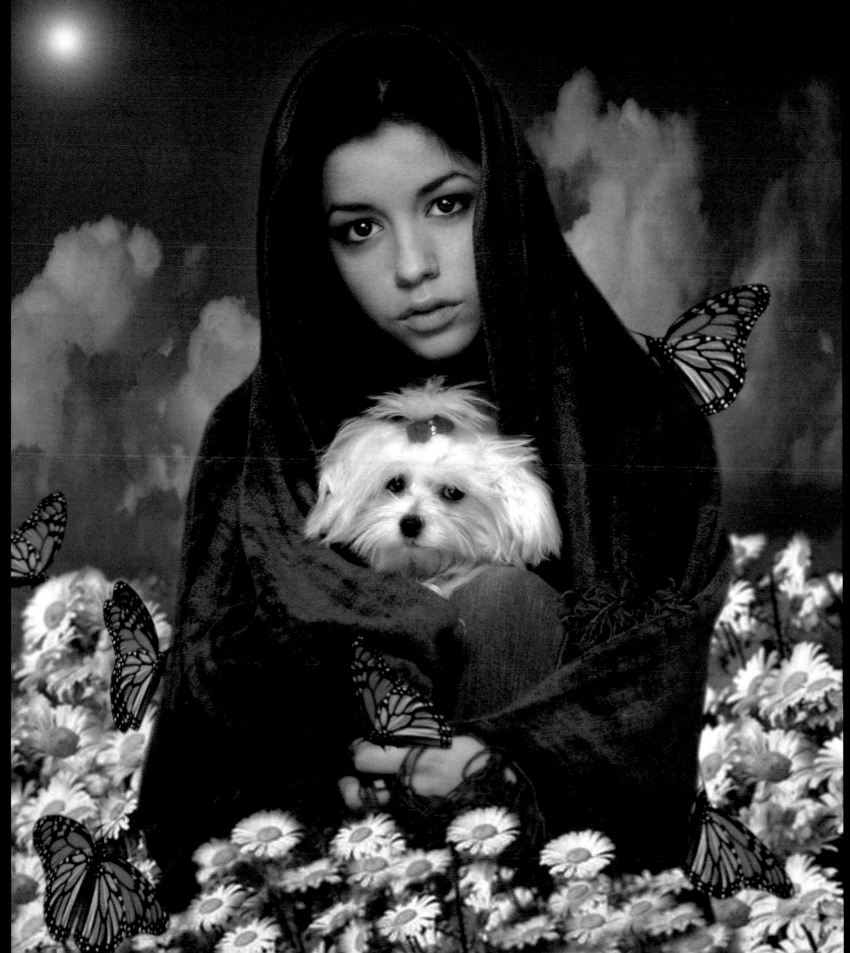

Masiela Lusha & Daisy

"Tucker is a very sweet, loving girl, but is also strong, tough and energetic!
She's the fastest dog I've ever seen.  Sometimes I think she may be part Greyhound!"

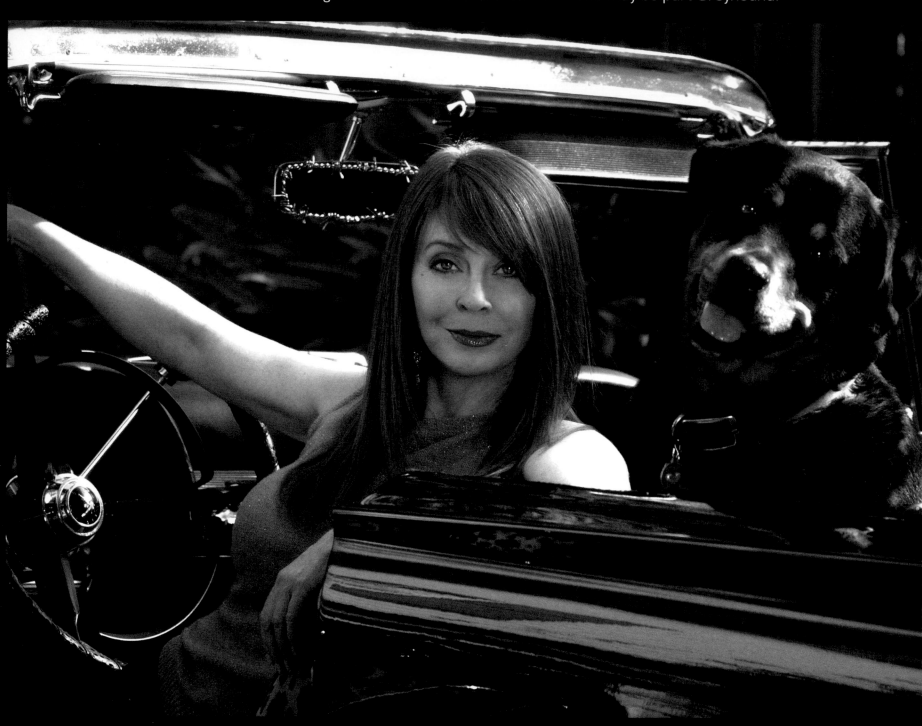

"I've been rescuing Rottweilers for 25 years.  Even though over the years I've rescued lots of other breeds
I keep coming back to Rotts.  I got Mina when she was just under a year old, from Rottweiler Rescue via
the pound. Now, she's a real loving and protective member of the family."

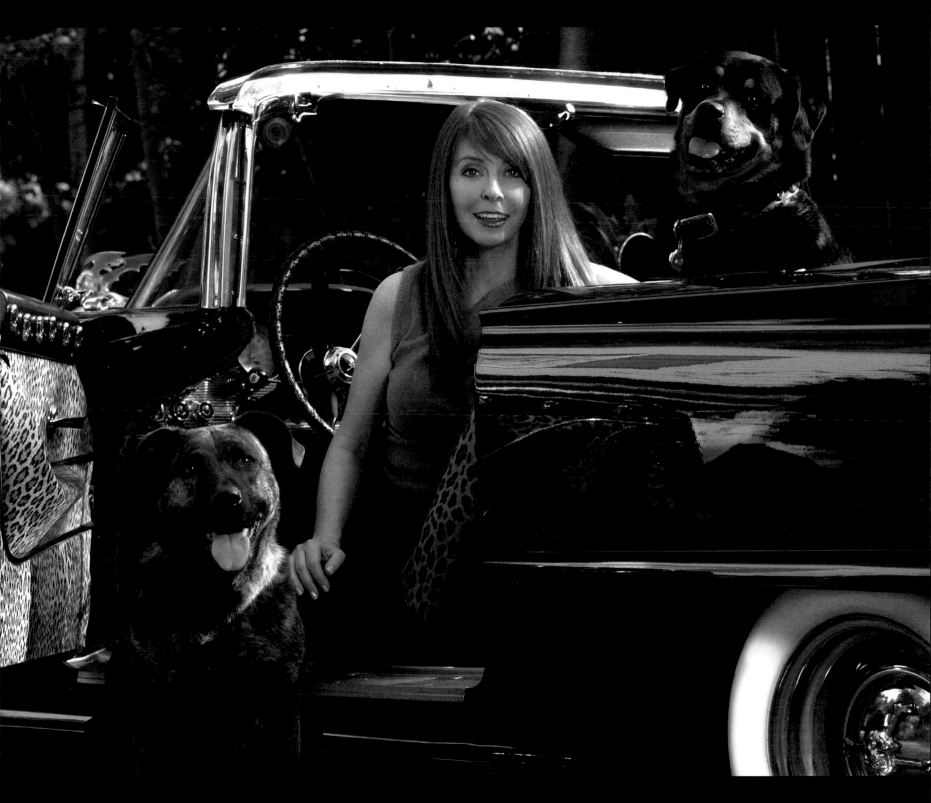

Cassandra Peterson, Tucker and Mina

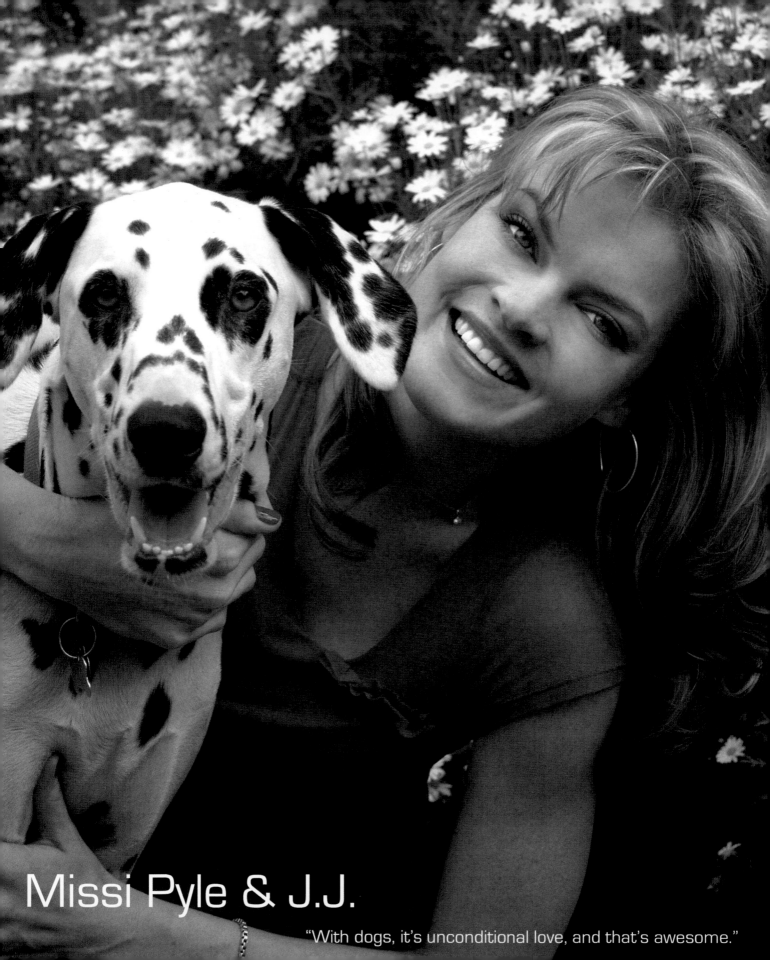

# Missi Pyle & J.J.

"With dogs, it's unconditional love, and that's awesome."

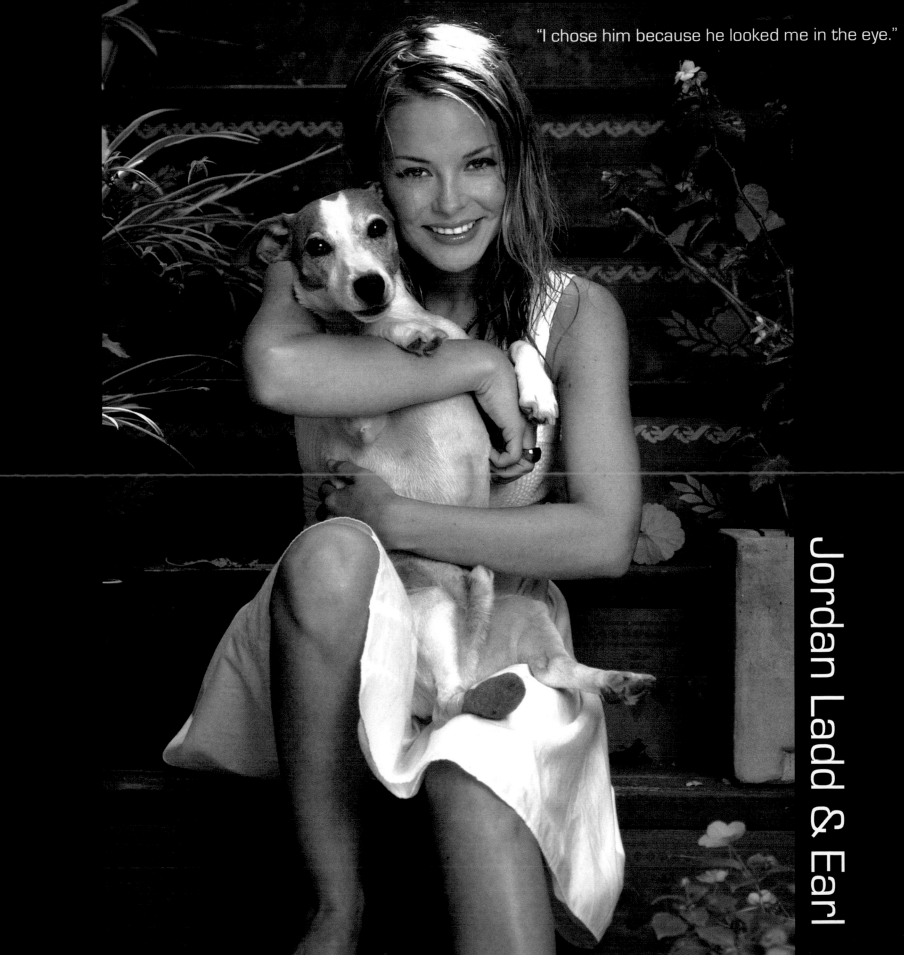

"I chose him because he looked me in the eye."

Jordan Ladd & Earl

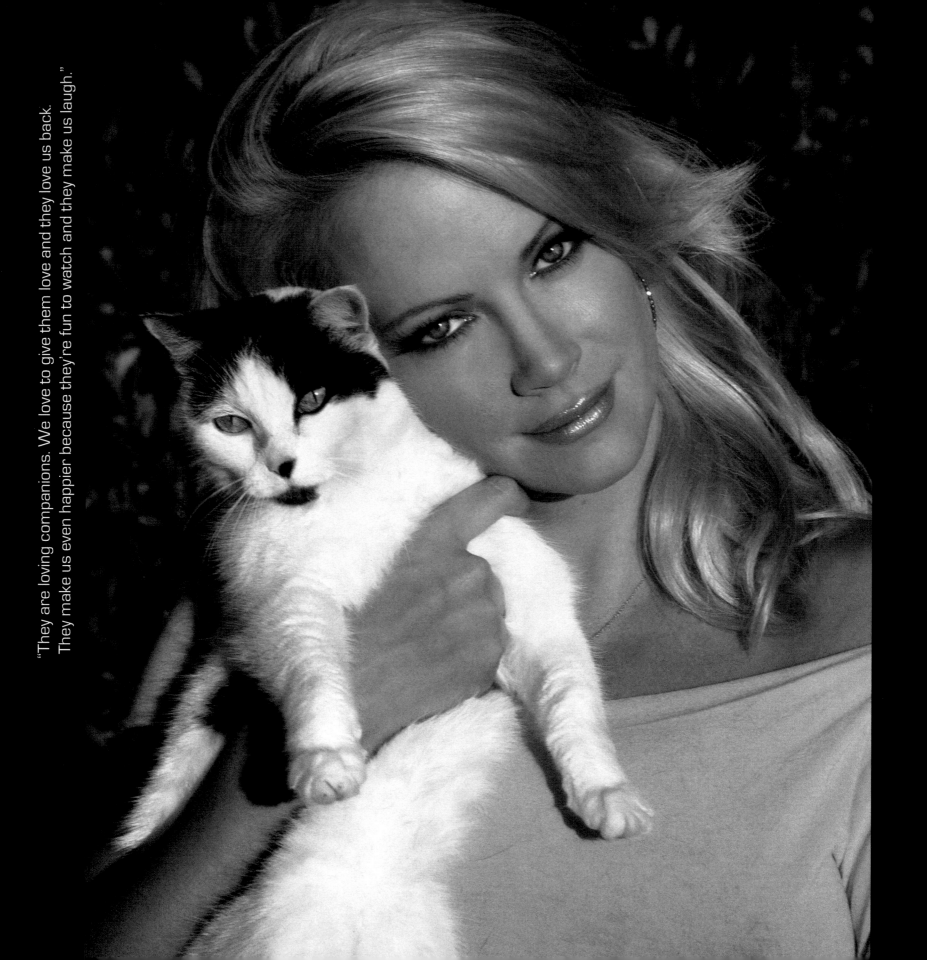

"They are loving companions. We love to give them love and they love us back. They make us even happier because they're fun to watch and they make us laugh."

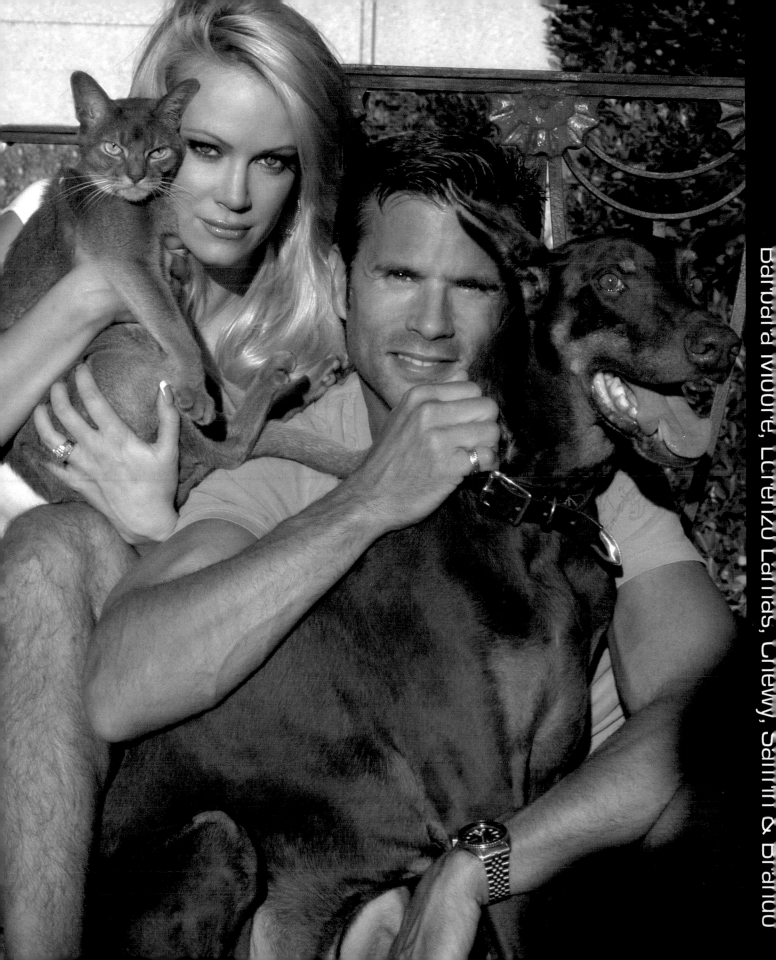

Barbara Moore, Lorenzo Lamas, Chewy, Samm & Brando

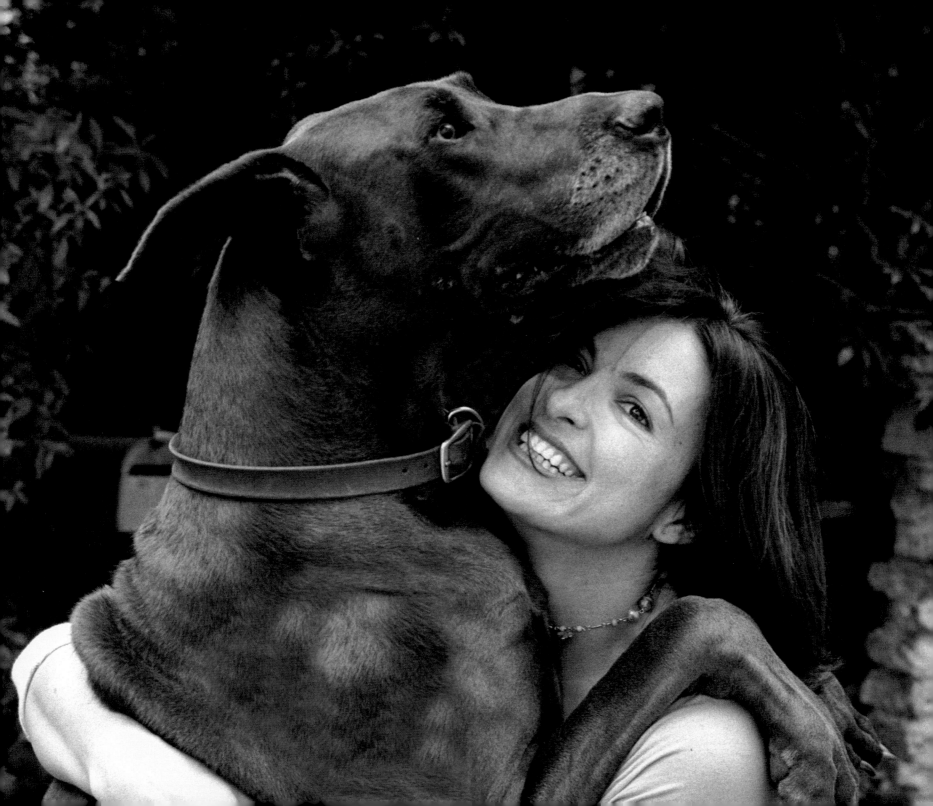

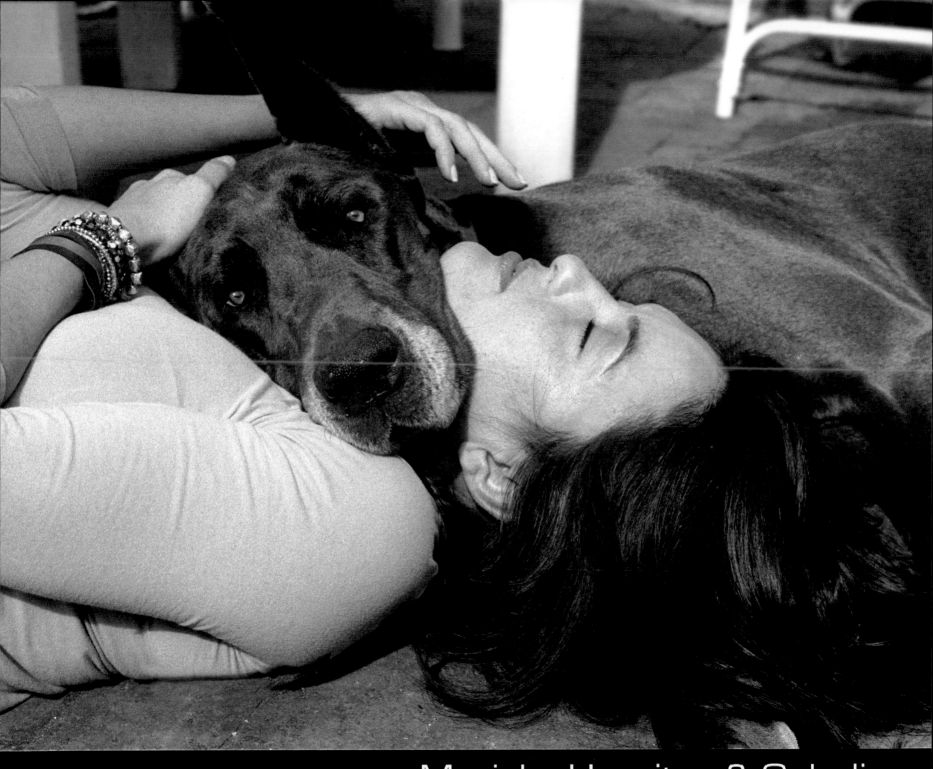

Mariska Hargitay & Ophelia

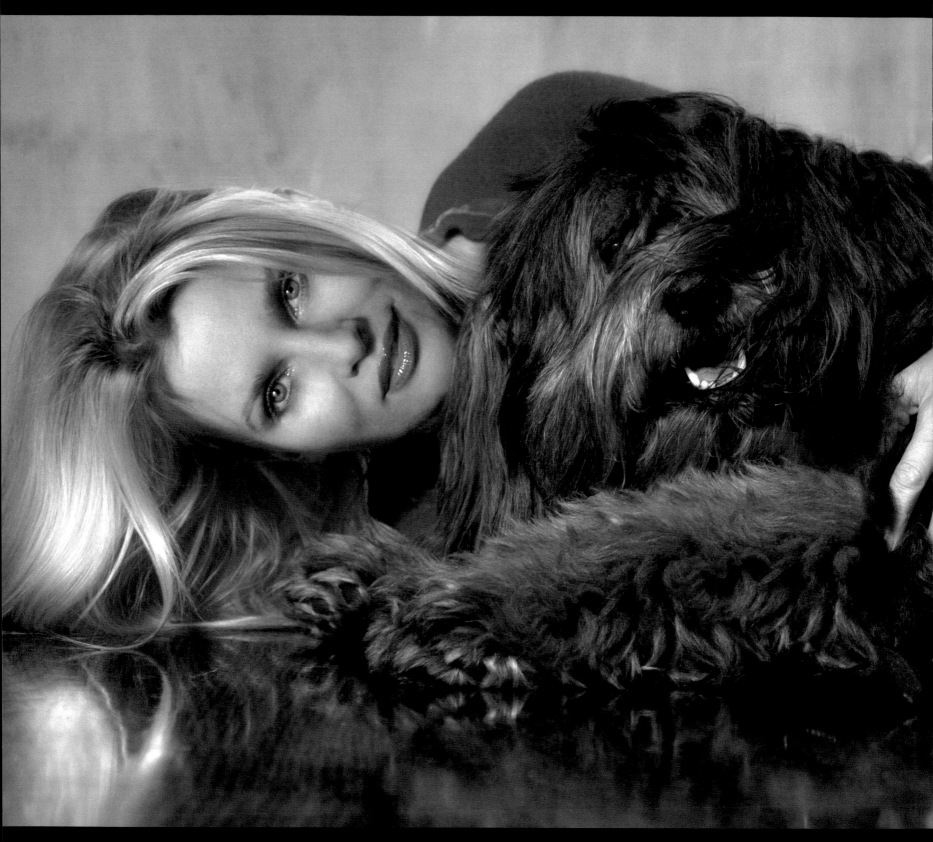

"She is so lovable. As soon as you meet her you fall in love with her. She is the kindest, cuddliest dog."

"Fatty is my best friend and the sweetest dog."

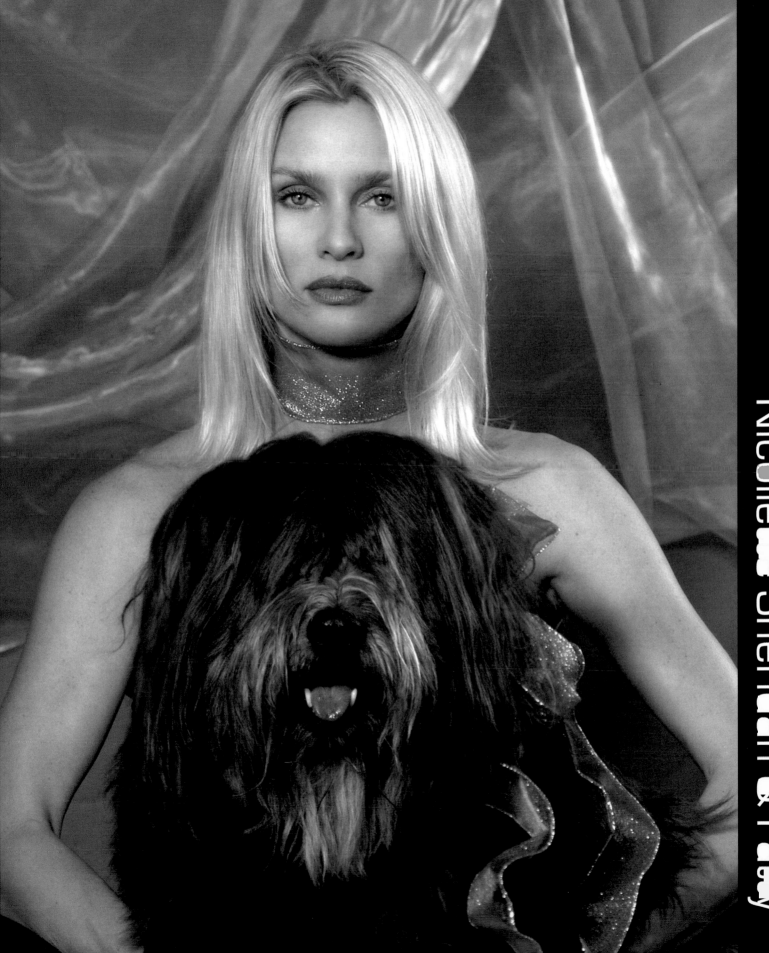

Nicolletta Sheridan & Fatty

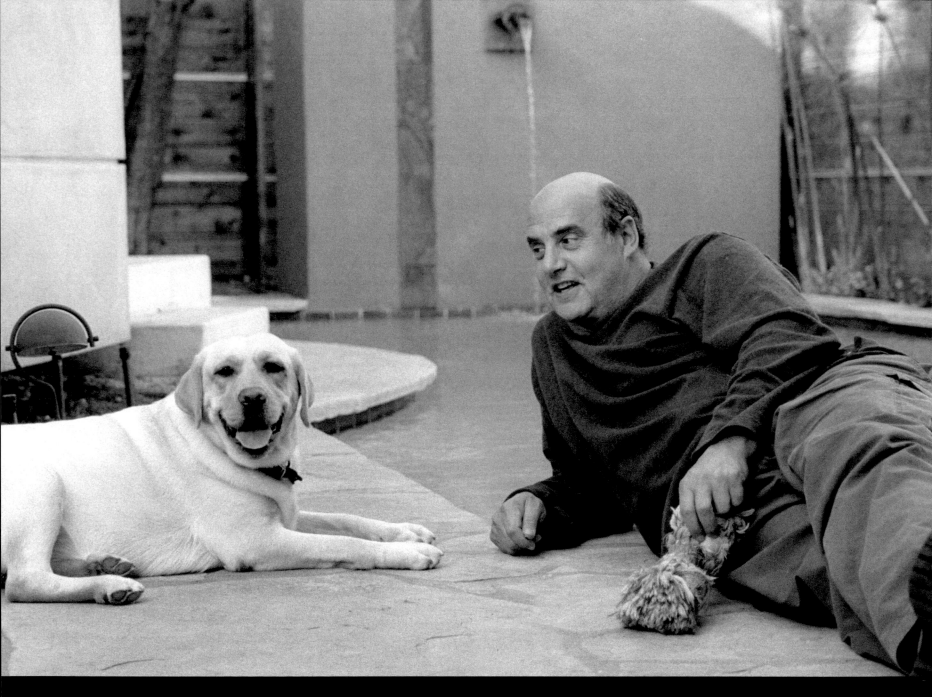

"She is my good friend."

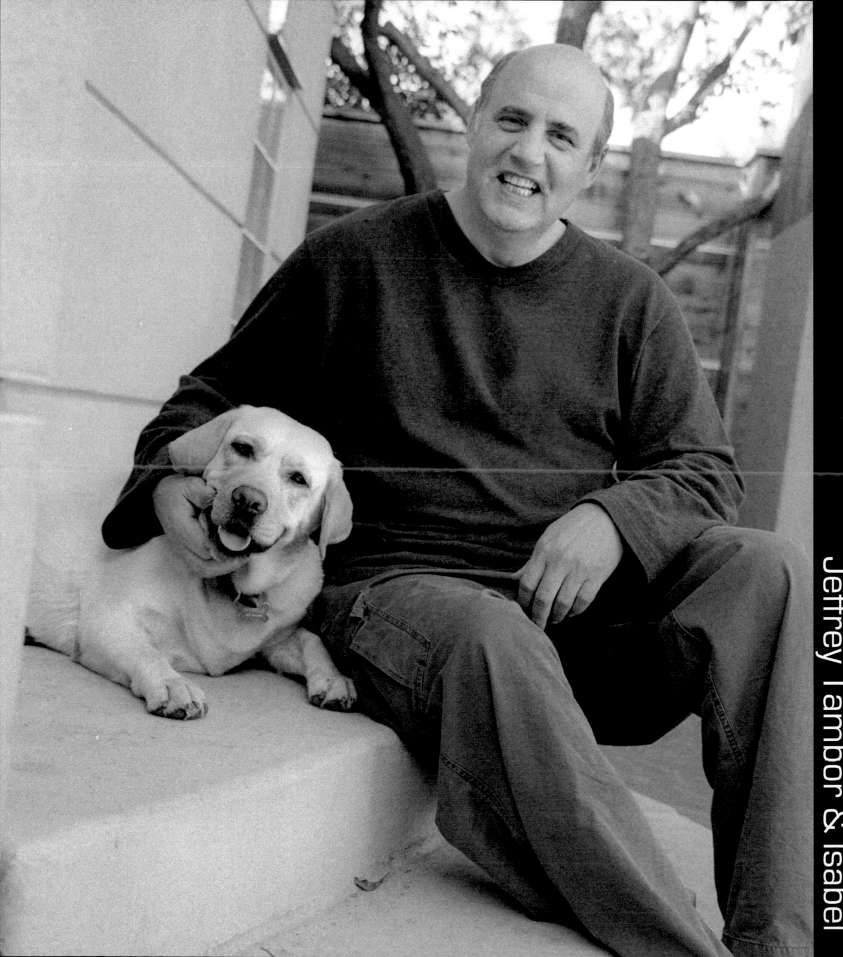

Jeffrey Tambor & Isabel

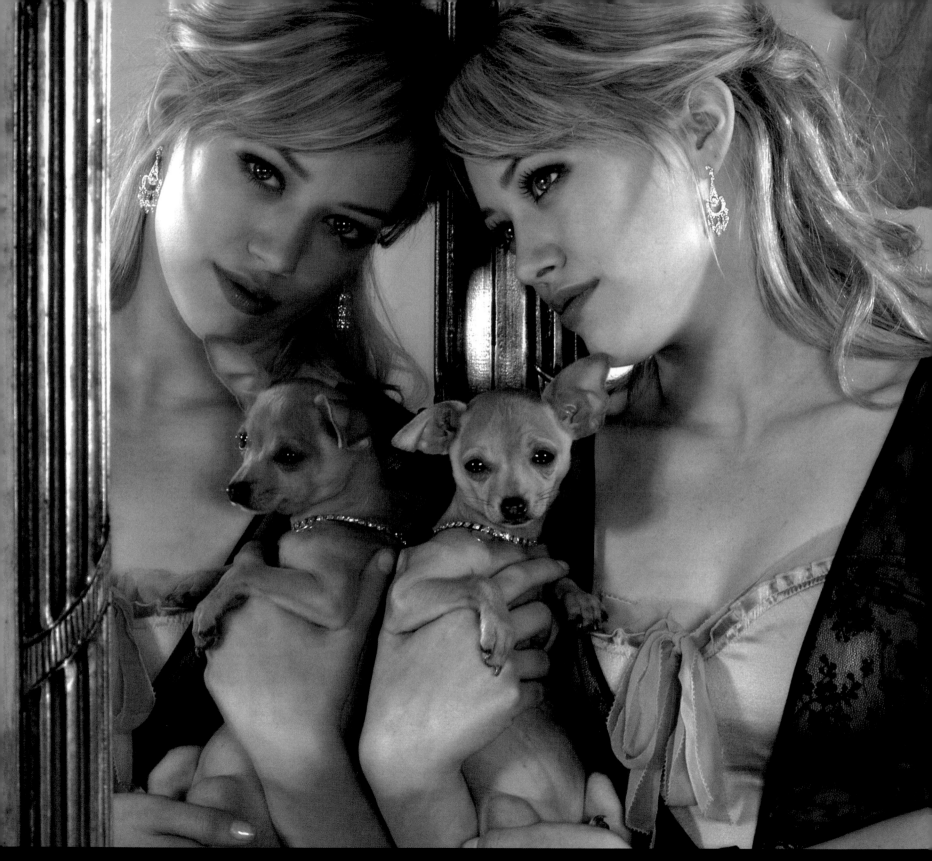

"I think Lola has my personality because she is a little bratty sometimes and she is really hyper.
I think dogs' personalities really do match their owners."

"They just bring so much happiness and unconditional love. I know I have a best friend waiting for me at home."

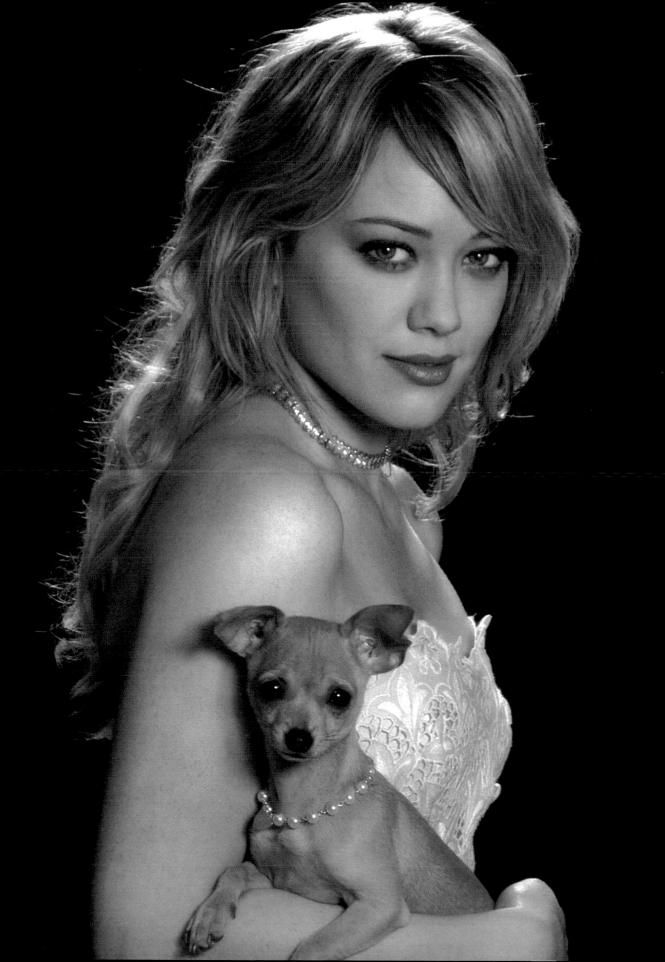

Hilary Duff & Lola

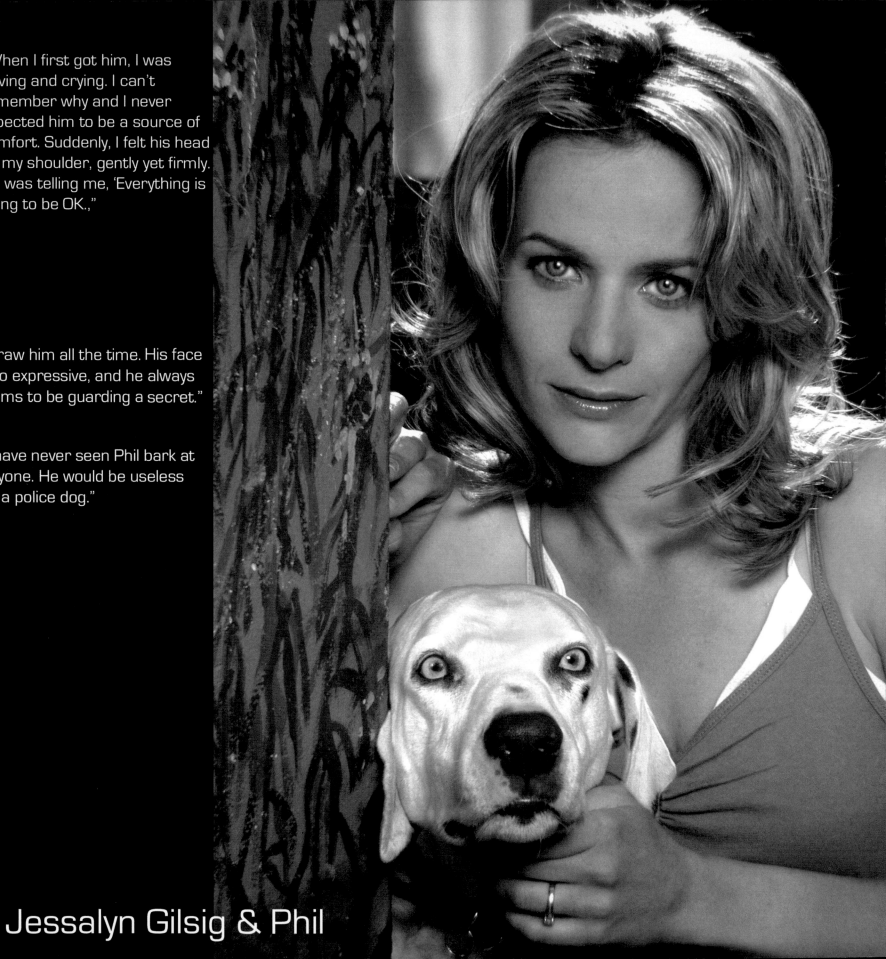

"When I first got him, I was driving and crying. I can't remember why and I never expected him to be a source of comfort. Suddenly, I felt his head on my shoulder, gently yet firmly. He was telling me, 'Everything is going to be OK.,'"

"I draw him all the time. His face is so expressive, and he always seems to be guarding a secret."

"I have never seen Phil bark at anyone. He would be useless as a police dog."

Jessalyn Gilsig & Phil

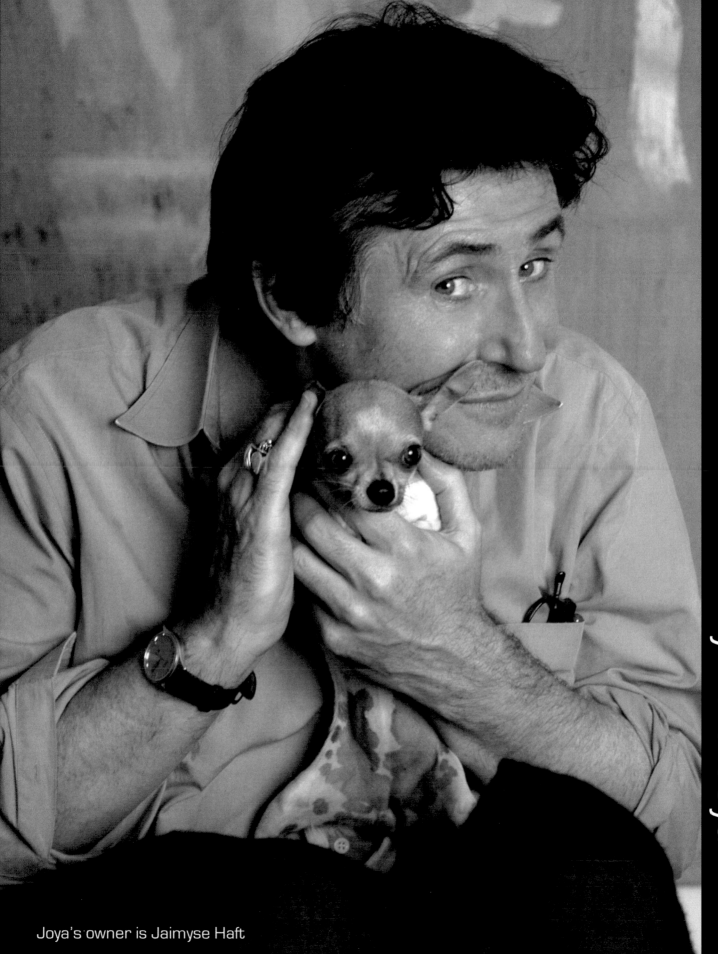

Gabriel Byrne & Joya

Joya's owner is Jaimyse Haft

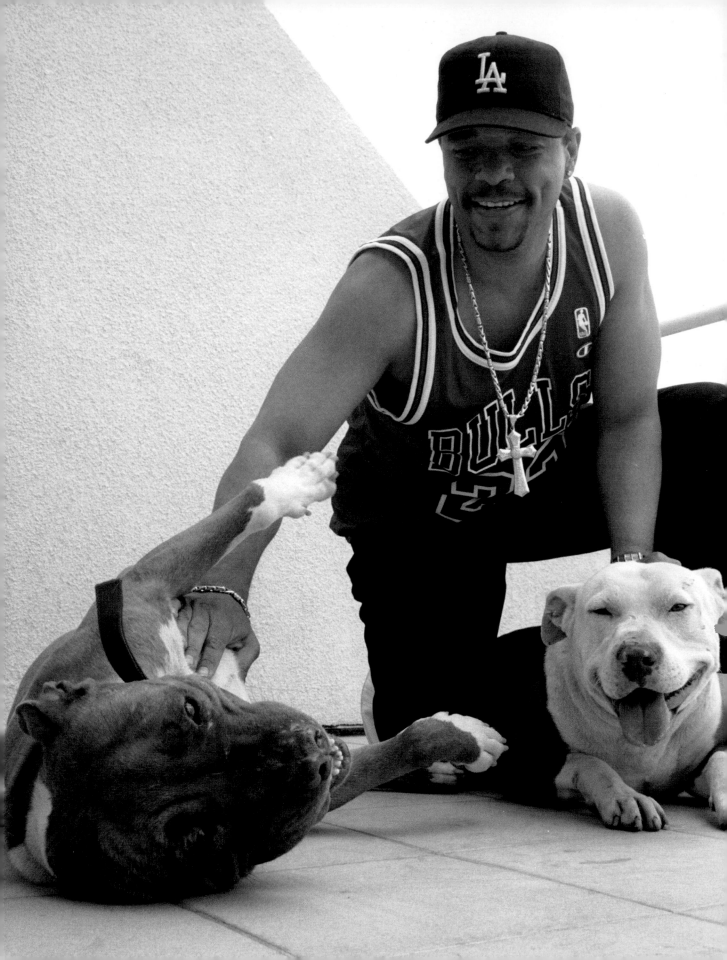

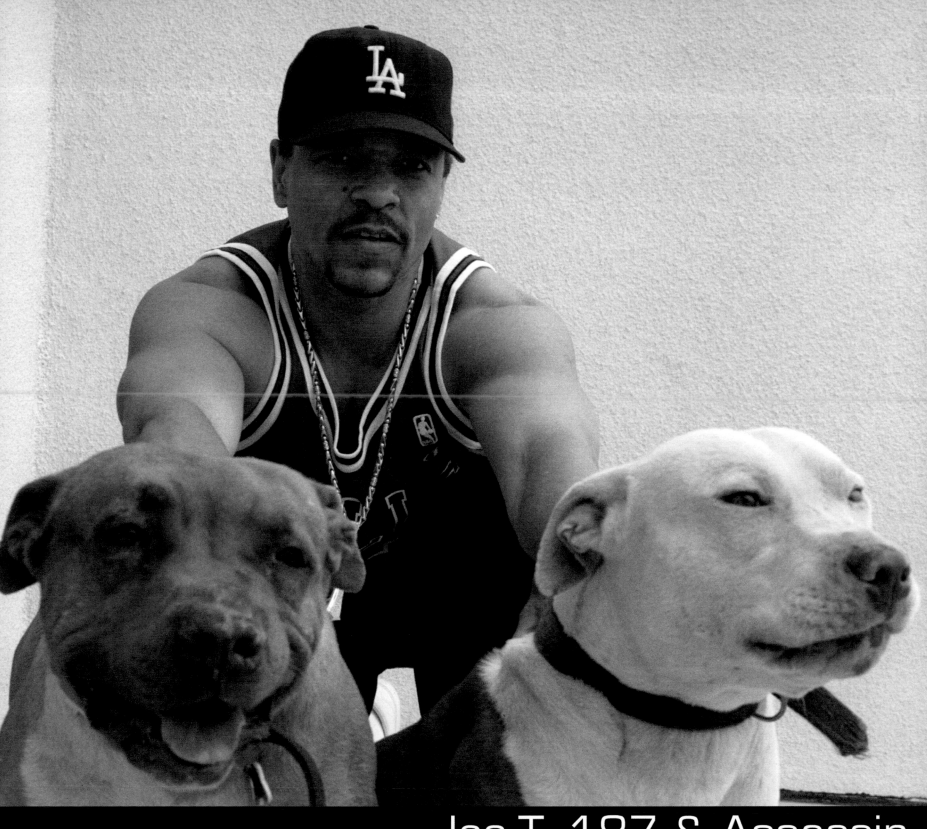

Ice-T, 187 & Assassin

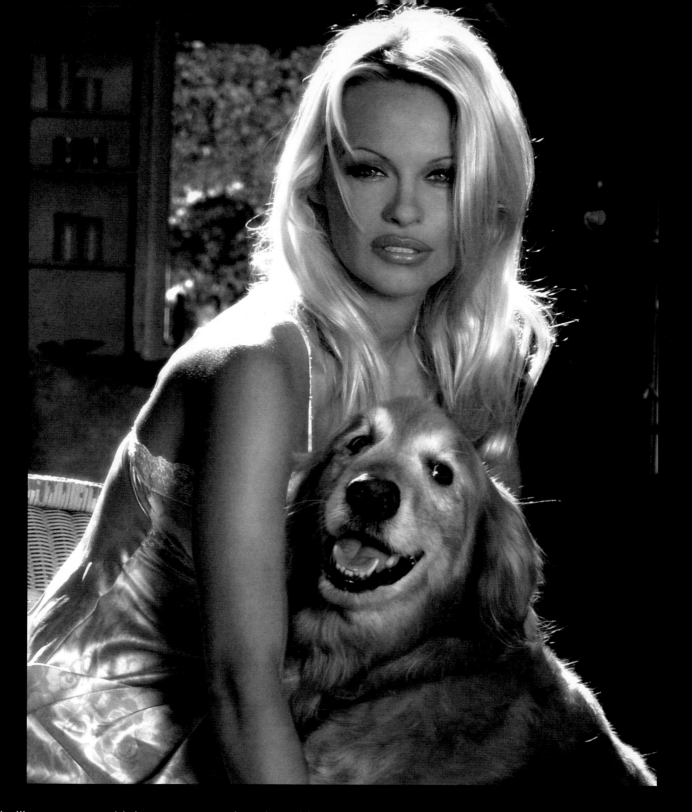

"He's like a person. He's my partner in crime. He's been with me longer than anybody. I look at Star and I can see my whole life pass before me, I can remember when he was 3 months 6 months...and whatever I was doing in my career I can kind of judge from the pictures and the memories that I have with Star. He's been through everything with me. I'm very fortunate that he's still with me."

Pamela Anderson, Peanut & Star

"My passion for animal rights activism
wasn't some trendy blip on my celebrity radar."

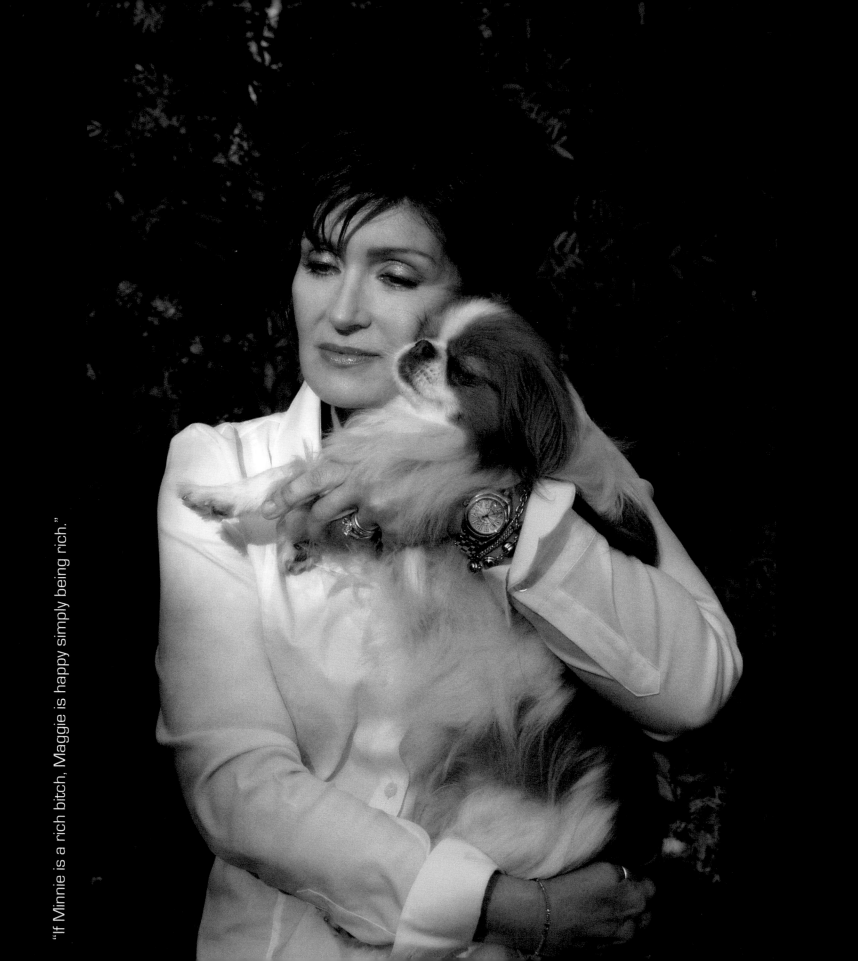

"If Minnie is a rich bitch, Maggie is happy simply being rich."

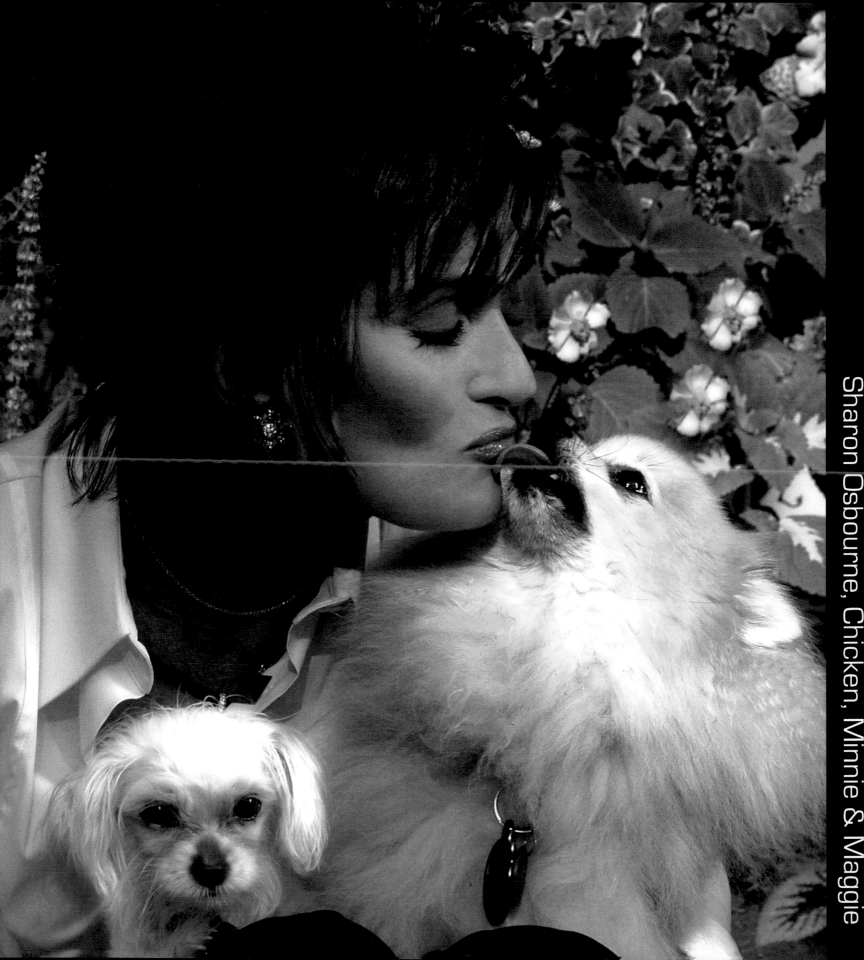

Sharon Osbourne, Chicken, Minnie & Maggie

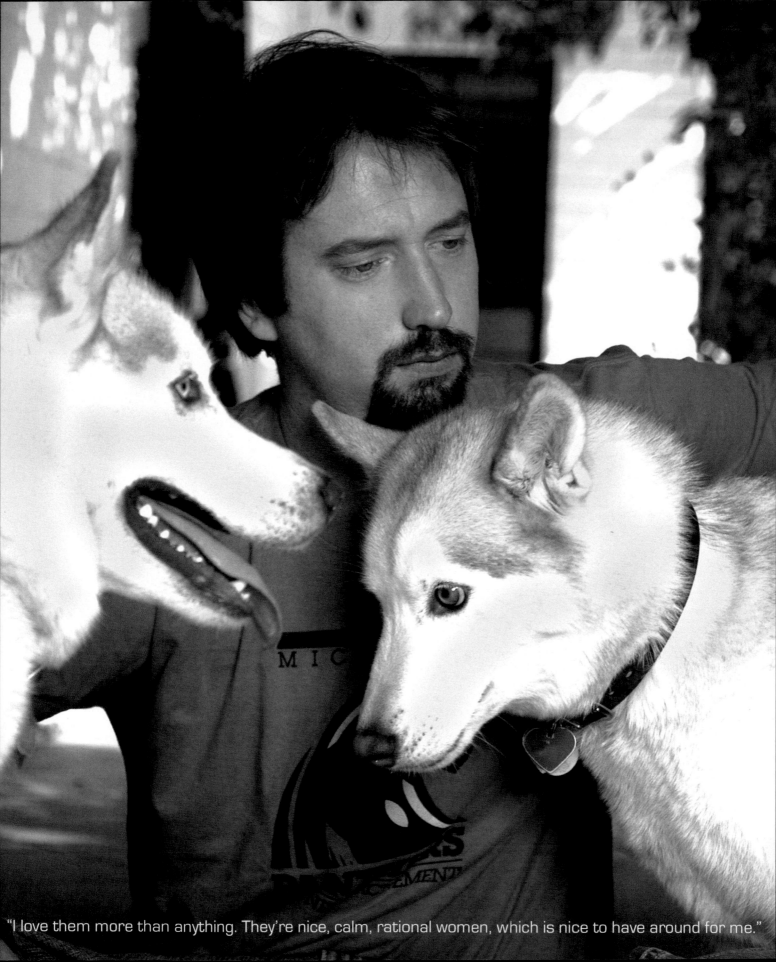
"I love them more than anything. They're nice, calm, rational women, which is nice to have around for me."

Tom Green, Steve & Annie

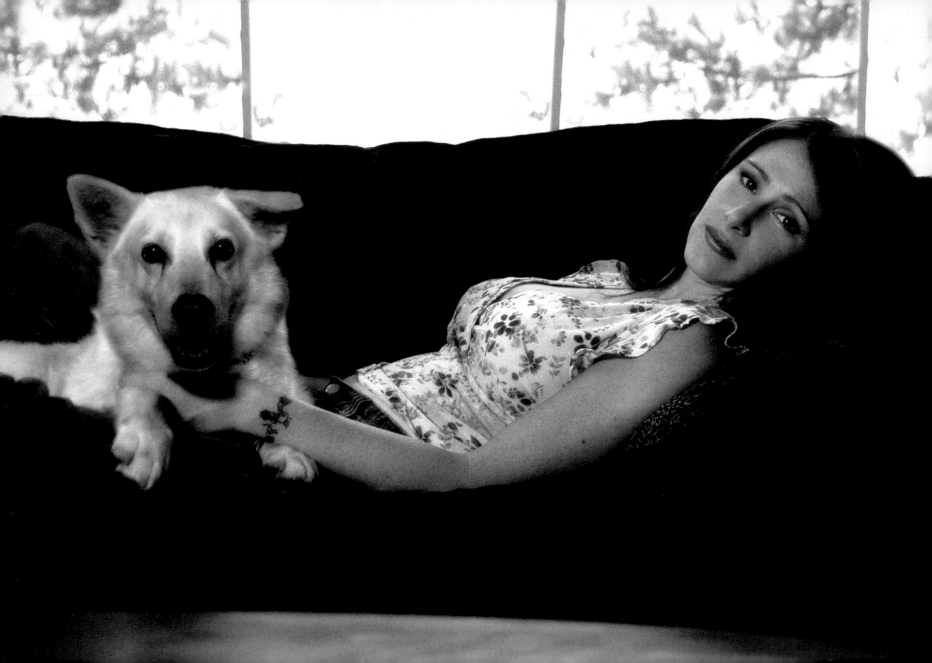

Tiffany & Fender

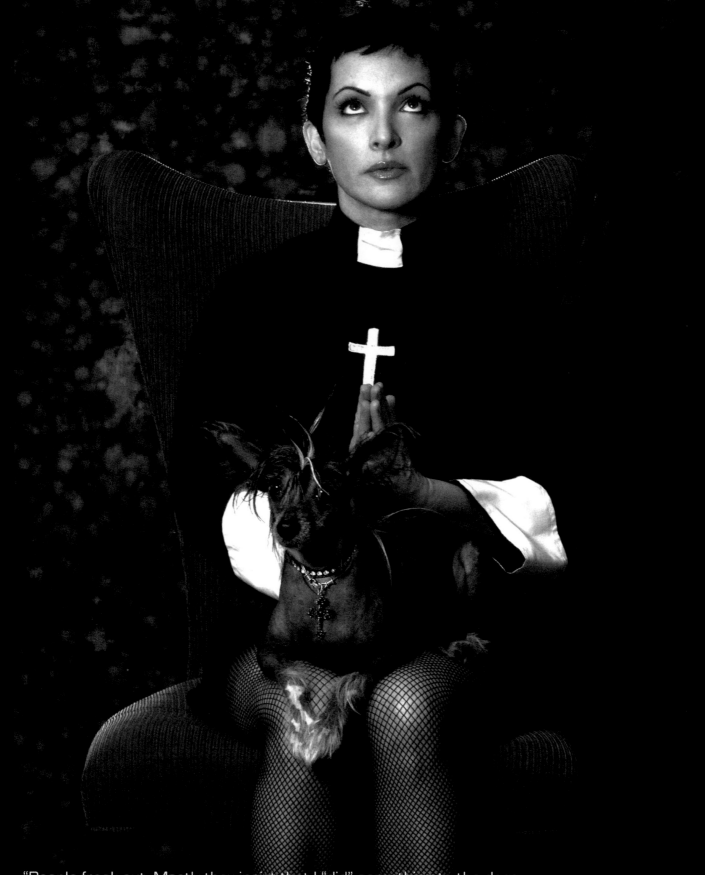

"People freak out. Mostly they insist that I "did" something to the dogs.
When I explain that their look is completely natural, they rarely believe me,
but of course it is true."

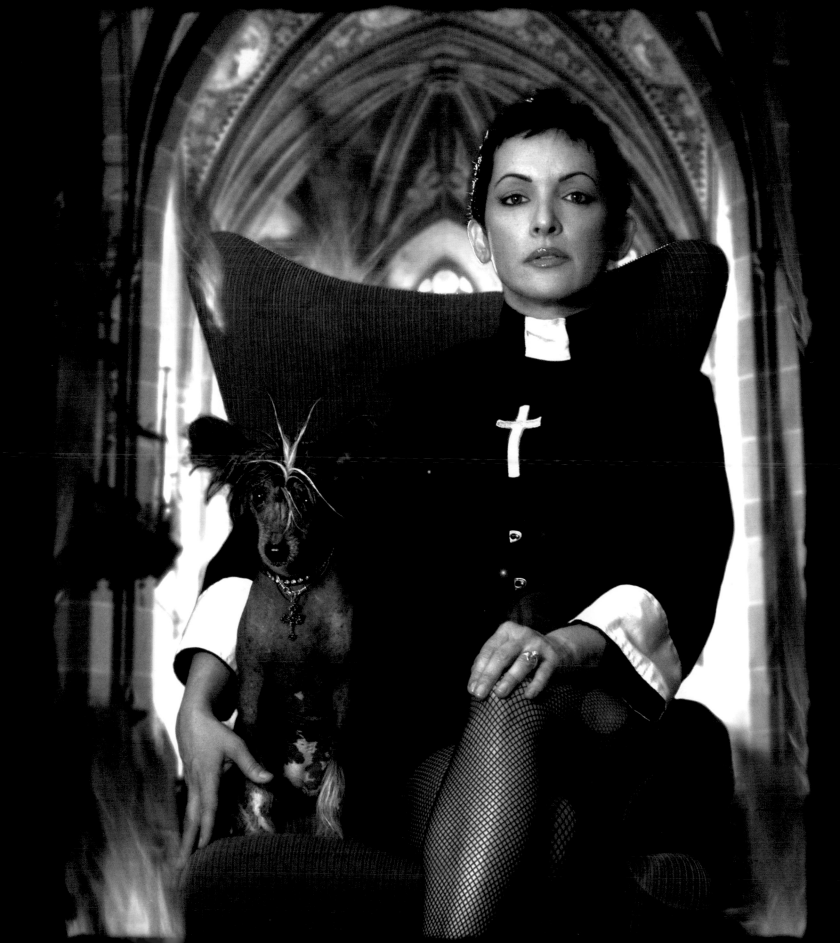

Jane Wiedlin & Orbit

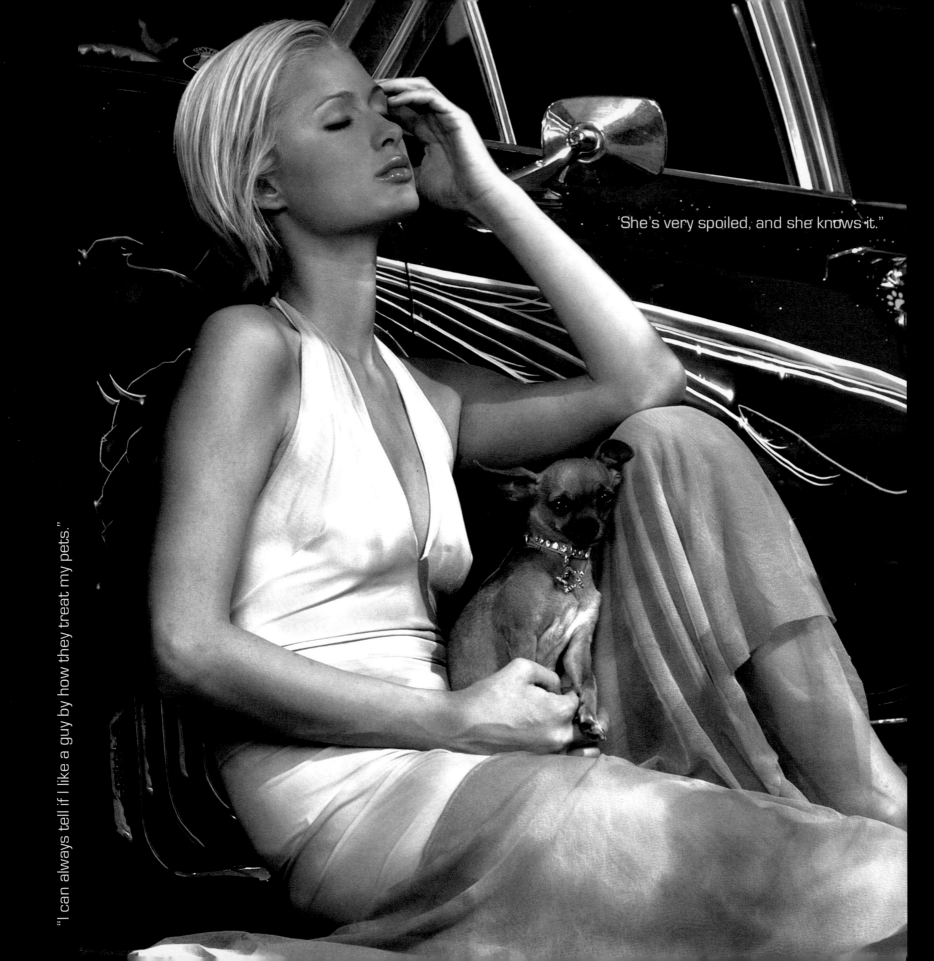

"I can always tell if I like a guy by how they treat my pets."

'She's very spoiled, and she knows it."

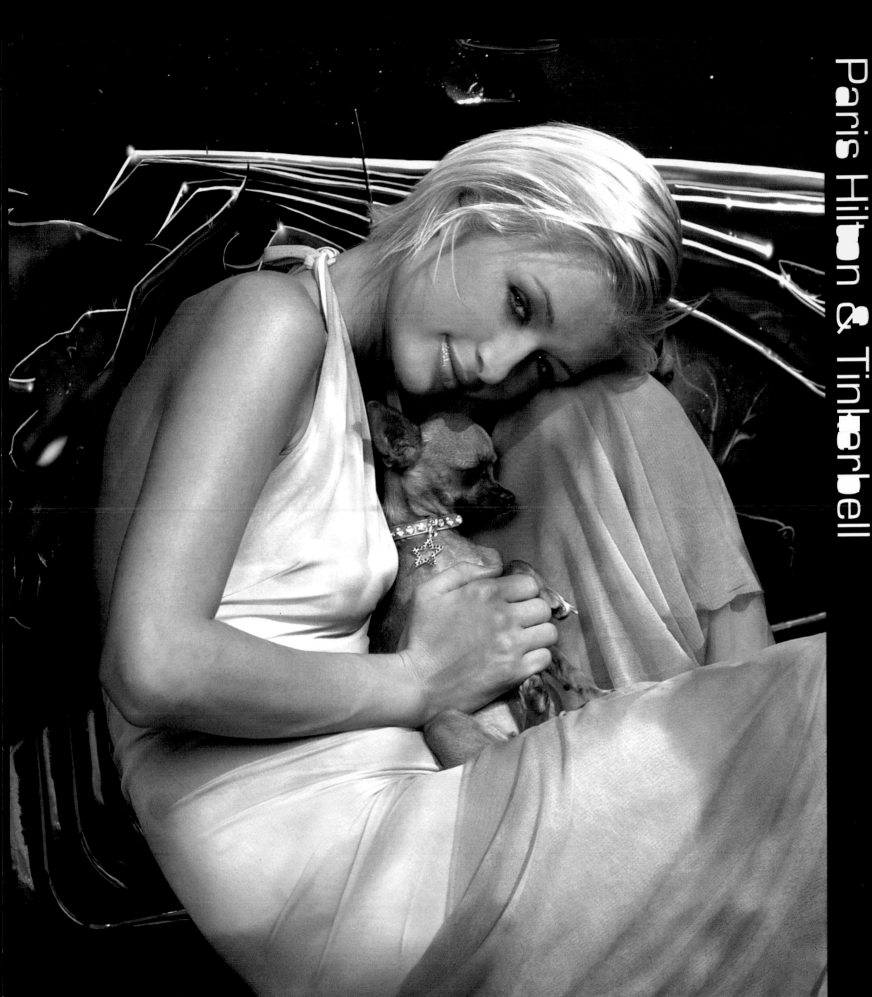

Paris Hilton & Tinkerbell

Corey Feldman & Jake

They're my children. I think about them constantly. If I have to go away it's torture for me.

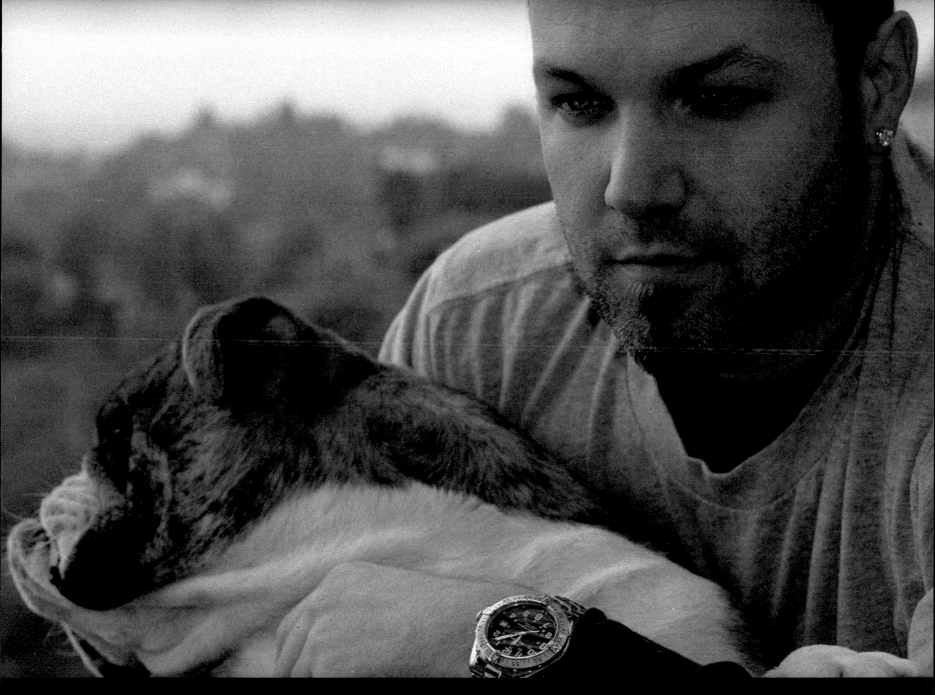
Fred Durst & Biskit

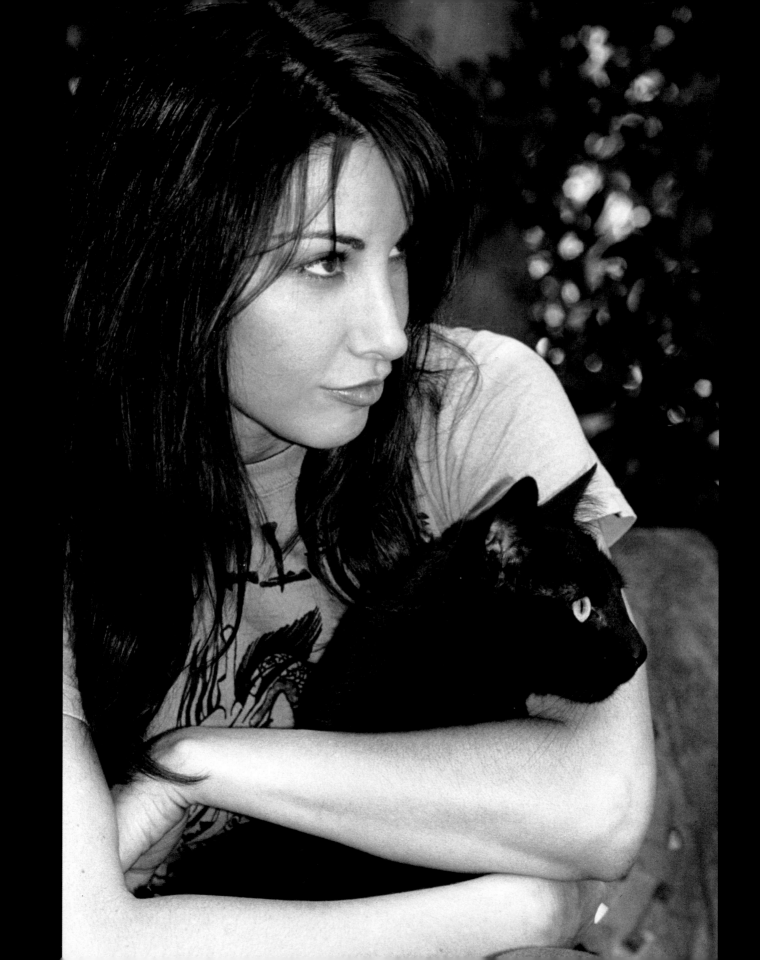

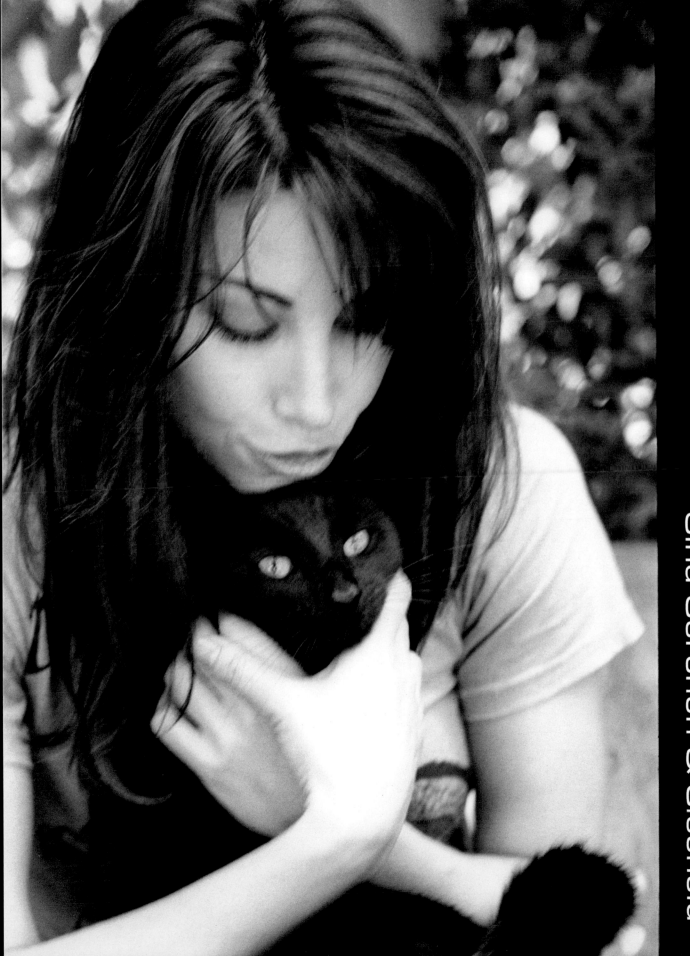

Gina Gershon & Cleohold

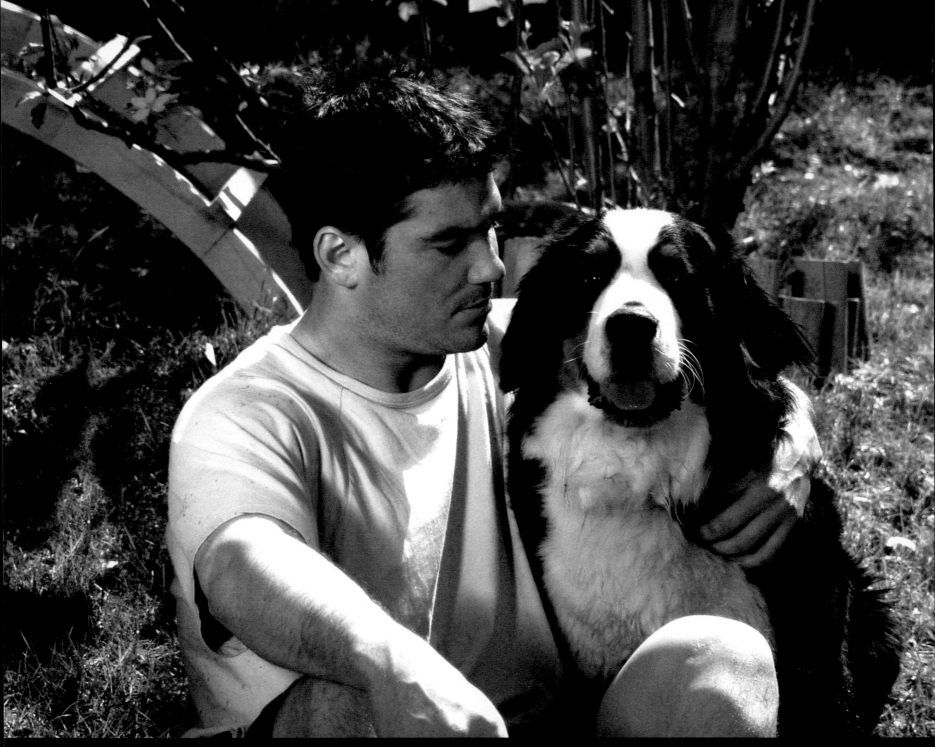
"I would never date a woman who didn't like dogs."

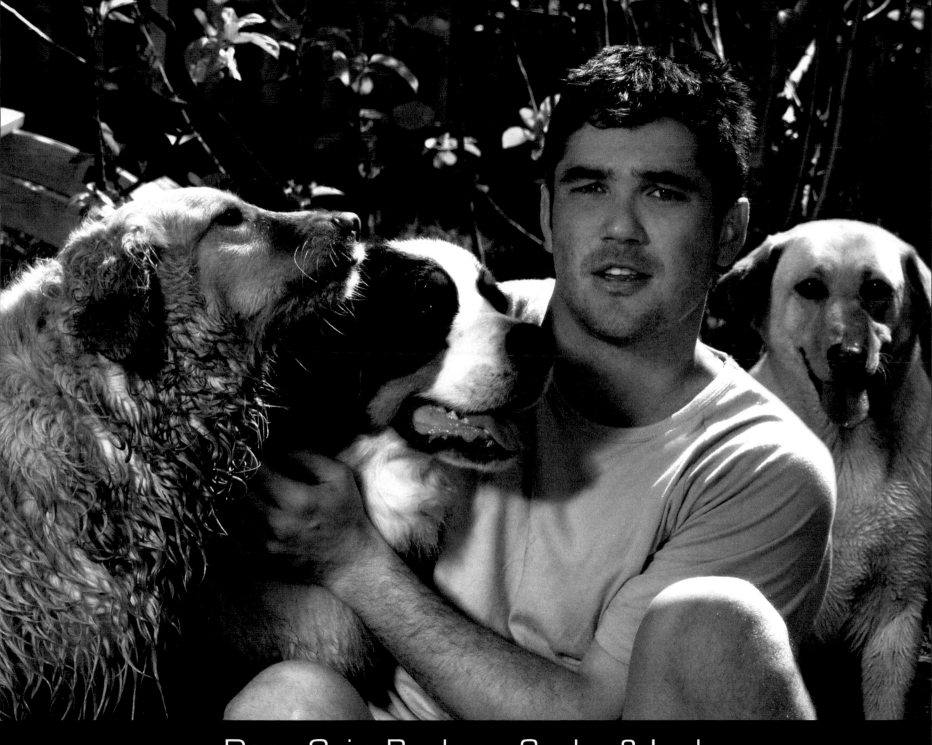

Dean Cain, Bonkers, Sasha & Lady

Ben Stiller: There's Something About Mary, Zoolander, The Royal Tenenbaums,  Meet the Parents, Tropic Thunder

Bo Derek: 10, Tarzan, the Ape Man, Tommy Boy, Malibu's Most Wanted

Brande Roderick: "Baywatch" Starsky & Hutch, Lucky 13, Win, Lose or Die

Brendan Fraser: Encino Man, School Ties, With Honors, George of the Jungle, The Mummy, & Mummy Returns,  Accidental Husband, Big Bug Man

Brian Green: "Beverly Hills, 90210," Laws of Deception, Fish Without a Bicycle

Brooke Burke: Wild On E! "Life is Great with Brooke Burke"

Bryce Dallas Howard: Book of Love, The Village, Manderlay, Mary Queen of Scots

Camille Winbush : Dangerous Minds, "The Bernie Mac Show"

Carre Ottis: Wild Orchid, Simon Says, Going Back)

Cassandra Peterson Elvira, Pee Wee's Big Adventure, Cheech and Chong's Next Movie, "Fantasy Island" Elvira's Haunted Hills

Catherine Oxinberg: "Dynasty," "I Married a Prince"

Cayden Boyd: Mystic River, Freaky Friday, The Adventures of Shark Boy & Lava Girl in 3D

Charlotte Ross:  Looking for Lola, "Beggars and Choosers," "NYPD Blue"

Cheri Oteri: "SNL," Liar Liar, Scary Movie, Dumb and Dumber, Aunt Bully

Christina Applegate: "Married… With Children," Don't Tell Mom the Babysitter's Dead, The Sweetest Thing, Suzanne's Diary for Nicholas, Mars Attacks!

Christine Taylor: The Brady Bunch Movie, Zoolander, Dodgeball: A True Underdog Story

Cole Hauser: Dazed and Confused, Good Will Hunting, 2 Fast 2 Furious, Paparazzi, The Cave, Dirty

Corey Feldman: Gremlins, The Goonies, The Lost Boys, Blown Away, The Waterfront, The Birthday

Courtney Cox Arquette: "Friends," Ace Ventura, Scream 1,2,3, The Longest Yard, Alpha Dog

David Faustino: "Married… with Children," Kiss & Tell, The Heist, The Trouble with Frank, Freezerburn

Dana Durey: "Providence," The Crew

Daphne Zuniga: "Melrose Place," A-List, "American Dreams"

David Allen Grier: "In Living Color," 15 Minutes, "Life with Bonnie," The Woodsman, Bewitched

David Shark Fralick "The Young and the Restless" Lockdown, The Unknown

Debbi Mazar: Goodfellas, The Doors, Beethoven's 2nd, Empire Records, Collateral, Be Cool

Debra Wilson: "Mad TV," Nine Lives, The Chosen One, White Paddy

Dominic Monghan: Lord of the Rings: The Fellowship of the Ring, The Two Towers, The Return of the King, "Lost"

Don Johnson:  "Miami Vice," "Nash Bridges," Tin Cup, Word of Honor

Donna Derrico: "Baywatch," Austin Powers in Goldmember, Kiss the Bride, Candy Man 2

Dorothy Lucy: Good Day L.A and Good Day Live, Behind Enemy Lines

Ed Begely Jr: The In-Laws, This Is Spinal Tap,  Renaissance Man, Best in Show, Auto Focus, Desolation Sound, Relative Strangers

E.G. Daily: Pee-wee's Big Adventure,  "Rugrats," voice of Tommy Pickles,  Babe, The Incredibles, The Devil's Rejects, Pledge This

Enrico Colantoni: "Just Shoot Me," "Veronica Mars"

Ever Carradine: Jay and Silent Bob Strike Back, "Lucky," My Boss's Daughter, Dead & Breakfast

Famke Jensen: Golden Eye, X-Men & X-2, Don't Say a Word, Hide and Seek, The Four Saints

Faith Ford: "Murphy Brown," North, "Hope and Faith")

Felicity Huffman : "Sports Night," Magnolia, Raising Helen, "Desperate Housewives," Transamerica)

Fred Durst: Limp Bizket

Gabriel Byrne: The Usual Suspects, Stigmata, Vanity Fair, Wah-Wah, Ghost Ship Leningard

Geri Haliwell: The Spice Girls, Spice World

Gina Gershon: Cocktail, Showgirls, Face/Off, Syriana, Dreamland

Haylie Duff: I Love Your Work, Napoleon Dynamite,  Dish Dogs, The After Dogs

Henry Winkler: "Happy Days," Scream, The Waterboy, Holes, Unbeatable Harold, The Kid & I

Hilary Duff: Material Girls, The Perfect Man, A Cinderella Story, The Lizzie McGuire Movie, Cheaper by the Dozen, "Lizzie McGuire," Raise your Voice

Hulk Hogan: Pro Wrestler, "Hogan Knows Best"

Ice-T: "Law & Order: Special Victims Unit," On the Edge, The Magic 7

Jack Osbourne: "The Osbournes," New York Minute

Jamie-Lynn Discalla: "The Sopranos,"  Love Wrecked, Dark Ride

James Gandolfini: True Romance, The Mexican, "Sopranos," Romance and Cigarettes

Jane Wiedlin: the Go-Go's, Firecracker, Live Freaky Die Freaky, Angels

Jason Wiles: Higher Learning, "Third Watch,"

Jeff Corwin: "The Jeff Corwin Experience," "King of the Jungle"
Jeffrey Tambourne: Meet Joe Black, Girl, Interrupted, "Arrested Development," Darwin Awards
Jenna Boyd: The Hunted, The Missing, The Sisterhood of the Traveling Pants
Jennifer Love Hewitt: "Party of Five," I Know What You Did Last Summer, Can't Hardly Wait, "In the Game" Garfield, The Tuxedo
Jerri Manthey: Survivor: The Australian Outback, Survivor: The Reunion, "The Surreal Life," Chloe's Prayer
Jessalyn Gisleg: The Horse Whisperer, "Boston Public," Fathers and Sons
Jillian Barberie: Good Day LA and Good Day Live, "Good Morning Miami," Cursed "Extreme Dating"
Joe Montegna: The Godfather III, "Joan of Arcadia," The Kid & I, Air Heads, Uncle Nino
John O'Hurley: "Valley of the Dolls," Seinfeld," Knuckle Sandwich
Jordan Ladd: Never Been Kissed, Cabin Fever, Dog Gone Love, Waiting…, Accidental Murder
Julliane Moore: Boogie Nights, Magnolia, The Hours, The Forgotten, Trust the Man, The Prize Winner of Defiance Ohio
Kyle Bax: Boys and Girls, Get Over It, Sports Illustrated model
Lacey Chabert: "Party of Five," Not Another Teen Movie, Mean Girls, The Pleasure Drivers
Lake Bell: Slammed, "Miss Match," "Boston Legal"
Lara Scott: DJ Star 98.7, On air television host
Linda Blair: The Exorcist, Exorcist II: The Heretic, "S Club 7" Roller Boogie, Cyber Meltdown
Linda Gray: "Dallas," "Melrose Place"
Lisa Ann Walter : Bruce Almighty, Shall We Dance, Dee Dee Rutherford
Lisa Edelstein: Say Uncle, "House, M.D., Fathers and Sons, Daddy Day Care, Obsessed, 30 Days
Lorenzo Lamas: Grease, Final Impact, Killing Cupid, "Renegade"
Mariska Hargitay: "Law & Order: Special Victims Unit," Perfume, Plain Truth
Maria Menunious: "Entertainment Tonight," Fantastic Four
Masiela Lusha: Fathers Love, "George Lopez," Cherry Bomb
Matthew Modine: The Goddess, The Transporter, Piggy Banks, Any Given Sunday, Pacific Heights, Birdy
Michael Madsen:  Reservoir Dogs, Free Willy, Die Another Day, Kill Bill: Vol 1 and 2 Sin City, Bloodrayne, The Last Drop
Michelle Rodriguez: Control, S.W.A.T., Blue Crush, Resident Evil, The Fast and the Furious
Missi Pyle: Big Fish, Along Came Polly, Anchorman, Charlie and the Chocolate Factory, American Crude
Natasha Alas: Miss World 2000, How to Marry a Billionaire: A Christmas Tale
Nicole Richie: The Simple Life 1,2, Kids in America
Nicollette Sheridan: "Knotts Landing," Beverly Hills Ninja, "Desperate Housewives"
Nikki Ziering: Serving Sara, Lady Killers, American Wedding, Standing Still
Ozzy Osbourne: Black Sabbath, MTV's "The Osbourne's"
Pamela Anderson: "Baywatch," "V.I.P," Scary Movie 3, BarbWire, "Stacked"
Paris Hilton: "The Simple Life 1,2,3," Wonderland, House of Wax, Pledge This
Persia White: "Girlfriends," The Fall of Night)
Peter Gallagher: While You Were Sleeping, American Beauty, Mr. Deeds, "The O.C."
Rachel Hunter: Rock Star, Redemption of the Ghost, Freezerburn, "Denial"
Roma Maffia: Married to the Mob, Disclosure, "Profiler," Kiss the Girls, I Am Sam, "Nip/Tuck"
Rosanna Arquette: Desperately Seeking Susan, Pulp Fiction, The Whole Nine Yards, Searching for Debra Winger
Rose McGowen: Scream, Jawbreaker, "Charmed," "Elvis"
Sandra Taylor: Batman & Robin, Runaway Bride, Raising Helen, Lucky 13, Princess Bride
Shannen Doherty: "Beverly Hills, 90210," Mallrats, "Charmed" "Scare Tactics
Shelly Morrison: "The Flying Nun," Fools Rush In, "Will & Grace," Shark Tale
Slash: Guns N Roses, Velvet Revolver
Sprague Grayden: "Six Feet Under," Joan of Arcadia," John Doe, Mini's First Time
Steve Valentine: Mars Attacks!, The Muse, "Crossing Jordan"
Taryn Manning: Crossroads, 8 mile, Cold Mountain, A Lot Like Love, Unbeatable Harold
Taylor Dayne: Singer, Jesus the Driver, Joshua Tree, Stag, Love Affair
Tiffany: Jetsons: The Movie, Death and Texas
Tom Green: Road Trip, Charlie's Angeles, "The Tom Green Show," Bob the Butler
Vanessa Lengies: "American Dreams," The Perfect Man, Waiting, Arthur: The Movie
Victor Webster: "Mutant X," Bringing Down the House, Must Love Dogs
Victoria Pratt:  "Mutant X,"  Ham & Cheese,  Comedy Hell, Murder at the Presidio
Vincente Scharvelli: Fast Times at Ridgemont High, Better of Dead, Batman Returns, Ghost
Virginia Madsen: The Rainmaker, The Haunting, "American Dreams," Sideways, The Wrong Element
Weird Al: "The Weird Al Show" UHF
William H Macy: Boogie Nights,  Fargo, Magnolia, Pleasantville, Sahara, Edmond, The Cooler, Door to Door
William Lee Scott: Pearl Harbor, Identity, The Butterfly Effect

For information please contact:
www.chrisaphoto.com or www.channelphotographics.com

Channel Photographics
116 East 16th Street
12th floor
New York, NY 10003
P212.254.5240  F212.254.5246

ISBN  0-9766708-3-6

First Edition

Photographs by Christopher Ameruoso
Book and Cover design by Christopher Ameruoso

Printed in China by:
Global PSD
www.globalpsd.com

A portion of this book's proceeds will benefit Linda Blair's World Heart foundation for animals
www.lindablairworldheart.com